Ta tical Media

Electronic Mediations
Katherine Hayles, Mark Poster, and Samuel Weber, Series Editors

Tactical Media

RITA RALEY

Electronic Mediations 28

University of Minnesota Press
Minneapolis
London

The Introduction and chapters 2 and 3 include material previously published in
"Statistical Material: Globalization and the Digital Art of John Klima," *CR: The New
Centennial Review* 3, no. 2 (Fall 2003): 67–89. A shorter version of chapter 1 was
published as "Border Hacks: The Risks of Tactical Media," in *Risk and the War on
Terror*, ed. Louise Amoore and Marieke de Goede (New York: Routledge, 2008).

Published by the University of Minnesota Press
111 Third Avenue South, Suite 290
Minneapolis, MN 55401-2520
http://www.upress.umn.edu

Library of Congress Cataloging-in-Publication Data

Raley, Rita.
 Tactical media / Rita Raley.
 p. cm. — (Electronic mediations ; 28)
 Includes bibliographical references and index.
 ISBN 978-0-8166-5150-4 (hc : alk. paper) — ISBN 978-0-8166-5151-1 (pb : alk.
 paper)
 1. Mass media—Simulation methods. 2. Digital media. 3. Computer simulation.
I. Title.
 P93.6.R35 2009
 302.23'1—dc22

 2008046554

Printed in the United States of America on acid-free paper

The University of Minnesota is an equal-opportunity educator and employer.

15 14 13 12 11 10 09 10 9 8 7 6 5 4 3 2 1

For Russell, who is very generous,

and Alan, who is very patient

Culture and art have become productive resources. But, exactly like the "general intellect," they can transform themselves into political resources for the multitude.

—PAOLO VIRNO

I don't believe in revolution, but I do believe in revolutionary resistance.

—PAUL VIRILIO

May I tell a story? I have no idea whether it is true. It is the third day of the Bolshevik Revolution, and Lenin is sitting somewhere in Saint Petersburg. Trotsky comes running in and says, "Kronstadt has been taken! We are lost!" Or whatever he said. And Lenin answers, "It doesn't matter! We existed for three days!" That's what I mean. It won't be carried to completion, but we are a generation that sees a vision of a utopia.

—VILÉM FLUSSER, *The Freedom of the Migrant*

Contents

Acknowledgments

Commentary on the impact of September 11 on academic criticism has become something of a cliché. Nevertheless, I cannot but note that events in this decade led me to shift my research focus from the modern colonial archives to the political, economic, and media systems of the contemporary moment. For a time, I thought this book was a consequence of my having moved to Southern California in the summer of 2001, but I have come to understand that it is the result not only of my immersion in the IT-rich environment of California but also of my years at the University of Minnesota, where the faculty and students working in the area of contemporary cultural studies and theory are without equal.

Katherine Hayles has been a great supporter of my work, and I can only gesture toward a complete acknowledgment of all that is owed her. I am also hugely indebted to Mark Poster and Doug Armato both for championing this book for the series and keeping an eye on its progress. For more than a decade, I have worked under the conscious and unconscious influence of Alan Liu as he was writing his magisterial study of knowledge work, *The Laws of Cool*. It goes without saying that Alan continues to give voice to many of my ideas and helps me bring them into being. So, too, Russell Samolsky has been collaborator and combatant; without his input this book would have taken a very different form indeed.

Thanks to the following for contributions that range from careful reading to general advice and reading suggestions: Carl Gutiérrez-Jones, Philip Armstrong, Julian Stallabrass, Karen Steigman, Jennifer Jones,

Jani Scandura, Maria Damon, Paula Rabinowitz, William Paulson, Mary Poovey, Brenda Silver, Aden Evens, Geert Lovink, Lisa Parks, Robert Nideffer, Noah Wardrip-Fruin, and John Klima. Friends and colleagues at Rice University, in particular Betty Joseph, Susan Lurie, Krista Comer, and Thomas Chivens, made invaluable contributions to the project during my time in residence there.

A version of chapter 1 was presented to the ISA-sponsored workshop "Governing by Risk in the War on Terror" (March 2006). I am grateful to Marieke de Goede, Louise Amoore, and other workshop participants for their valuable comments and suggestions. Another version of this chapter was presented as part of the symposium "Alternative Networks," sponsored by the Global Cultures in Transition research initiative at the University of California, Santa Barbara (May 2006). I am also grateful to audiences at the University of California, Irvine; Dartmouth College; University College, Cork; University of Wisconsin, Madison; Blekinge Institute of Technology; and Uppsala University.

Finally, particular gratitude must be extended to all the artists and tactical media practitioners who inform this book. It is my fervent wish that this book will become obsolete because the world will have changed so dramatically that this study of art-activism could only appear as a quaint historical artifact, its latent pessimism misguided, its failure to imagine otherwise indicative of the author's poverty of imagination. Until such a point, I will continue to look to tactical media artists for inspiration and guidance.

Introduction
Tactical Media as Virtuosic Performance

Why save the world when we can design it?

—SERPICA NARO

There is much in the world to protest. The pressing question, particularly for a generation schooled in intellectual history by those who believed in revolution and had in fact stormed the barricades, is this: how does one express dissent and conceive of revolutionary transformation while distancing oneself from one's forebears, whose lingering nostalgia for their own storming of the barricades, not to mention their idealistic belief in the possibility of visible and permanent social change, seems quaint, if even a trifle embarrassing? Of course, the Battle of Seattle caught the world by surprise. Antiglobalization, WTO, and G8 protests have been nothing if not spectacular, starkly defined spatial and temporal events. So, too, were the street demonstrations in support of U.S. immigrant rights in the spring of 2006. But the fact remains that the doxa about the value, cultural significance, and efficacy of the streets has changed. This is less an objective than a subjective truth, a truth of perception, a general impression of a shared sensibility. It is precisely this change in sensibility that politically engaged new media art projects negotiate. As we will see in the pages that follow, Critical Art Ensemble's suggestion that "the streets are dead capital" informs their theses about the work, and the targets, of tactical media. Critical Art Ensemble (CAE) argues that the shift in revolutionary investments corresponds with a shift in the nature of power, which has removed itself from the streets and become nomadic. Activism and dissent, in turn, must, and do, enter the network, as we will see from the new media art projects I address in this book. These projects are not oriented toward the grand, sweeping revolutionary event; rather, they engage in a micropolitics of disruption, intervention, and education.

1

Josh On and Futurefarmers' *They Rule* (2001/2004) affords us an example of a new media work that is at once aesthetic design, intellectual investigation, and political activism.[1] A work of tactical cartography, *They Rule* affords users the ability to visualize the myriad and intricate connections among Fortune 100 corporations and directors. Users can choose from a list of institutions, people, and companies and build their own maps from the data the artists have compiled from SEC filings and public Web sites. Or they can view the archived maps that powerfully document the concentration of wealth and power in the hands of "the ten richest people" and "the magnificent seven."

By rendering economic and political complexity in the form of a basic cartography, *They Rule* strives to make legible the kind of behind-the-scenes loyalties and corporate collusions that drive public policy. Further, its use of simple, monochromatic icons and geometric lines suggests that "design" as such is constituted by the architecture of corporate power. With Mark Lombardi's graphite-on-paper drawings, Michael Moore's *Fahrenheit 9/11*, and Craig Unger's *House of Bush, House of Saud* as precedents, the maps voted most popular tend to be those that trace the degrees of separation from, variously, the Bush family, Dick Cheney, Harken Energy, and Halliburton.[2] Tactical maps such as these do not offer the omniscient point of view we associate with Cartesian cartographic practice; in that they are individually tailored and produced, they are fundamentally subjective. *They Rule* in particular embodies a sense of bottom-up resistance: it may map the top-down power relations, but it does so in a manner and style we have come to associate with cultural dissent and oppositionality. *See what I have made*, the tactical user says. *See how I try to manage the ties that bind and produce me.* It may be a hollow laugh at power, but it is still a laugh, the enjoyment at once solitary and shared, for, as the list of "hot" or favored maps on the site indicates, *They Rule* forges a social bond and a political consciousness held in common.[3]

Oil politics are even more directly at the fore in Michael Mandiberg's *Oil Standard*, a Firefox plug-in that uses real-time pricing information in the dynamic conversion of U.S. dollars into barrels of crude oil.[4] The most recent book on media activism? One half barrel. Last month's water bill? A full barrel. So are we instructed in the new monetary stan-

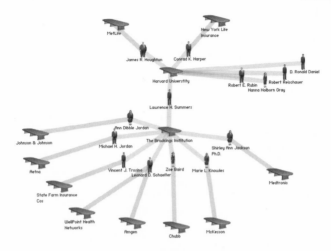

Josh On/Futurefarmers, They Rule, *"Why Harvard Doesn't Fund Alternative Health Care Research" (created by user Shojo).*

dard, the fluctuating unit of account to which the dollar is pegged, a unit that in turn fixes the value of the dollar. There are practical differences between these two projects—one is a visualization tool, and the other is a browser plug-in—but they share certain pedagogical and ideological investments. How we might account for the work they do, and how we might account for the political interventions of other new media artist-activists, is the subject of this book.

Tactical Media contributes to the discourse on the digital humanities by examining the aesthetic and critical practices that have specifi-cally emerged out of, and in direct response to, both the postindustrial society and neoliberal globalization. The hallmark of the postindustrial society is the information economy and the emergence of a correspond-ing technical intelligentsia. It is theorized in these terms by Daniel Bell and in terms of informational capitalism by Manuel Castells, who uses the phrase to describe the new "techno-economic system," the structure of which was ultimately determined by the neoliberalism of the 1980s.[5] Regardless of the terminology employed, it is "information" and the col-lapse of the Bretton Woods system regulating the monetary economy that make possible neoliberal globalization, the name given to the philosophy governing our current global markets. In sum, the ideology of neoliberal

globalization holds that financial markets should operate unfettered and that state intervention or regulation of any kind is anathema. What new digital art practices have emerged out of a context in which efficiency, operationalism, and instrumental rationality are core values and market transactions the predominant social good?

One such art practice is the persuasive game, the mechanics of which are particularly well suited to political themes such as labor, migrancy, and war. As Ian Bogost and others have noted, persuasive games take care to model causality and consequences; within them, critical arguments are made via the emphasis on the effects of gameplay actions. For example, the dystopian *TuboFlex*, by Molleindustria, takes precarious labor as its central theme.[6]

Set in 2010, the game literalizes the ideology of a flexible, modular, and mobile workforce with Tuboflex Inc., a postindustrial workplace in which the player/worker is propelled on demand from task to task via something like a pneumatic tube. Somewhat in the mode of Chaplin's *Modern Times*, the repetitive and often mechanized work speeds up as the player progresses through the different workplace settings, which include a McDonald's drive-through window, Santa Claus putting smiles on the faces of children (an instance of affective labor), assembly line drilling, an office worker with a computer, and a box handler at a shipping warehouse. All the scenarios feature temporary work, replaceable and finite (as with the seasonal labor during Christmas). The quickest of players can manage to stave off the ending of the game for a time, but all attempts to play end with the central character begging on the street. The game rhetoric is clearly pedagogical and persuasive, as with all political or activist games. The lesson of this game in particular is that "life" has been mobilized for work, that the techniques for biopolitical management of the body include the tools of the postindustrial workplace, and that postindustrial labor is not in fact radically heterogeneous.

Many of the formal features and thematic concerns of the field of new media art, information art, or digital art have been articulated in works authored or edited by Michael Rush, Lev Manovich, Stephen Wilson, Christiane Paul, Julian Stallabrass, Rachel Greene, Lucy Kimbell, Bruce Wands, Mark Tribe and Reena Jana, and Joline Blais and Jon Ippolito.[7] On the whole, these surveys address the genealogies of new media art,

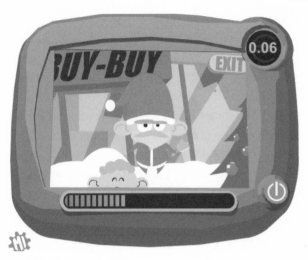

Molleindustria, TuboFlex.

the specificity of medium and mechanism, new modes of reader-user engagement, the distinctive language of computational media, the particularities of composition and delivery (programming languages, software applications, the cultural and technical aspects of networks). Combining an analysis of social contexts and media texts, my book will address the varying responses of new media artists to the neoliberal condition in all its aspects—political, economic, cultural. In that it foregrounds technological expertise, it is less a study of new media art in terms of consumption and modes of embodied interactivity than a study of production and technique. There have been numerous studies of "wired" political engagement in all its diverse forms, network-based activism and political organization (e.g., clicktivism, smart mobs) and hacktivism chief among them.[8] While I do cross paths with some of these studies in my treatment of electronic civil disobedience and other hacktivist tactics, my interests lie in articulating the aesthetic strategies of artist-activists producing persuasive games, information visualizations, and hybrid (we might even say "new") forms of academic criticism. I will note, too, that I do not propose a full catalog of works that would be situated under the label "activism, hacktivism, artivism." Such archiving efforts already exist, and to pursue that course would be to move into the mode of the

encyclopedia, somewhat like Stephen Wilson's crucial guide *Information Arts*. Instead, I sample works and art practices that are paradigmatic. My study will not collapse the material distinctions among these different media projects, but it will articulate them all as instances of tactical media. This is to say that they are all forms of critical intervention, dissent, and resistance. I will go further to find strong and suggestive correlations between tactical media—as I understand it, but also as it has been theorized by Critical Art Ensemble, Carbon Defense League, and the digerati—and virtuosity, intellectual labor that manifests in virtuoso performance rather than extrinsic product.

The Next Five Minutes

Generally taken to refer to practices such as reverse engineering, hacktivism, denial-of-service attacks, the digital hijack, contestational robotics, collaborative software, and open-access technology labs, "tactical media" is a mutable category that is not meant to be either fixed or exclusive. If there were one function or critical rationale that would produce a sense of categorical unity, it would be disturbance. In its most expansive articulation, tactical media signifies the intervention and disruption of a dominant semiotic regime, the temporary creation of a situation in which signs, messages, and narratives are set into play and critical thinking becomes possible. Tactical media operates in the field of the symbolic, the site of power in the postindustrial society. Critical Art Ensemble has insisted that tactical media are pliable and that pliability allows for on-the-fly critical intervention: statements, performances, and actions that must continually be altered in response to their object, "constantly reconfigured to meet social demands."[9] Geert Lovink has also emphasized the inclusiveness and flexibility of tactical media, which he identifies as a "deliberately slippery term, a tool for creating 'temporary consensus zones' based on unexpected alliances."[10] In use since the first Next Five Minutes conference (N5M) in Amsterdam in 1993, the term "tactical" itself was, as Lovink explains, "introduced to disrupt and go beyond the rigid dichotomies that have restricted thinking in this area for so long."[11] As the organizers of N5M indicate, the dichotomies under pressure include amateur and professional, "all forms of old and new, both lucid

and sophisticated media."[12] Since the category of tactical media has been fluid since its inception and since the assemblage of practices it would seek to describe has not yet been fully articulated, I will assume a critical license to work within its perimeters, highlighting certain discursive features and introducing others. The distinct temporality of tactical media, their ephemerality, along with their opening to the unexpected, will be one of the key components of my analysis.

That tactical media present a challenge to "the existing semiotic regime by replicating and redeploying it," as Critical Art Ensemble explains, might seem to indicate that the critical object is the substitution of one message for another, the imposition of an alternative set of signs in the place of the dominant. But when the Yes Men launched gwbush.com and announced the "Amnesty 2000" campaign, effectively hijacking the president's official Web site, their purpose was not to impose a definitive countermessage but to provoke and to reveal, to defamiliarize and to critique. Lovink notes that tactical networks do not "aim to become an alternative CNN, a Yahoo! for the protest generation."[13] Rather, the activity of disturbance and provocation "offers participants in the projects a new way of seeing, understanding, and (in the best-case scenario) interacting with a given system."[14] A charming but dated and even futile endeavor, perhaps, hopelessly removed from the real politics and activities of social transformation? Irredeemably caught up in the kind of irony that disguises a co-optation by the very system with which one putatively interacts anew? In what terms can we speak of the efficacy of cybersquatting? Critical Art Ensemble addresses the question by casting its lot with speculation, uncertainty, and the aleatory:

> Treading water in the pool of liquid power need not be an image of acquiescence and complicity. In spite of their awkward situation, the political activist and the cultural activist (anachronistically known as the artist) can still produce disturbances. Although such action may more closely resemble the gestures of a drowning person, and it is uncertain just what is being disturbed, in this situation the postmodern roll of the dice favors the act of disturbance.[15]

It is not simply that interventions by tactical media may disturb but that the outcomes of those disturbances remain uncertain and unpredictable. Moreover, we can see in CAE's figure of the drowning person an emphasis on the perception of the audience: we can read the interventions

either as hopeless desperation or, to extend the metaphor, as a strong battle against the currents. For historical perspective we might juxtapose CAE's hope of "offering participants a new way of seeing, understanding, and interacting" with Félix Guattari's 1992 call to "invent new spheres of reference so as to open the way to a reappropriation and a resymbolization of the use of communication and information tools outside of the hackneyed formulae of marketing."[16] The actual developments we have seen in the intervening years—peer-to-peer computing, as just one example—retroactively respond to this call for symbolic awareness and individual technological mastery. What I wish to emphasize in CAE's vision and Guattari's appeal is the necessary abstraction, the unspecified qualities, of the way, the "new way," forward. As will become clear throughout the course of this book, tactical media requires a certain openness, a surrendering to chance or the "postmodern roll of the dice"; even more, it requires that its practitioners cede control over its outcomes.

It is in these terms that we can understand the tendency of Critical Art Ensemble and collectives such as the Bureau of Inverse Technology to provide assembly instructions for their products and projects, not all of which are designed to be fully realized. The Bureau of Inverse Technology's "BIT Cab" project plans to co-opt the wireless GPS infrastructure currently in use for advertisements on taxi roofs to provide site-specific information about toxic pollution instead.[17] For this and their other projects, the critical emphasis falls not only on the moment of execution, the actual performance, but also on the engineer's reports and kit instructions, information that would allow viewers themselves to master the mechanism. To do so would be to reappropriate the technological platform, to deploy it for "inverse" purposes. Exercises in "tactical gizmology" are fundamentally educative: witness an illustrative Eyebeam workshop (August 2002), the objective of which was to give participants hands-on experience with hardware and to teach them to build digital tags for "friendly" interventions in spaces where we have come to expect screens, such as movie kiosks.[18] The broader ideological and pedagogical imperative, the balancing of symbolic and network awareness, similarly lies behind Konrad Becker and Francisco de Sousa Webber's Netbase/t0, a nonprofit Internet provider that also supports workshops, lectures,

and instructional courses in the interest of developing a "heightened consciousness for the implications of the new communication and information technologies."[19] What interests me in particular is the double lesson, both the kit information for "BIT Cab" and the environmental messages transmitted through the taxi displays. The Bureau of Inverse Technology's FAQ unusually comprises authoritative questions without answers, ranging from "How do you negotiate the difference between Art and Engineering?" to "Why?" It is almost necessary that these inquiries be left unanswered, I will speculate, because tactical media focuses on open-ended questions rather than prepackaged lessons, instructions rather than products.[20] Carbon Defense League—whose many projects include Re-code.com, FtheVote.com, and the collaborative reverse engineering of a Nintendo Game Boy—proposes that tactical media aims to create situations "where criticality can occur."[21] More important, "tactical media practitioners should not suggest where the use of these qualities [criticality] should lead once unrestrained."[22] Their operative field, rather, is that of the next five minutes.

Choosing tactics over strategy might seem to suggest a certain temporal structure: the temporary rather than the protracted, the unguarded and unexpected moment rather than the long-range plan. But, as Carbon Defense League explains, both temporalities are at work in tactical media:

> Incident-based parasitic media response takes place in a very specific time and space. There is no need for the parasite to live longer than a few days or even a few seconds. The more complex system is generative parasitic media response. Generative parasites must adapt and grow with their host system. This growth creates an allowance for greater sustainability of backdoors or hijacks. A parasite need not take advantage of its host's vulnerability to hijack. It is in the best interest of the parasite to live and feed alongside its host.[23]

The incident-based parasite exists in the here and now. It uses itself up in its operation. The generative parasite, on the other hand, has to study and understand its host; it must adapt in order to thrive. So, too, does the host adapt to its parasite. While parasitic media responses may have a cumulative effect, any systemic change they bring about may be both imperceptible and undesirable.

This is avant-garde artistic experimentation that shuns the manifesto

("the style of the disempowered"), lacks a big picture, and refuses strategy: the doing, the performance, is all.[24] As Critical Art Ensemble observes, "After two centuries of revolution and near-revolution, one historical lesson continually appears—authoritarian structure cannot be smashed; it can only be resisted."[25] There are, then, as Lovink notes, "no apocalyptic or revolutionary expectations here."[26] Absolute victory is neither a desirable nor a truly attainable object for tactical media, which is why it will be possible for me to trace parallels between guerrilla warfare and systems disruption. The political imaginary for our moment is thus not Sergei Eisenstein's *October* but the muddled film adaptation of Alan Moore's *V for Vendetta*. Its fantasy—the destruction of the Old Bailey and Parliament without loss of life—and the abstractions of V's idea tell us a great deal about the symbolic value and currency of this revolutionary mythology at the present.[27] Indeed, is this not the fantasy of revolution without revolution, as Slavoj Žižek would say?[28] Josh On, whose *Antiwargame* I will address in a later chapter, maintains that "it is possible to have a revolution" in the game simulation that he has collaboratively designed. In its theoretical outcome, "everyone jumps up and down and is happy. I think you need a ton of protesters."[29] Situating even the *simulation* of revolution within the realm of possibility, and framing it as revolutionary happiness rather than revolutionary violence, On's comment has much to tell us about the orientation of tactical media. There are no proffered fantasies of radical systemic change: it exists as a possibility within the realm of the imagination—another technology of simulation—but it requires collective action, a "ton of protesters." This is not the mystification of the California Ideology 2.0, whereby digital artisans articulate a vision of individual freedom realizable from within the structures of the network society.[30] But neither is it the replacement of the old with the new vanguard, an avant-garde 2.0, whereby "a technocratic class of resistors acts on behalf of 'the people,'" a fantasy that, Critical Art Ensemble explains, "seems every bit as suspect, although it is not as fantastic as thinking that the people of the world will unite."[31] What is required, rather, is a multitude of different creative agents, a multitude that fuses or is situated between the individual and the collective.[32] On this note, the work of artist collectives in particular allows us to think about the emancipatory potential of sociality and cooperation.

As Michael Hardt and Antonio Negri observe, immaterial labor directly involves social interaction; in this sense, cooperation is not imposed from outside but emerges from within. To continue along these lines, we might think about the double-sided quality of the labor of programmers and technocrats: on the one hand it is a means of economic value, but on the other it can be a source of subversive, if not revolutionary, potentiality.

Lovink and David Garcia together argue that tactical media are not mired in the position of the oppositional or the minoritarian.[33] Tactical media events and projects, and the moments of dissent and critique they produce, are not simply oppositional because there is no definitive "they" to confront. They also cannot easily inhabit an oppositional stance because—as we will see in examples ranging from an intervention in the game space of *America's Army* and corporate-sponsored visualizations of stock market data—tactical media are "forced to operate within the parameters of global capitalism," or, in Critical Art Ensemble's terms, in the "pool of liquid power."[34] These artist-activists thus critique and resist the new world order but do so from within by intervening on the site of symbolic systems of power: networks of finance, technologies of war, even, as in the case of the Yes Men, corporate conferences. This is more than Dadaist provocation, however, and not simply a variant of a radical art practice that endeavors to disrupt sociopolitical, economic, and cultural structures. Their campaigns comprise little tactics rather than bold strategies, but paradoxically we might understand their efforts by turning to a theorist of 4GW (fourth-generation warfare), John Robb: "To global guerillas, the point of greatest emphasis is the systempunkt. It is a point in the system . . . usually identified by one of the many autonomous groups in the field, that will collapse the target system if it is destroyed. Within an infrastructure system, this collapse takes the form of disrupted flows that result in financial loss or supply shortages. Within a market, the result is a destabilization of the psychology of the marketplace that will introduce severe inefficiencies and chaos."[35] One of the premises of my study is that this articulation of dynamic, decentralized, and bottom-up resilience has become paradigmatic for netwar, activist movements, and the academy. Witness the central statement in Alexander Galloway and Eugene Thacker's *The Exploit:* "Protocological

struggles do not center around changing existent technologies but instead involve discovering holes in existent technologies and projecting potential change through those holes. Hackers call these holes 'exploits.'"[36] Whether oriented toward systempunkt or exploit, tactical media comes so close to its core informational and technological apparatuses that protest in a sense becomes the mirror image of its object, its aesthetic replicatory and reiterative rather than strictly oppositional. As we will see, then, tactical media's imagination of an outside, a space exterior to neoliberal capitalism, is not spatial but temporal. So, informed by Critical Art Ensemble's understanding of power as diffused, networked, multiple, and a-territorial, tactical media do not necessarily evade the us-them dialectic, but they do recast it such that "us" and "them" are no longer permanently situated.

To articulate tactical media in terms of performance rather than as static art object emphasizes viewer experience and engagement. Tactical media is thus relational in the terms Nicolas Bourriaud has outlined, like much contemporary art activity, in that it takes "as its theoretical horizon the realm of human interactions and its social context, rather than the assertion of an independent and private symbolic space."[37] Among its many subjects, then, is the sphere of human relations, moments of social encounter and moments of direct address and engagement with the viewer. Moreover, the performance paradigm allows CAE and other tactical media practitioners to conceive of "participants" as a flexible rather than fixed role, encompassing both artists—cultural workers— and viewers. To conceive of tactical media in terms of performance is to point to a fluidity of its actants, to emphasize its ephemerality, and to shift the weight of emphasis slightly to the audience, which does not simply complete the signifying field of the work but records a memory of the performance. And here we must once again place tactical media in the context of Bourriaud's commentary on contemporary relational art, to stress that the audience is an analytic category, singular yet multiple, heterogeneous rather than homogeneous, an experiential rather than ontological entity. As Bourriaud explains, "the audience concept must not be mythicized—the idea of a unified 'mass' has more to do with a Fascist aesthetic than with these momentary experiences, where everyone has to hang on to his/her identity. It is a matter of predefined coding and

restricted to a contract, and not a matter of a social binding hardening around totems of identity."[38] The audience concept is thus as flexible and ephemeral as the artistic activity itself. Tactical media is performance for which a consumable product is not the primary endgame; it foregrounds the experiential over the physical. It "leaves few material traces. As the action comes to an end, what is left is primarily living memory."[39] Hacktivist tactics such as FloodNet, as we will see in chapter 1, leave material traces of their operation in server logs; however, as Critical Art Ensemble explains, "traces and residues are far less problematic than strategic products, which come to dominate the space in which they are placed."[40]

If there is to be no strategic product, no manifesto, and even no totality, what, then, is the task of this book? For practitioners of tactical media, shifting from strategy to tactics is important because it renders the phenomenon of resistance fleeting, ephemeral, and subject to continual morphing. The swarming operations of flash mobs provide an analogue: media artist-activists gain access to a server, a URL, or a game space; perform an intervention; and then just as suddenly disperse. What has to be acknowledged, though, is that the critical operation makes visible, stabilizes, and even concretizes a set of projects for which ephemerality and mutability are not only part of the epistemology of the work but also a means of functioning. To some degree, this book will take what are diverse, "deliberately slippery," and heterogeneous practices—and what is a stratified political movement—and make them cohere. The tactics of tactical media are not homogeneous, but in the act of assembly, I will provide a certain coherence that these projects may resist. Lovink, after all, notes that "tactical media are not so much in need of theories or Big Ideas. . . . There is no 'World Federation of Tactical Media.'"[41] One must therefore pose the question: is there a lurking danger in bringing tactics into visibility, in making stable that which maintains a kind of power by being unstable? Is there a contradiction between my methodology and the tactics I describe? An initial response, both pragmatic and prosaic, is to note that there is not necessarily a way out of this problem: a critical text, after all, demands a certain coherence, and therefore all one can do is point to the contradiction between the critical act and the heterogeneous and even subscopic aspects of the projects under discussion. There

are, however, other strategies: one might place tactical media under erasure or perhaps develop a methodology and a mode of critical writing that contains within it a kind of instability, such as Matthew Fuller was able to do in his magisterial *Media Ecologies,* which performatively renders his media objects fundamentally unstable, such that neither critic nor reader can get a definitive fix on them.

But we can find a better answer to this question within the works of tactical media themselves, which are more interested in repurposing, modifying, and disrupting than they are in remaining invisible. They are invested in stability, at least insofar as they want to have a material effect on the world, however temporary and provisional, which is to say that their object is not exactly formlessness and uncontainability. In fact, in that their tinkering, playing, and visualizing are themselves a kind of academic criticism, they are not so far removed from my own discourse. That is, these artist-activists may not necessarily be invested in the idea of a fundamental structural transformation, but they are invested in cultural critique, itself invested with a transformative power that may not be immediately perceptible but in which one must place a certain belief. And cultural critique, insofar as it abstracts and generalizes, itself allows for the formation of a provisionally stable descriptive category: abstraction is one means of establishing temporary, nonessential, even tactical commonality among art practices as disparate as distributed denial-of-service attacks and information visualization. This commonality does not suggest homogeneity; rather, abstraction forges a set of tactical links that do not collapse the differences among different projects, practices, and investments.

The initial development of tactical media was coterminous with the development of information technologies and the subsequent dot-com boom—this is the era of the first Next Five Minutes (N5M) conferences—but the war on terror, the expansion of financial capitalism, and the intensified implementation of neoliberal policies in the opening years of the twenty-first century have given rise to what I read as a more fluid, extensive, and thereby more powerful set of art-activist practices. It is therefore not simply critical license that allows me to see beyond the era of tactical gizmology and to discover a range of new media art prac-

tices with clear sociopolitical engagements. In the pages that follow, I showcase different projects on topics such as territorial borders, war, and finance capital. Such a structure cannot hope to be comprehensive; rather, it is representative and illustrative. The projects I discuss are not isolate or discrete but intricately linked: the voice of dissent is not alone in the wilderness of the art world, somehow external to its primary institutions, but is growing into a resounding chorus. What might seem to be the presentist quality of my discussion—many of the projects I discuss are mere months old—is counterbalanced by an attention to the rich history of interventionist art practices that inform tactical media. It is further counterbalanced by a sociology-of-knowledge approach that outlines the conditions to which tactical media projects respond.

Tactical Gizmology

In the age of the network society, a range of new media activities have been written under the sign of the tactical: TXTMobs; contestational robotics (LittleBrother); hacktivism (encompassing practices such as electronic civil disobedience, distributed denial-of-service attacks, and campaigns by the Electronic Frontier Foundation);[42] alternative or independent media; clicktivism (Moveon.org); peer-to-peer network building; virtual communities (WELL, BBS); laboratories (Makrolab); open-source software platforms; anticorporate parody (Yes Men, 0100101110101101.ORG); cybersquatting (Etoy, Vaticano.org);[43] modding; and Life hacks (the dissemination of instructions about how to hack the iPhone or how to plant herbicide-resistant seeds). One might think, then, that this is an analytic and artistic category designating all technology-based activism. But in my analysis, tactical media is also the rubric for work that does not easily fit within the activism category, whose political critique is subtle, not immediately obvious, even covert.

The true departure from this earlier wave of tactical media can be achieved by revisiting Michel de Certeau, whose theorizing of tactics and strategy in *The Practice of Everyday Life* deeply informs Lovink, Critical Art Ensemble, and others writing about tactical media in the 1990s and extending through the publication of a special issue of the journal *Subsol*

on the topic in 2002.[44] On the whole, from this critical discourse we get the sense that "tactical media" ought exclusively to mean the use of low- or no-tech tools as a mode of protest against governmental, corporate, and biopolitical structures of control. In my view, we can take a more expansive view than that of DIY and protests articulated via billboards and simple scripts, although such tactics still require our critical attention. Put simply, de Certeau's neat alignment of users and tactics, producers and strategy, is complicated by tactical media practitioners who write their own scripts and build their own gadgets. Tactics, that is, are tools for users who are also producers. As the Tactical Media Crew explains, "Tactical Media are what happens when cheap 'do it yourself' media made possible by the revolution in consumer electronics are exploited by those who are outside of the normal hierarchies of power and knowledge."[45] Thus does the Institute for Applied Autonomy hail the new models of technical expertise: "Praise be to the tinkerers, to the toy makers, and to the amateurs. New versions of expertise must be constructed."[46]

Such tinkering might include Critical Art Ensemble's hacking of a Nintendo Game Boy to produce *Super Kid Fighter*, a text-based role-playing game modeled on Wilhelm Reich's writing about children's sexual rights. In the new game space, players have to ditch school, sell drugs, and engage in other criminal activities to fulfill the objective, which is to gain admission to the town's brothel. The purpose of this reengineering is to counter what the artists regard as the false Puritanism in the U.S. social context (the mass hysteria about children seeing Janet Jackson's breast, for example). We will see a different kind of reengineering at work in my second chapter, where I discuss Joseph DeLappe's intervention in the game space of *America's Army*, with the result that it temporarily functions not as a game of military valorization but as a game of mourning. What both modes of reengineering indicate is the extent to which tactical media operates both at the level of technological apparatus and at the level of content and representation. It is not simply about reappropriating the instrument but also about reengineering semiotic systems and reflecting critically on institutions of power and control. The work of the Preemptive Media collective—which informs and deforms mobile digital technologies such as RFID, Wi-Fi, and bar codes—is particularly

apposite here. Preemptive Media's object is to exploit consumer electronics for a larger purpose, not only to instruct users and consumers but also to foster critical consciousness and a kind of low-tech amateurism. In one representative performance, *Swipe* (2002–2005), the collective installed a bar at a media arts event and scanned the driver's licenses of all the bar patrons, producing a visualization of the data along with individual receipts detailing each patron's demographics including income, profession, and consumer habits.[47] The idea behind this activity was to encourage consumer awareness of processes of automated identification data collection (AIDC) and to encourage a critical conversation about privacy, surveillance, and data mining. As the setting indicates, *Swipe* functioned within a social, rather than private, symbolic realm, its relational aesthetic true to Nicolas Bourriaud's vision of an artistic praxis that struggles against the reifying and commodifying of social relations. It is in this sense that readers can understand my expansion of the category of tactical media beyond a narrow focus on tactical gizmology, such that it might also encompass practices such as artistic data visualization.

A strong emphasis on DIY drives the work of tactical gizmologists: in an updating of Alan Kay, the mantra is "Give every user her tool and show her how to work it." It makes intuitive sense, then, that the Electronic Civil Disobedience group—which I discuss at length in my first chapter—not only encourages users to participate in distributed denial-of-service actions but also encourages them to modify the script. Given this appreciation of tinkering and production, and given, too, the powerful cultural and economic force of open-source movements, we might expect the current generation of new media art-activists to place a premium on code and invite user participation that was also pedagogical. As we will see, however, this is not necessarily the case. A brief return to Josh On's *They Rule* will be instructive: unlike the work of Bureau d'Etudes, which provides visual analyses of financial capitalism and contemporary political networks, users of *They Rule* are allowed to create their own cartographic structures.[48] We work within the parameters of *They Rule* but not at the level of its code. Tactical media practitioners, then, are not code workers whose raison d'être is the revealing of the symbolic, and at

times actual, conditions of production. None of the game or visualization interfaces that I discuss in this book make visible the underlying streams of encoded information except in representative form; that is, the encoded information is only present as something else, for example, the gamelike creatures representing national currencies in John Klima's *ecosystm*, which features prominently in my third chapter. Our limited engagement, then, is part of the epistemology of tactical media: we are meant to interact and engage while simultaneously becoming aware of our own limitations and our own inability to make an immediately perceptible impact on the project as it stands in for the socioeconomic and political system.

Despite the expansive title, then, the project of this book is not to archive all those cultural productions, works, and practices that profess or otherwise support a radical politics. In that sense it differs from projects such as *The Interventionists: Users' Manual for the Creative Disruption of Everyday Life,* the Massachusetts Museum of Contemporary Art exhibition and corresponding book documenting public-space and street-based performances.[49] As the title might indicate, de Certeau provides a crucial theoretical lens through which to view the tactics of artists such as the Yes Men, Reverend Billy, the Surveillance Camera Players, and the Biotic Pie Brigade. Their interventions are also situated in the tradition of the Situationists, with their two tactics of *detourné* and *dérive,* and the culture jamming of the yippies. The works I engage differ not only with respect to medium but also in tone: there are aspects of humor and parody present in some of the games and installations I discuss, surely, but the payoff is not exclusively the trick or the prank.[50]

A case in point is the "digital hijacks" of the überprovocateur Hans Bernhard, one of the founders of Etoy and Ubermorgen.com, the art collective responsible for projects such as "Vote-Auction" (slogan: "Bringing Capitalism and Democracy Closer Together"), "Injunction Generator," and "Google Will Eat Itself."[51] Ubermorgen's latest subversive happening is *Amazon Noir: The Big Book Crime* (November 2006), a hijack of Amazon's "search inside" tool that both violated and critically reflected on digital copyright. With the assistance of Alessandro Ludovico and Paolo Cirio, Ubermorgen produced a software bot ("foolingware") that

outwitted Amazon's search feature by making five thousand to ten thousand search inquiries per book and reassembling the individual parts into a complete text. Users were then able to "legally" copy and distribute copyrighted books: between April and October 2006, over three thousand books were distributed through peer-to-peer networks such as BitTorrent.[52] In the end, the artists, the self-described "bad guys" in this particular scenario of media hacking, were of course threatened with legal action; Amazon bought the Amazon Noir software, and the two parties settled out of court with a nondisclosure agreement. What remains of the hijack are an abstract diagram of the software bot and pdf files of some half-dozen books, among them Abbie Hoffman's *Steal This Book*. Their political point is as manifest as the genre of noir would indicate. But to recognize the intellectual lineage and philosophical content of this collective's work, one need only look at their name: *Ubermorgen*, after all, means "the day after tomorrow" or "super-tomorrow."[53]

Data Visualization as Tactical Media

Three world maps are aligned on the opening screen of the digital artist John Klima's *Political Landscape, Emotional Terrain:* one political, one topographical, another emotional. Color-coded in accordance with data culled from the United Nations, the U.S. Geological Survey, and the World Health Organization, respectively, the three maps register global reports of human rights abuse, geophysical data, and life expectancy statistics.[54] The cartographic display, which is interactive and three-dimensional, renders the political and emotional components of individual lives in different colors and tonalities and makes it possible to compare incidents of UN-classified political oppression and life expectancy. Klima describes the work: "Frequently, we use the metaphor of a landscape to describe a seemingly unrelated human condition, be it political or personal. . . . I decided to create a series of global terrains that relate to the aforementioned metaphors. . . . The result is a compelling visual comparison and representation of a particularly intriguing source dataset."[55] His methodology for the graphing component of the project is the A* (A-star) algorithm used for artificial intelligence and

John Klima, Political Landscape, Emotional Terrain, *September 2002.*

the gaming industry. This algorithm allows a character or sprite to avoid artificial and physical obstacles and navigate the most efficient solution path through a terrain, which creates the appearance of intelligence.[56]

In the context of this work by Klima, the A* algorithm functions as a graphing technique that produces a visual analysis of the data sets and makes the links among them paradoxically concrete. As a consequence, biopolitics are rendered in the interface of the game.[57] In *Political Landscape, Emotional Terrain,* "life" is brought into the arena of knowledge, management, and calculation. The integrated maps register biopolitical control of the individual body and of populations while also articulating statistics as the mechanism of that control. They function as a visual illustration of the modern Foucauldian regime of power, which is "situated and exercised at the level of life, the species, the race, and the large-scale phenomena of population."[58] Occluded, but still suggested, by the data Klima integrates into a global biopolitical terrain are the range and proliferation of techniques required to coordinate control of the individual body and of the species body. The global management that *Political Landscape* suggests has been accomplished by the instrumental rationalization of medical, economic, and political systems.

Klima's aesthetic practices in computer media involve elements of data and information visualization, interactive computer-animated 3-D graphics, elementary robotics (using nonautonomous agents), gaming

paradigms, and data manipulation.[59] Like the network-based data visualization artwork of Lisa Jevbratt, Klima tends to focus on larger social processes rather than on real-time personal experiences.[60] Klima's work revolves around representations of global events, processes, and statistics. Working within a tradition of electronic art that takes data as its material, signals that it then aestheticizes, modifies, interrupts, negates, and returns, Klima's particular source material includes financial market data and "terrain, topography, and geographic information systems."[61] As he notes with regard to one of his recent works, *Terrain Machine,* Klima works toward "an aesthetic investigation of the world as it currently exists 'in data.'"[62] Such a project invites certain questions: What does the aestheticizing of data ultimately reveal about that data? How can one use data maps and visualizations to think about causes and material effects? In a data visualization project, especially using the data of global finance and the statistics of global control, what aesthetic does one produce? Is it simply replicatory or reiterative of the logic of the control society and of neoliberal globalization?[63] I suggest that the visual spectacles Klima produces are subversive of the technicity and technological rationality inherent in statistical calculation and that they are also generated by a practice and an operation that produces an aesthetic. This aesthetic is grounded in the material realities of global capitalism and the global language of statistics, risk, and probability.

Because the data are not continually updated and are thereby static, *Political Landscape* does not immediately register continuous control, monitoring, or assessment. However, particularly when read in the context of Klima's related projects—*The Great Game,* which translated daily Department of Defense records of the Afghanistan bombing campaign into the interface of a topographical game, and *ecosystm,* which animates real-time currency exchange rates—this project does suggest an increasingly complex, invasive, and integrated regime of control. The authority of disciplinary institutions (school, factory, prison) is no longer temporally and spatially limited by these institutions; it is not owned or bounded but administered. Control is dispersive rather than concentrative; it works by communication rather than by confinement. One does not need to look to the Department of Homeland Security to recognize

that we are now in a moment marked by new structures of continuous oversight and what Gilles Deleuze calls "open circuits" of control. Indeed, the administrative control of information requires immediately executable, incessant, and flexible strategies of surveillance. One difference between the two orders of society, according to Gilles Deleuze in his reading of the problematic in Foucault, is that control "is short-term and rapidly shifting, but at the same time continuous and unbounded, whereas discipline was long-term, infinite, and discontinuous."[64] Control is constantly subject to reconstitution, its indexes of command contingent, its structure neither fixed nor stable. The figure for the control society is the snake rather than the mole, which would suggest nondestinational movement rather than a teleology. And the machine that expresses the social forms of the control society is the computer. Many of Klima's digital art projects, particularly *ecosystm*, function as visual illustrations and supplementary figures of this metastable control system. Here and in subsequent chapters, I offer an integrative reading of Klima's style, practice, aesthetic, and political project as contemporaneous with its moment: exemplary of the tele-visioning and projecting of the world through the computer screen and illustrative of certain discursive features of globalization.

In a different context, but on the theme of the abstraction of numbers, Fernando Coronil has aligned the global market with globalcentric discourses in their mutual technological rationalization, which reduces material things to numbers. The distillation of the West into abstract financial networks, Coronil suggests, has contributed to the occlusion of "real" modalities of power.[65] The global market functions as an allegory for his reading of the effects of globalcentric discourses because it absorbs the commodity as a thing and transforms it into a historical entity of the stock market. This transformation erases the commodity's "proper" identity and converts its qualitative value into the quantitative. To a certain extent, *Political Landscape, Emotional Terrain* provides a visual representation of this logic of the global market, the transformation of material bodies into statistics, assets, even geometric icons. However, in that Klima uses official data sets that generate symbolic representational systems, these systems are not simulacral. But the work indeed registers the extent to which the "real" modalities of power are eclipsed and evacuated by figures and data streams.

Klima's *Political Landscape* highlights the very space between the meta-geophysical and the geophysical, the virtual and the real. The map's continents, in other words, operate in both registers by recording that which is invisible to, if not evacuated by, the global statistic. Gathering together the whole of North America under the lowest possible statistical incidence of human rights abuse, for example, the monochromatic spaces on the map have an attendant homogenizing force and power of occlusion. The telecontinental map announces the remainder, through its absence, as that which cannot be discursively captured or managed. Even as it gestures toward totalization, the statistic must necessarily remain incomplete, an incompleteness emphasized in Klima's data visualization project.

To speak of the political-aesthetic work of data visualization, we thus need to acknowledge a distinction between functional or pragmatic visualization on the one hand and artistic visualization on the other.[66] The difference is not in aesthetic—many transportation maps are nothing if not beautiful, and the power of *They Rule* is less visual than conceptual—but rather in intentionality, procedure, and self-reflexivity. Artistic visualizations do not proceed from the assumption that data are neutral; in fact, one of the desired effects is often that the viewer will recognize the gaps and perspective embedded not only in the data but in any act of calculation. In that sense, artistic visualizations are fundamentally perspectival, and here we can remember one of Lovink and Garcia's comments: "Tactical media do not just report events, as they are never impartial they always participate."[67] If their use of persuasive rhetoric is subtle and they do not themselves make overt arguments, these works of tactical cartography give the users all the tools necessary to map structures of capital, power, and influence (John On's visualizations).

In data visualization projects, the data bear an ideological valence recorded in the art. These works rely on the real elements from which the statistics are drawn, but they also critique both their ideology and source. If the data are flawed, these works document and critique that flaw by rendering the data in other forms. They visualize and materialize the data so as to give it a kind of ideological and political impact that it might not otherwise have. Witness Valdis Krebs's political book network, a visualization of Amazon.com purchases from January 2003 that

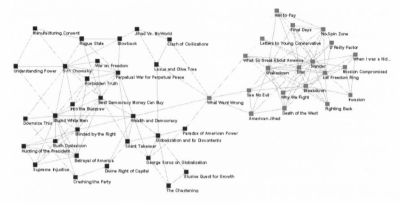

Valdis Krebs, "Political Patterns on the WWW."

divide almost precisely into "red" and "blue" categories, two communities of readers linked only by their common investment in one book: Bernard Lewis's *What Went Wrong: The Clash between Islam and Modernity in the Middle East.*[68] Visualizations such as I discuss here do not interrupt the flows of informational capitalism as much as they interpret and represent the integrative alliances among finance capitalism and biopolitical regimes of control. It is perhaps in this respect that we might discern the metapolitical content of their art.

Virtuosity

Storming the Winter Palace is no longer an option, as has frequently been noted, but what would be its postimperial equivalent? Michael Hardt and Antonio Negri have argued that older modes of political organization have become obsolete partly because of the linear structure that traces the progression of struggle from the moment of insurrection to the forming of political vanguards, or "the dictatorship of the proletariat."[69] But would contemporary forms of revolutionary resistance, or revolutionary becoming, as they are articulated in the work of tactical media, also run the risk of vanguardism in the guise of the Netzvolk, the digerati, the cognitariat, the hacker class, the virtual class—however one is to articulate the new proletariat class of the symbolic economy?[70] Perhaps the notion that revolutionary resistance no longer requires a single spatiality,

or Foucault's notion that "there is no single locus of great Refusal," means that power will not, cannot, reconstitute either on-site or in the hands of a limited few. If we have only a "plurality of resistances," a "being-against," always and everywhere (with echoes of Trotsky's Permanent Revolution and Snowball's continual rebellions difficult to overlook), then in fact the teleology of revolutionary organization itself is disrupted.[71] Instead of a single, spectacular disruption, we have a "multiplicity of discontinuous sites of enunciation."[72]

The models of resistance, dissent, and "being-against" articulated by tactical media do not adhere to the ideology of the "wired" Left (e.g., Arthur and Marilouise Kroker), which draws explicitly on twentieth-century traditions of activism and social protest. Neither do they adhere to the ideology of the cyberlibertarians, who have been active in public-policy debates about censorship, privacy, and intellectual property and tend to focus on individual freedom rather than social justice.[73] Instead we can locate in the work of these new media artist-activists a kind of virtuosity that is also a politics: political activity that would supplement but not displace other forms, modes, and practices of politico-aesthetic engagement in the network society, specifically refusal, destructivity, cyberactivism, and hacktivism.

After Hardt and Negri's *Empire,* the paradigmatic figure of refusal and exodus would no doubt be Bartleby, whose refusal is one of evasion and withdrawal rather than of confrontation. His refrain "I would prefer not to" is passive but not without menace. It is expressive of dignity yet still announces a power held over him. The refrain cedes power but retains the power to withhold. As the neoliberal state began fully to emerge in the 1980s, Hakim Bey fired an even closer shot across the bow: "Refusal of *Work* can take the forms of absenteeism, on-job drunkenness, sabotage, and sheer inattention—but it can also give rise to new modes of rebellion: more self-employment, participation in the 'black' economy and '*lavoro nero*,' welfare scams and other criminal options, pot farming, etc.—all more or less 'invisible' activities compared to traditional leftist confrontational tactics such as the general strike."[74] And now, Maurizio Lazzarato explains how refusal plays out in the context of Workerism and attendant revolutionary praxis: "These social struggles and 'invisible' behaviors engage both in direct, molar confrontations

with the apparatuses of power and strategies of withdrawal, flight and circumvention. In the same way, they alternatively articulate strategies of both separation and 'mediation,' both negotiation and refusal."[75] Finally, Alan Liu updates the industrial-age gesture of refusal to the postindustrial cubicle and locates dissent in the ethos of cool:

> There are only two equivocal ways that the archaic and the unreasonable can protest their submission to the new rationalization. One is to quit and move to another job, which exactly reproduces the conditions of mobility, modularity, and random access that support the "flexibility" and "centralization" of postindustrialism. The other way is just as conflicted: to express in lifestyle and, increasingly, in what I have called "workstyle" the enormous reserve of petty kink that *Processed World* called "bad attitude" but that now appears with mind-numbing regularity in popular culture, the media, and the Web as "cool."[76]

The law of cool, then, is "the 'gesture' of ambivalent, recusant oppositionality (not quite a 'statement,' 'expression,' or even 'representation' of defiance) within knowledge work."[77] The coolest ideology of art within the culture of information is "destructive creativity," of which hacking would be one logical extension.

As we will see in chapter 1, hacktivist tactics of the Electronic Civil Disobedience movement, the Electronic Disturbance Theater, and the Zapatistas (Floodnet applications that produced pseudo–error messages such as "human rights not found on this server") correspond to, and are occasionally informed by, Deleuze's notion of the event. To precipitate an event is to act without knowing the situation into which one will be propelled, to change things as they exist: "For a while, they have a real rebellious spontaneity. . . . Events can't be explained by the situations that give rise to them, or into which they lead. They appear for a moment, and it's that moment that matters, it's the chance we must seize. . . . If you believe in the world you precipitate events, however inconspicuous, that elude control."[78] The event is unpredictable; it is not fixable or determinable. It becomes history only after its rupture. There is a certain skepticism within new media studies toward activist practices modeled on the structure of the event.[79] The unpredictable event troubles the teleology of class struggle; from that perspective, it is perhaps too messianic, the notion that revolutionary change, if it comes at

all, depends on the unforeseen too troubling. From the perspective of transvergence, as Marcos Novak has described it, the event might be too deeply embedded in—because it is constituted by—the disciplinary language of philosophy and would thereby inhibit the emergence of truly transdisciplinary collaborative practices. But there are intersections between the structure of the event and self-organizing new media works that are open to the unexpected, both programmed and non-programmed in the sense that they are open to a nonpredictable future. From the perspective of a tactical media practitioner, the belief in this temporal opening to a better tomorrow makes the question of immediate efficacy less pronounced. A skeptic might wonder what difference a temporary disturbance makes, but for tactical media there is a certain power in the spontaneous eruption, the momentary evasion of protocological control structures, the creation of temporary autonomous zones, that surely play their part in making possible the opening for political transformations.

It is in this sense that we might understand why the rhetoric of emancipatory human agency is largely absent from the projects featured in this book. They are not mired in the present, but neither do they fully invest in the kind of imaginary and prescriptive social engineering that one finds in a utopian text. Instead their sense of historical time is unpredictable, open, contingent, variable. Responding to Jean-François Lyotard's lament that postmodern architecture has been forced to abandon the project of fundamental structural transformation for the project of "minor modifications," or what we might call tinkering, Bourriaud articulates the aesthetico-political rationale of contemporary art praxis in terms absolutely applicable to tactical media. Art in the present moment, he explains, is *"learning to inhabit the world in a better way,* instead of trying to construct it based on a preconceived idea of historical evolution. Otherwise put, the role of artworks is no longer to form imaginary and utopian realities, but to actually be ways of living and models of action within the existing real, whatever the scale chosen by the artist."[80] With the recognition that there is no getting outside the global techno-military-economic world order, tactical media thus performs a sociopolitical intervention by gesturing only obliquely toward a better world in the future, its vision of tomorrow much like that offered at the

end of Alfonso Cuarón's *Children of Men:* a boat fleetingly visible on the horizon and detached from any concrete articulation of an ideal political community or certain historical destiny.

That said, the crushing experience of a seemingly permanent war on terror, alongside Halliburton-Enron economics (and we could continue the list), has been sufficient to squash even the staunchest of affirmative beliefs, so it is not surprising that Lovink would come eventually to regard tactical media with a great deal more pessimism. In 2005, with Ned Rossiter, he writes:

> Tactical media too often assume to reproduce the curious spatio-temporal dynamic and structural logic of the modern state and industrial capital: difference and renewal from the peripheries. But there's a paradox at work here. Disruptive as their actions may often be, tactical media corroborate the temporal mode of post-Fordist capital: short-termism. . . . This is why tactical media are treated with a kind of benign tolerance. There is a neurotic tendency to disappear. Anything that solidifies is lost in the system. The ideal is to be little more than a temporary glitch, a brief instance of noise or interference. Tactical media set themselves up for exploitation in the same manner that "modders" do in the game industry: both dispense with their knowledge of loop holes in the system for free. They point out the problem, and then run away. Capital is delighted, and thanks the tactical media outfit or nerd-modder for the home improvement.[81]

A comparative analysis of the earlier "ABC of Tactical Media" manifesto (1997) and this manifesto for organized networks reveals a similar investment in dissensus rather than the overly idealistic consensus. It also reveals a subjective, rather than objective, reappraisal of the logic of tactical media. It is not that its functioning has changed in the intervening years but that the perception of its power and efficacy has changed: what was once "provisional" and "flexible response" is now regarded as "short-termism." While I am less certain about the definitive claim that capitalism is always able to erase the possibilities for political repurposing, I would acknowledge that Lovink and Rossiter make a strong point in their critique. Their emphasis on perspectival, subjective truths about tactical media, however, reminds us of the integral role that the audience has to play. The right question to ask is not whether tactical media *works* or not, whether it succeeds or fails in spectacular fashion to ef-

fect structural transformation; rather, we should be asking to what extent it strengthens social relations and to what extent its activities are virtuosic.

What I wish now to point to is a correlation between tactical media as performance and what Paolo Virno has theorized as virtuosity. Virtuosity necessarily partakes of the same underlying unpredictability that constitutes the structure of the event. In his analysis of the multitude, Virno explains that virtuosity is "activity which finds its own fulfillment (that is, its own purpose) in itself, without objectifying itself into an end product, without settling into a 'finished product,' or into an object which would survive the performance." Unlike the plastic arts, where what survives the artist is a material product, virtuosity exists as performance or in the traces of performance it leaves. Because the performance does not result in an end product, the activity of the virtuoso requires the performance of an audience to witness and record a memory of her achievement. It is in this sense that the performance as such "makes sense only if it is seen or heard."[82] Virno here draws on Hannah Arendt in noting the affinity between performing artists and politics: both need "a publicly organized space for their 'work,' and both depend upon others for the performance itself."[83] Virno pushes further to note that "all virtuosity is intrinsically *political*."[84] In my view, tactical media projects share with performing artists and political actions a sense of contingency in that they too are performed "on the fly" and require the presence and response of a user to complete their signifying fields. It is in this respect that we can understand the foregrounding of technique and technological expertise, which might initially appear to frustrate attempts to situate these works in relation to a social context and which also seems instead to invest in what Pierre Bourdieu calls a "pure aesthetic."[85]

Entered into fashion shows with the slogan "Precarity Is in Fashion," the Japanese designer Serpica Naro emerged on the metaphoric stage with the provocative question "Why save the world when we can design it?" Serpica Naro—an anagram of San Precario—was a brand itself designed, as it were, by Milanese precarity activists to stage a disruptive protest during fashion week. In general terms, precarity is the name

given to life without security, certainty, or predictability, life that is essentially subject to financial markets. More specifically, precarity identifies uncertainty as the fundamental condition of labor in the postindustrial moment. It is the name given to intermittent work, work without stability and a living wage, a category of temporary labor that links together chain workers, service workers, and knowledge workers.[86] In response to the ideologies of corporate creativity and innovation, which imagine a flexible, modular, streamlined, and mobile workforce capable of rapid-fire response to competition, precarity activists speak to the material conditions of unemployment, job security, and social exclusion in the contemporary moment. That the Milanese precarity activists should engage these issues through the medium of design and performance, in addition to traditional organizational models, suggests a certain cultural logic. The event of the fashion show was an elaborate hoax: the activists' "actual" protest was staged via fake threats and protests against the designer, thus necessitating protection and a strong police presence at the event, the simulation of danger and insecurity thus negating the very distinction on which the law is based. This tactic of placing design at the center of political engagement truly is, as Serpica Naro promises, the triumph of creativity over insecurity.

The practice of designing rather than saving the world is another model of political engagement that has elements of destructivity (it often participates in a similar poetics of interference and interruption) and elements of other modes of political organization that depend on collectivity and solidarity. The degree of ethical concern in the works I discuss in this book should no doubt not be underestimated, but perhaps it could be suggested that their politics are a metapolitics. However, the unavoidably cynical conclusion is that, while their critical practices do not have the hollowness or emptiness of Space Invaders—the paradigmatic scene of the individual fighting back against a relentless and formless enemy—at times they participate in the same solitary, and sedentary, aesthetic.

1. Border Hacks: Electronic Civil Disobedience and the Politics of Immigration

> No cultural bunker is ever fully secure. We can trespass in them all,
> inventing molecular interventions and unleashing semiotic shocks
> that collectively could negate the rising intensity of authoritarian
> culture.
>
> —CRITICAL ART ENSEMBLE, *Digital Resistance*

> Hacking is understood as the penetration, exploration or investiga-
> tion of a system with the goal of understanding it, not of destroying
> it, and that is exactly what we are trying to do: to understand the
> border, to know what it represents and to become aware of the role
> that we play in it. All this with the goal of improving the relations
> between two worlds (the first and the third), Mexico and the U.S.
>
> —Borderhack! Manifesto

Symbolic Performances

Leading up to Labor Day 2005, the Department of Ecological Author-
ing Tactics, Inc., launched a border disturbance action with the yellow
Caution signs mounted along the San Diego area highways.[1] Introduced
in the early 1990s, the signs were intended to warn drivers about the
possibility of immigrants trying to cross the busy highways before bor-
der checkpoints. DoEAT's intervention was to defamiliarize the iconic
silhouettes of three running figures, surprising drivers with the new
titles: "Wanted," "Free Market," "No Benefits," and "Now Hiring." Re-
ducing the plurality of migrants to the singular family made more sym-
pathetic by the inclusion of a young girl, the icon itself eliminated the
verbosity of the former signs' labels ("Caution Watch for People Cross-
ing Road") and made the anonymous swarms said to be "flooding" or
"pouring" over the border into a more manageable unit. In the wake of
Operation Gatekeeper (1994) and the construction of the "Iron Curtain,"

the fourteen-mile San Diego–Tijuana border fence, highway deaths are no longer as common as they once were—the scene of death has shifted eastward to the deserts and mountains—but the iconic signs remain, indices of the borderlands of San Ysidro–Tijuana that have been appropriated for numerous parodic and commercial purposes.[2] In the hands of the DoEAT group, the signs were no longer simply cautionary warnings; they became a tactical art performance enacted with a sense of urgency that also resonates in the Spanglish wordplay in the group's acronym: "do eet." Reminiscent as it was of the Situationist technique of détournement, DoEAT's interruptive and resignifying art performance commented on the neoliberal economic policies that compel the forced movement of migrant labor.[3] In its allusion to NAFTA and the "free market" that opens the U.S.–Mexico border to commodities but reinforces its closure to people, the DoEAT tactic was truly site specific, situated both physically and socioculturally.[4] Highlighting the disparity between the mobility of capital and the immobility of people, the signs continue to speak both to the conditions of labor (free market = wanted + now hiring + no benefits) and to the criminalization of border crossings (free market + now hiring + no benefits = wanted). The circulation of goods and capital has been enabled by the free trade agreement, the signs remind us, but border security practices, particularly walls and fences, continue to prohibit the circulation of people. At the new Iron Curtain, neoliberal market ideologies of liquid, free-flowing capital and open borders for commodities come up against new policing tactics to regulate the movements of people.

DoEAT's border disturbance action thus raises a crucial question at the outset: in the new mode of Empire, have we in fact seen a fundamental shift from a territorial to a capitalist logic of power?[5] We can start to address this problem with a critical look at the reinforcement of territory and national sovereignty along the U.S.–Mexico divide. There is a complex history of securitization along this border, particularly complex with respect to the calls to preserve or otherwise defend the sixty-six-mile stretch in San Diego County, but it is the post-Gatekeeper period that directly informs projects such as DoEAT's.[6] Beginning with the five-mile stretch of Imperial Beach, rows of fencing and surveillance technologies have been introduced on the San Ysidro–Tijuana border, pushing im-

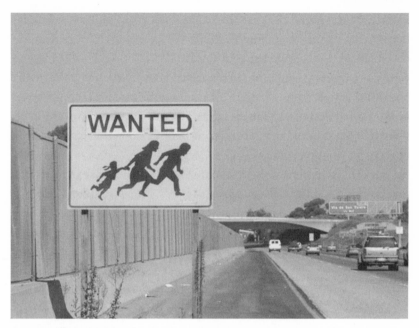

DoEAT, "CAUTION," 2005.

migration further east into the more dangerous desert and mountain areas.[7] More than 3,500 people are reported to have died attempting to cross into the United States since the implementation of Gatekeeper, far more than the dozens killed trying to cross the San Diego highways, the vagueness of both numbers speaking to the sense in which the migrants are not granted the dignity of singularity either in life or in death.[8] Art-activist groups such as SWARM the Minutemen, which I will discuss further, have made a conscious effort to record the names of those killed, memorialization by naming such as one sees on the Vietnam Wall and with the chairs of the Oklahoma City memorial; others have commemorated and critically responded to the deaths by hanging replicas of coffins on the Mexican side of the fence.[9] Criminalizing movement—the visible manifestation of which would be miles of double and triple fencing, barbed wire, concrete pillars, light towers, helicopter patrols, and video surveillance cameras—has also resulted in the Sisyphean task of capture and return. Surely this massive investment in border control and the assertion of territorial sovereignty, beginning again at precisely the

moment that NAFTA is signed, indicates if not a shift at least a complex imbrication of territorial and capitalist logics of power.[10] Further, the development of a "virtual fence" with remote-detecting sensors, remote-controlled cameras, and unmanned autonomous vehicles (UAVs) along the U.S.–Mexico divide, along with recent anti-immigration initiatives in the United States and Secure Flight and other "trusted traveler" programs, reminds us of the intensification of both biometric and territorial borders.[11]

The sheer numbers of those who do not register in biometric testing or otherwise "slip through the fence" can only suggest an intensification, rather than a true fortification or securitization, of borders.[12] The new Iron Curtain has hardly stopped migration north—indeed, by all accounts, the numbers appear to be at a historic high—so what other purposes does it serve? Étienne Balibar writes in a different context about the symbolic power of "obsessive and showy security practices" at the border, which are "designed, indeed, as much for shows as for real action."[13] What would be the sociocultural function of such "shows"? Peter Andreas's important study *Border Games: Policing the U.S.-Mexico Divide* provides some answers.[14] Noting that "'successful' border management depends on successful image management [which] does not necessarily correspond with levels of actual deterrence," Andreas concludes that border control is a "public performance for which the border functions as a kind of political stage" (9). In other words, the performance of security is more important than actual security, and the theatrical serves as a substitute for the real. The miles of razor wire, the ubiquity of "boots on the ground," the air support—they are all material entities, but they are also crucially part of what Andreas names as a "symbolic performance." "Border control efforts," he explains, "are not only *actions* (a means to a stated instrumental end) but also *gestures* that communicate meaning" (11). If indeed it is the case that border control is an "escalating symbolic performance," then we would also have to understand the interventionist tactics of DoEAT and other art collectives in precisely the same terms. Their battle is at once material and symbolic, fought on the very "political stage" where power is exercised. Within a regime of signs, then, the gesture of renaming the migrant family as "Wanted" is as provocative and significant as it is clever.

Andreas's thinking about the inverse relation between the "escalating symbolic performance" of border control and "actual deterrence" resonates with Ulrich Beck's noted articulation of the central problem for world risk society, which is "how to feign control over the uncontrollable."[15] As Beck notes, we have seen a shift from risks that can be calculated and controlled and about which one can make decisions to uncontrollable risks, which exceed rational calculation. The alarmist quality of mainstream media news may make us feel as if risk has increased, but in fact, Beck explains, risk has simply been spatially, temporally, and socially unbounded. Pollution, climate change, infectious diseases: these are risks that are no longer limited to region, territory, or nation-state and are now spatially unbounded. Risks have become temporally unbounded in that we are not able accurately to predict future damage or assess the long-term dangers of, for example, toxic materials or genetically modified foods. Last, responsibility for economic and environmental disasters can no longer be attributed with certainty to a single individual; in this sense, risk is socially unbounded. We have only to think of the *Prestige* oil spill off the coast of Spain in November 2002 as an instance of the three-dimensional debounding of risk. As a result of this debounding, Beck argues, "The hidden critical issue in world risk society is *how to feign control over the uncontrollable*—in politics, law, science, technology, economy, and everyday life."[16] How, then, does a nation-state simulate control over the ultimately uncontrollable movement of people across borders? With "symbolic performances," military operations that double as public relations campaigns.

And now the stage is set for my reading of a selection of new media artworks and performances that critically respond to the securitization of the U.S.–Mexico border. For the crucial problem is not whether we can articulate an exclusive logic of power for our historical moment but how we can understand the critical response to the manifestation and material consequences of that power. As securitization procedures and policies intensify, so, too, does the art-activist response, which gains not only an urgency but also a critical sophistication. As symbolic analysts, these artists are particularly well positioned to think about the deployment and manipulation of signs. Recognizing that their project of sociocultural and governmental critique is also "advertising," the "corporate

psychological warfare of perception management," these artists, tactical media practitioners all, engage in nothing less than a full-scale "PR war" (Mediafilter.org). The Tactical Media Crew goes further to announce a "guerilla information war, with no division between military and civilian participation."[17] Who better to inform such a campaign than the Critical Art Ensemble, the preeminent tactical media practitioners who for two decades have used theory and performance to alter our perceptions of normalized social practices? CAE's intervention is defamiliarization, to change the way we see the otherwise "transparent codes" of Empire. In an interview, CAE outlines the work of all socially engaged art practices: "Now domination is predominantly exercised through global market mechanisms interconnected with a global communications and information apparatus. Any type of resistant production of representation intervenes and reverse-engineers the displays, software, and hardware of this apparatus."[18] Reverse engineering is most obviously at work in the DoEAT highway sign performance and more subtly in the other new media art projects I will discuss. What I will work to demonstrate is the way in which these new media artists use the virtuality of their medium to critique the immobility of material bodies. Their critique of the neoliberal ideologies of free-flowing virtual capital is manifest in their tactical use of the very technologies, techniques, and tools that late capitalism itself employs.

There is a long-term discourse on the U.S.–Mexico borderlands/*la frontera* as a space of conflict but also of negotiation, exchange, mixture, and hybridity.[19] As the border itself has become increasingly materialized as a fence, a wall, a line, there has of necessity been a shift to thinking of the border itself as a metaphysical binary. This is the point, then, to emphasize the situated aspect of my analysis. We can certainly see a more complex, integrative notion of borders at work in sites such as the Canary Islands or Melilla and Ceuta (Spanish enclaves in Morocco frequently used as passage from Africa to the EU), where a clear binary logic is not necessarily at work. Different media forms, notably narrative cinema, have intervened with regard to these other borders.[20] The new media art projects I address in this chapter are not about the borderlands as a space of hybridity; rather, we will see the insistence on the binary structure of the United States and Mexico. In this respect, they

perhaps indicate the extent to which tactical media in the United States, as Geert Lovink has suggested, even now remain wedded to the singular campaign, "rooted in local initiatives with their own agenda and vocabulary"; unlike the media artists of former Communist countries, their terrain is not that of the broad social movement or of revolution as such.[21]

Through an analysis of border disturbance actions initiated by the Electronic Disturbance Theater (EDT)—along with a succession of works situated on the line between artistic and political statements, particularly projects featured in the inSite_05 festival—we will trace the contours of a new front in the battle over immigration and mobile labor populations. Instead of celebrating the crossing of literal and figurative borders (of disciplinary boundaries, genre, language, gender, race, sexuality), as has been the case within cultural criticism in recent decades, these projects serve as a reminder of the material border's irreducibility. No articulation of a space in between, of a third term, of any spatial or geometric metaphors for hybridity, can overcome the material fact of the new Iron Curtain. Reminiscent to some extent of the cultural nationalisms of Frantz Fanon and Aimé Césaire, such thinking marks a moment of anticolonial art practice: the aim is not to theorize liminality but to force a rupture in the binaries of interiority and exteriority, here and there, native and alien, friend and enemy. The radical dichotomies integral to the war on terror—"you're either with us or against us"—find their counterpart in art practices that themselves depend on the solidarity of the "we" against the "them." A fence has been built, binaries constructed, and these artists intend to overturn them. Their struggle, while embedded in a binary, rather than a hybrid, cultural logic, nevertheless suggests a reconfigured notion of oppositionality. As we will see, both the we and the them in these artists' projects and practices are understood to be diffuse, networked, and temporarily, rather than territorially, situated.

The imaginary of the new world order maintains territorial divisions as metaphysical divisions, informed as it has been in the last few decades by texts such as Samuel Huntington's *The Clash of Civilizations and the Remaking of World Order,* whose familiar thesis about civilizational identities and differences naturalizes the U.S.–Mexico border, demarcating the putatively archaic and primal divisions between Anglo and Latino.[22] But we must push further to recognize that the articulation of

the U.S.–Mexico border in terms of friend versus enemy is a hallmark of our Schmittean moment. Friend and enemy are not for Carl Schmitt private, individual, emotional, or psychological categories. It is not *my* enemy but *our* enemy. That is, "the enemy is solely the public enemy," and it is the defining of the enemy that unites "us" against "them."[23] In times of crisis, in a state of emergency, Schmitt claims, a political community must decide who is different or threatening enough to warrant the designation "enemy"; enemies, then, are those who threaten a community's security and economic prosperity. Friends are those who are sufficiently loyal and obedient to the commands of the sovereign, those who are willing to risk their lives in the defense of a community. It is in these morally absolutist terms that migrants, "illegals," have been figured not only as a contaminant of the social body but as a sinister threat to the political community in the United States.

That citizens assume the responsibility of making sovereign decisions about the normal and abnormal, trusted and untrusted, is another hallmark of our current moment. It is not simply that citizens have been incorporated into the war on terror but that citizens assume the role of proxy sovereigns. As Judith Butler notes in *Precarious Life,* "when the alert goes out, every member of the population is asked to become a 'foot soldier' in the war on terror."[24] And as Giorgio Agamben observes in his analysis of the "state of exception," "every citizen seems to be invested with a floating and anomalous *imperium.*"[25] With the U.S.–Mexico border written under the sign of national security, we have seen paramilitary and vigilante organizations such as the Minutemen claim the right to make sovereign decisions about friend and enemy. We have also seen gubernatorial plans to broadcast live surveillance footage from the Texas border, allowing not just citizens but all Web users to report supposed illegal crossings to an emergency hotline.[26] It is in these terms that we can revisit the DoEAT intervention: their Wanted sign directly invites citizens to be proxy sovereigns insofar as illegals are enemies in the war on terror. It reminds us that we are all invited to become—at times it seems almost required to become—proxy sovereigns. In an updating of Cold War logics, we are invited to join the search for the enemy within.

How, then, are enemies contained and managed as the U.S. national security state evolves? In January 2006 the Department of Homeland

Security awarded a $385 million contract to the Halliburton subsidiary Kellogg Brown and Root for the construction of new immigrant detention centers for future states of emergency: "The contract, which is effective immediately, provides for establishing temporary detention and processing capabilities to augment existing ICE Detention and Removal Operations Program facilities in the event of an emergency influx of immigrants into the U.S., or to support the rapid development of new programs. . . . The contract may also provide migrant detention support to other U.S. Government organizations in the event of an immigration emergency."[27] It is not difficult to imagine parallels with the World War II Japanese internment camps or to guess at the countries of origin of possible future detainees. Moreover, we do not need to be excessively paranoid to recognize the great ambiguities of the phrase "new programs." So let us call these planned detention centers what they are—camps—and thereby turn to Agamben's articulation of the concept of *homo sacer*, that which can be eliminated or killed but not sacrificed. The war on terror has necessitated extensive critical commentary on *homo sacer*, particularly in relation to camps and other contemporary states of exception, so it is perhaps sufficient to note only that sacred life is the human body separated from its normal political circumstances. Immigrants become "sacred" in these terms at the moment of crossing the border, becoming "illegal" and "enemy."

We might probe more deeply into the relation between *homo sacer* and the migrant by situating it within Butler's commentary on violence and derealization. For Butler the migrant (which I address here as a representative instance of wretched, excluded, derealized life) cannot simply be restored to, or reinserted into, the category of the human. Rather, the migrant poses the question of the human not in the exclusion it suffers from the normative condition of the human (the category, which by its very exclusion, it helps to constitute), but by operating as "an insurrection at the level of ontology."[28] The migrant, that is, forces on us the question of whose lives remain real in light of those who have already suffered the violence of derealization. Butler remarks: "If violence is done against those who are unreal, then, from the perspective of violence, it fails to injure or negate those lives since those lives are already negated. But they have a strange way of remaining animated and so must

be negated again (and again)" (33). The migrant, then, literalizes this spectral condition of negated life. Excluded both from the category of the human real and from life that deserves to live, the migrant nevertheless lives on, returning to haunt the very site of its exclusion. "Violence," Butler asserts, "renews itself in the face of the apparent inexhaustibility of its object. The derealization of the 'Other' means that it is neither alive nor dead, but interminably spectral. The infinite paranoia that imagines the war against terrorism as a war without end will be one that justifies itself endlessly in relation to the spectral infinity of its enemy" (33–34). We might further generalize this condition of spectrality to the very institution of the border itself. Here I do not mean to erase or negate the "real" material border with its powers of exclusion but to insist that the border represents simultaneously a material space of violent exclusion as well as a space of exclusion that is haunted by the return of that which it has to exclude over and over again. This is to say, the border is that which becomes spectralized by the very return of the migrant. The border, then, functions as a space that is both real and yet made unreal. This leads us to a strange relation between the material border and network traffic, between flooding a material border and flooding a server. Flooding, pulsing, "apparent inexhaustibility"—this is the mode of the swarm, the paradigmatic mode of conflict for netwar and for the Electronic Disturbance Theater in their strikes against the Minutemen.

Swarm the Minutemen

On May 1, 2006, the Electronic Disturbance Theater partnered with activists in the Tijuana–San Diego area for a virtual sit-in particularly directed against the Web sites of California and Arizona Minutemen organizations, Save Our State initiatives, and congressional representatives supporting anti-immigrant legislation.[29] SWARM (South West Action to Resist the Minutemen) targeted Web sites with a distributed denial-of-service attack, specifically with a FloodNet application that is a hallmark of the Electronic Disturbance Theater. Emerging from the research environment at CADRE in 1998, FloodNet began as a SuperCard script that was used playfully to upload secret messages to the error logs.[30] In the hands of the Java programmer Brett Stalbaum, in collaboration

with Carmin Karasic, Stefan Wray, and Ricardo Dominguez, himself a former member of the Critical Art Ensemble, FloodNet evolved into a hacktivist tactic, an applet available to anyone wishing to support the Zapatista movement and social justice campaigns at the U.S.–Mexico border. The SWARM the Minutemen activists provide a succinct description of FloodNet's operation:

> The software we are using requests files from the servers of the targeted websites that are not found—files like Justice, Freedom, and the names of those who have died crossing the border. In effect you will see the error message—"files not found." The sit-in will interfere with and slow down the servers of these various groups and individuals—much like a physical sit-in slows down the movement of people in buildings or on streets. In addition, the administrators of the servers will see logs of the action where the names of those who have died crossing, and the requested files like justice, appear repeated thousands upon thousands of times.[31]

The orthographic formulation "hacktivist" suggests that a denial-of-service attack, with its emphasis on interference and disturbance, can be considered a legitimate means of social protest, but such a claim has met with some resistance. For example, Oxblood Ruffin, a long-term member of the hacking collective Cult of the Dead Cow, from which the term "hacktivist" originated, has argued that the primary target of hacktivist actions ought to be Internet censorship. According to Ruffin, hacktivist networks are the "blue helmets" of the Internet and thereby ought to work toward open code and peace rather than war.[32] Since access to information is in Cult of the Dead Cow's terms a fundamental human right, it follows that a distributed denial-of-service attack is an assault on free speech and a violation of the principle of free flow. Distributed denial-of-service attacks have also been literally interpreted as assaults: at the time of FloodNet's initial deployment in 1998, it generated a great deal of publicity and anxiety about possible terrorist applications.[33] More recently, Estonia was the target of high-profile distributed denial-of-service attacks apparently originating in Russia, an event that now informs the many cyberwar game scenarios between the United States and China. Thus we are seeing a massive private- and public-sector investment in monitoring and controlling risks related to computer use: InfoSecurity, especially data protection, is the currency of our moment.[34]

In his analysis of Net-based activism, Michael Dartnell draws a distinction between hacking in the form of distributed denial-of-service attacks and Web activism to make the case for Web activism as the more powerful form of insurgency.[35] Since hacking aims to sabotage, Darnell classifies it as "information terrorism," understanding its disturbance of networks to be destructive, threatening, and thereby pejorative. On the other hand, he reads Web activism as productive and nonthreatening. Rather than interfering with the operations of infrastructure, Web activism aims to transform the social conditions in which that infrastructure is situated. In his three case studies of social movements in Ireland, Afghanistan, and Peru, Dartnell suggests that communication—for example, raising public awareness of gender politics of the Taliban regime—is the prima facie form of "insurgency." His contribution to the discourse on Net-based activism notably shifts the focus from the state to engage nonstate actors and a nonterritorial politics; however, it is precariously based on an evaluative distinction between "good" and "bad" insurgencies. Moreover, it is not ultimately clear how visual and verbal images might not disturb or terrorize, how a public relations campaign might not itself be a form of sabotage.

Coco Fusco describes Electronic Disturbance Theater's FloodNet operations as "nonmimetic theater," with only "abstract representations of the 'hits' and textual descriptions of the purpose and/or motive for the actions," and indeed that is an apt description of the visual record of the performances.[36] Though there is an element of play at work in a FloodNet virtual sit-in, and certainly there is no small amount of delight in reading the outbursts of saveourstate.org forum members when their server temporarily goes down, EDT is adamant: "This is a Protest. FloodNet is not a game."[37] It is indeed not a game but in fact the primary weapon in EDT's arsenal, over time targeting various institutions and symbols of Mexican neoliberalism, NAFTA, CAFTA, the School for the Americas, the U.S. Defense Department, Samuel Huntington, Representative Sensenbrenner, and others.[38] Though these targets appear focused, SWARM's overall concern is not simply a set of antagonists but a "systemic logic," which "'others' migrant people and people of color in general" and willfully erases the complex history of migration to the United States in order to posit a rightfully native population.[39]

How is it that one battles a "systemic logic" rather than a clearly iden-
tifiable opponent, one that can be seen and therefore destroyed?[40] What
is the critical rationale for FloodNet as a mode of protest? To understand
the rationale, we must understand the swarm as it has been theorized by
Rand Corporation researchers John Arquilla and David Ronfeldt in their
work on the effects of information technologies on conflict. Put simply,
swarming is a mode of conflict in what has been called, variously, "cyber-
war," "infowar," and "netwar."[41] Such conflict has never been limited to
traditional military warfare, nor does it necessarily need to be online;
in fact, as Arquilla and Ronfeldt explain in *Networks and Netwars*, "we
had in mind actors as diverse as transnational terrorists, criminals, and
even radical activists" (2). Swarming, then, can be high-, low-, or no-
tech (11). Regardless, it is a mode of attack, both a military tactic and a
practice of political resistance: "Swarming is a seemingly amorphous,
but deliberately structured, coordinated, strategic way to strike from all
directions at a particular point or points" (12). And in the context of their
analysis of the Zapatista movement, they write: "Swarming occurs when
the dispersed units of a network of small (and perhaps some large) forces
converge on a target from multiple directions. The overall aim is *sus-
tainable pulsing*—swarm networks must be able to coalesce rapidly and
stealthily on a target, then dissever and redisperse, immediately ready to
recombine for a new pulse."[42] We can contrast the swarm with the wave-
like structure of the phalanx: the swarm is the dispersion of force rather
than its massification or concentration. It is also the paradigmatic figure
for the CGI battle scene (*The Matrix Reloaded*, the Crazy 88s scene in *Kill
Bill*), and as such its choreography—marked by convergence, "sustainable
pulsing," even "apparent inexhaustibility"—has been firmly ensconced in
our cultural imaginary. That it would similarly be lodged in our political
imaginary is indicated by the Electronic Disturbance Theater's proposal
for the development of "non-violent Electronic Pulse Systems (EPS)."[43]
Themselves the kind of "radical activists" whose tactics Arquilla and
Ronfeldt seek to describe, EDT in turn has recourse to the Rand papers
on swarming to articulate their project of digital Zapatismo.

Dominguez and his fellow tacticians work with some of the core prin-
ciples of Critical Art Ensemble: power is no longer centralized but has
become networked and nomadic; the site of resistance has in turn shifted

from the street to the network; the object of electronic civil disobedience (ECD) is disturbance and obstruction; and disturbance is necessarily temporary.[44] In their first book, *The Electronic Disturbance*, Critical Art Ensemble (with Dominguez on board) announces that power "has shed as many of its sedentary attachments as possible"; it is fluid, decentralized, capable of resituating itself.[45] For Critical Art Ensemble, then, revolution is no longer a matter of spatialized expression; there is no longer a Winter Palace to storm. That is, "the architectural monuments of power are hollow and empty, and function now only as bunkers for the complicit and those who acquiesce. . . . These places can be occupied, but to do so will not disrupt the nomadic flow" (23). The architectural monuments are defunct, and so, too, are the streets, which are "dead capital"; in fact, "the streets in particular and public spaces in general are in ruins."[46] Or, as Hardt and Negri will put it later in *Multitude*, "basic traditional models of political activism, class struggle and revolutionary organization have become outmoded and useless."[47] Resistance, then, must withdraw to the networks, for "to fight a decentralized power requires the use of a decentralized means."[48] Power has become nomadic and, as such, "has created its own nemesis—its own image . . . in the barbarian hordes— the true nomads of cyberspace."[49] In his 1998 paper on the futures of electronic civil disobedience, Electronic Disturbance Theater member Stefan Wray predicts that the site of resistance will shift as "more and more these acts will take place in electronic or digital form."[50] He speculates that the wars of the future, our present, "will be protested by the clogging or actual rupture of fiber optic cables and ISDN lines—acting upon the electronic and communications infrastructure." Such transgressive tactics shift the Internet "from the public sphere model and casts it more as conflicted territory bordering on a war zone."[51] Wray takes care to stress that street protests will by no means disappear; rather, "we are likely to see a proliferation of hybridized actions that involve a multiplicity of tactics, combining actions on the street and actions in cyberspace." Electronic civil disobedience, then, will gradually develop as a "component" or "complement" to more established forms of civil and political protest. It may be the case that guerrilla action is limited, but, as Critical Art Ensemble notes, the "old school" of street protest "has plenty of currency in local affairs where problem institutions are present and concrete."[52] On this point, we would certainly need to acknowledge

both the street protests against proposed anti-immigration legislation in spring 2006, when the *Los Angeles Times* Web headline announced, "Wave of Dissent Grips U.S. Cities" (May 1), and the school walkouts coordinated by social networking tools and Web-to-SMS broadcasting.

The use of electronic civil disobedience to thwart the flows of information, to obstruct, block, and otherwise disturb has been extensively documented, but what bears reiterating here is the notion, again articulated by Critical Art Ensemble, that "blocking information access is the best means to disrupt any institution, whether it is military, corporate, or governmental."[53] Again we see an adumbration and an echo of Arquilla and Ronfeldt's thinking about electronic activism (they seem in some sense to produce each other): "It means disrupting if not destroying the information and communications systems, broadly defined to include even military culture, on which an adversary relies in order to 'know' itself."[54] The Rand authors leave open the possibility of outright destruction, but CAE and EDT will insist this is not their aim.[55] Rather, the objective of a disruptive action or performance is the temporary reversal, not the cessation, of the flows of power.[56] FloodNet in particular is also, as Graham Meikle notes, "primarily a media event."[57] On this point, too, we might remember that the threat of FloodNet applications is perhaps more symbolic than actual, however dangerous it may seem to disrupt server traffic for a few hours.[58] Dominguez acknowledges the difference between the symbolic and the real: "Electronic civil disobedience has a certain symbolic efficacy against power. With the Mexican government, no matter what you do to their website, you're not going to disturb their tanks, their missiles. No matter how much you disturb Nike's website, you're not going to disturb their stores, because they have real exchange power on the ground."[59] (We might certainly extend the point to include the Minutemen and NAFTA Web sites.) To put the inevitable question bluntly: what, then, is the point? The answer offered by Dominguez, EDT, and other tactical media practitioners is again informed by CAE, but to understand fully the investment in temporary provocations and disturbances, we need to return to Foucault, for whom "there is no single locus of great Refusal, no soul of revolt, source of all rebellions, or pure law of the revolutionary. Instead there is a plurality of resistances, each of them a special case: resistances that are possible, necessary, improbable; others that are spontaneous, savage, solitary, concerted, rampant, or

violent."[60] After Foucault, then, we have CAE ("resistance can be viewed as a matter of degree; a total system crash is not the only option, nor may it even be a viable one") and Dominguez himself: "There is only permanent cultural resistance; there is no endgame."[61]

In what are we investing, then, if not a revolution or an endgame? In sum it is the "negation of negation": "The hope is to try to maintain the open fields that already exist, and perhaps expand this territory and elongate its temporality, rather than insist that we can change the whole structure with some kind of utopian ideal."[62] In David Garcia and Geert Lovink's manifesto "The ABC of Tactical Media," we see a similar focus on an elongated temporality of the present, the provisional, the "here and now."[63] "Tactical Media are never perfect," never finished, Garcia and Lovink tell us. Rather, tactical media are "always in becoming, performative and pragmatic, involved in a continual process of questioning the premises of the channels they work with."[64] In all we can see the recognition that "revolution" as such does not need to be a singular temporal or spatial event, that it does not need to be a moment of spectacle. Instead, we can think, as does Dominguez, in terms of "symbolic efficacy." A temporary provocation, however momentary, can change the signifying field in which it occurs, though its material effects cannot be determined in advance. In this respect, the provocation has no necessary teleology; its outcomes are unpredictable and unforeseeable. Why else should the Amsterdam tactical media festivals be organized under the rubric "Next Five Minutes"? This is not to say that utopian vision is somehow bounded or curtailed but to observe that a practitioner of tactical media acts for the here and now with a fragmentary and hopeful vision of an ideal future, but one that may very well not, as Vilém Flusser reminds us, be "carried to completion."[65] Dominguez speaks to the shifting quality of his vision of utopia, which is not fixed on a future horizon but ever in flux: "A difficult kind of hope because it's not bound to a specific image of utopia. . . . [but] must be built without a prerecognition of what the endpoint will look like."[66] Critical Art Ensemble, too, writes of the need to gamble on a tactical event: "All that is required is the ability to live with uncertainty, and the willingness to act despite the potential for unforeseen negative consequences."[67] In other words, just DoEAT.

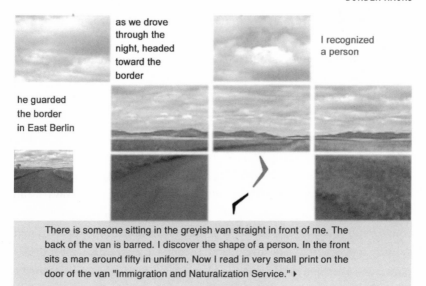

Trebor Scholz and Carol Flax, Tuesday Afternoon, 2001.

Crosser/La Migra

Much like the DoEAT performance with the San Diego highway Caution signs, Trebor Scholz and Carol Flax's hypermedia project *Tuesday Afternoon* (2001) speaks to the discontinuities in the movements of money and goods in our neoliberal moment. Superimposed on a low-contrast map of the U.S.–Mexico border are the following opening lines: "The right to navigate one's own geography is not shared by the migrant or the refugee. The borders or frontiers, which capital crosses with ease, are insurmountable for the poor or the dispossessed." The project description on Rhizome puts it succinctly: "In the process of globalization, international borders become increasingly easy to cross for capital. Corporations reach super-mobility, but borders are militarized against 'undesirable' populations."[68] From the outset, then, *Tuesday Afternoon* articulates one of the central demands not only of migrants, refugees, and asylum seekers but of all people: the right of free movement, the "right to navigate one's own geography." The call for freedom of movement has resounded from numerous activist organizations in Europe and North America. For example, the No Border Network cohered in late 1999 to

document and coordinate movements driven by the twin principles of free movement and settledness, "for the freedom for all to stay in the place which they have chosen."[69] The call has also resounded from theorists embedded in antiglobalization movements and practices: most notably, Hardt and Negri have asserted the right to free movement as "the multitude's ultimate demand for global citizenship."[70] It is in these terms, too, that we can understand the importance of the audio in *Tuesday Afternoon*. From the map we move into the primary frame of the piece; on the left is a small QuickTime video shot from the perspective of someone walking along an unpaved desert road that curves toward the distant horizon. The primary audio track of the video, which is on a continual replay loop, is the sound of someone walking, of purposeful and solitary movement. No leisurely stroll through a pastoral landscape, this movement is insistent, its relentlessness suggesting a focused intensity. Like the project's title, it captures the ordinariness, the noneventness, of migrancy. The audio does not represent an authentic "migrant experience," but it does in some sense approximate it. It evokes a typological, categorical experience similarly evoked but then negated by the textual narratives.

A set of interlocking short stories of border crossings unfolds in basic hypertextual form: one follows a young couple traveling by bus for a family visit in Europe; somewhere in the Balkans, the young woman with the "outlandish looking" green passport imprinted in Cyrillic letters is stopped by border control and denied entry. Her travel visas are useless, she is told; Britain has not signed the Schengen Agreement. The first-person narrator of another, set in the border town of Nogales, Arizona, considers his compulsory army service on the East German border and wonders why someone would voluntarily serve as a border guard "on this so very different border." Another outlines a marriage of convenience that unravels and is detected and nullified by the UK Home Office, which gives the woman thirty days to leave the country. A third poetically evokes the condition of an asylum seeker: "she does not want to leave"; "this safe place"; "why would she go back"; "and maybe be tortured." This thread, which is not geographically or culturally specific, becomes even more sinister with the suggestion that the woman's movements are being tracked: "I recognized a person / in the back of the van." The "two broth-

ers" narrative indirectly recounts the death by dehydration of two broth-
ers twenty miles outside of Tucson, Arizona. In its articulation not only
of movement but also of the cessation of movement, *Tuesday Afternoon*
is aligned with artist-activist projects such as SWARM, which takes
pains to document northward migratory routes as well as the estimated
sites of death during failed crossings.[71] The background landscape for
Tuesday Afternoon is not experienced as the pastoral; rather, it is figured
as a "site of discrimination and even death."[72]

These stories are specific and yet also in some sense generalized. They
all contain geographic and sociocultural markers, and yet a certain gen-
erality is preserved within them. To understand the full significance of
this, we need to turn to the project description: "*Tuesday Afternoon*, made
to be experienced online, is an easily accessible hypermedia project that
contrasts issues of individually experienced border crossings. . . . Using
sound, text and video, the game-like structure of *Tuesday Afternoon*
makes each visitor's interaction with the piece unique." The assertion of
the "unique" aspect of each visit dates the project somewhat, reminding
us of a moment in which the discourse on interactivity made claims for
the radically individual aspect of each textual encounter and a reading
experience that was more singular than shared. Today this insistence on
singularity also points us in a different direction. It is not that the piece
suggests that the migrant experience is somehow substitutable—in fact,
the project description insists the opposite by explaining that it "con-
trasts issues of individually experienced border crossings." The apparent
typological aspect of the text—"two brothers" or "she married"—instead
speaks to the fundamental nonreproducibility of the migrant experi-
ence. Scholz and Flax's decision to forgo literal representation and ren-
der the migrant and refugees' stories only in the third person suggests a
certain cognizance of the critical problems of "speaking for."[73] If border
crossings are understood to be "individually experienced," then, absent
a direct testimony, a witnessing of one's own experience, one can only
have recourse to the categorical. (It is in these terms that we will come
to understand the game spaces as well.) Highlighting one final aspect of
the project will lead us to a coterminous work set against a seemingly
pastoral landscape and engaging issues of immigration and borders.
Scholz and Flax emphasize the "easily accessible" aspect of their online

project, which introduces an inverse relation between the accessibility of the project and the migrant's lack of mobility, between open systems and closed systems, between free movement and restricted movement. This is the critical space of Heath Bunting and Rachel Baker's *BorderXing Guide* (2001).

BorderXing Guide set out to perform and document a set of walks that cross national boundaries within the European Union, often by the most difficult means possible.[74] Responding to the restrictions on movement of non-EU citizens, that is, less "trusted travelers," the project was staged at a moment of transition for the European borders, when the nation-state opened and the EU borders simultaneously closed, the moment when the line between interior and exterior was being resituated. The artists traversed nearly two-dozen international borders without papers and, in doing so, pointed to the ease of travel afforded to EU citizens. The project, however, might initially seem quite removed from the border crossings of asylum seekers, refugees, or *sans papiers*. But its nomadic pastoral aesthetic is interrupted by the documentary photographs of razor-wire fences and other material demarcations of borders. Particularly in the crossing of borders into the former Eastern Europe, Bunting and Baker highlighted the remnants of the security state in photographs of fences and crossing-guard stations. In keeping with Bunting's ongoing investment in maps and networks that are alternative and oppositional to the global network economy, *BorderXing Guide* put the pedestrian into dialogue with the asylum seeker and walking into dialogue with vagrancy. The project also resulted from Bunting's "drive to reduce my possessions to almost nothing and to replace them with techniques."[75] There is an aspect of the pilgrimage, then, in the shedding of possessions and the commencement of a long and arduous journey. The online slide show of the journey might also confirm this were it not for the "guide" component of the project, which provides maps and suggested routes for illicit border crossings. Bunting's recent collaborative work, *Status Project* (with Kayle Brandon, 2004), contains in this vein, offering as it does to "make visible . . . both street and institutional systems" and "to facilitate easy movement within them."[76] A review in the *New York Times* speaks to the tension between this project and the national security state: "In its final form, their project may be viewed as

the Homeland Security Department's worst nightmare: a road map en-
abling all sorts of undesirables to penetrate a nation's borders, banking
systems, supermarket loyalty clubs."[77] But the more salient component
of *BorderXing Guide* for my discussion here is the delineation of private
and public use. Bunting notes that the work is "biased against private
consumption," a literal statement about the restriction of site access to
authorized clients. To gain access, viewers either have to travel to a pub-
lic site with a static IP address—authorized clients include galleries such
as the Tate and all servers in "developing" countries—or to make their
own private terminal public. We might then see a clear parallel between
trusted users and trusted travelers, with *BorderXing Guide* speaking to
the relation between online access and the freedom of movement.

Judi Werthein's shoes—*Brinco (Jump)*—provide us with an entryway
into the crossroads between migrancy and the global corporatization of
goods and labor.[78] Designed for the inSite_05 show and manufactured
in China, the shoes were equipped with the necessary tools for crossing
borders on foot, including a compass and a flashlight for night crossings.
A small pocket on the tongue of the shoe holds either money or pain-
killers, and the removable insole is printed with a map of documented
safe crossing points on the Tijuana–San Diego route. The movement of
the migrants who wore them—a set number of pairs were distributed
along the border as part of Werthein's intervention/show/project—is
marked at three points along the shoe. On the heel is an image of Santo
Toribio Romo, the Mexican patron saint of migrants, their guide and
protector. An Aztec eagle is embroidered on the side, and the eagle of the
U.S. quarter appears on the toe, indicating or perhaps even propelling
the migrant's movement toward the United States. The artist designed
one thousand pairs for manufacture in China; after she distributed some
along the U.S.–Mexico border, the remainder were sold in a high-end bou-
tique in San Diego. The contrast between the Chinese production costs
($17) and the resale costs in the boutique ($215) not only brings issues of
outsourcing and wage inequities to the fore but also points to the inevi-
table commodification of the experience of the other.

At this stage, the thematic significance of the shoe, of walking, of the
visual and auditory representation of movement, should be clear, its con-
nection to the demand for the freedom to control one's own movement

apparent. The canonical text on this issue of freedom of movement is Hardt and Negri's *Empire*. In their schema, Empire depends on a migrant labor force; it cannot then shut down the flows of autonomous movement without destabilizing itself. It is a bit of an understatement to say that Hardt and Negri have a more optimistic than pessimistic view of nomadism, of the "specter of migration" and the "irrepressible desire for free movement." On the issue of nomadism as a form of class struggle, they are unequivocal: "Mobility and mass worker nomadism always express a refusal and a search for liberation: the resistance against the horrible conditions of exploitation and the search for freedom and new conditions of life."[79] We might contrast their vision of the potentialities of free movement with the intensification of the biometric regulation of movement under the US-VISIT and related programs, with the division of the population into trusted and untrusted travelers. But we should not think that the calls for free movement are limited to one group or another. That the demand for freedom of movement is part of a more fundamental claim for the *droit de cité* (rights to full citizenship) is explained by Balibar in his extended review of an essay by the Italian sociologists Alessandro Dal Lago and Sandro Mezzadra:

> I do not believe that the political "demands" of migrants (be they "refugees" or "workers," two not necessarily separate categories)—extremely powerful demands that are ever rejected but never obliterated and which are fundamental if we are to have democratic change—constitute a demand that mobility as such, "deterritorialized" mobility, be recognized. I believe that the relation of these demands to the construction of modern Europe is solely a relation to the "mechanisms of control" of capitalist globalization. Surely freedom of movement is a basic claim that must be incorporated within the citizenship of *all people* (and not only for representatives of the "powerful nations," for whom this is largely a given).[80]

The demand for freedom of movement, as Balibar notes, is not a demand for movement as such; in fact, the freedom not to move might also be construed as expressive of a certain dignity. The withholding of movement is certainly a familiar practice of civil disobedience, wherein "I would prefer not to move" is a mode of refusal by withdrawal rather than confrontation.[81] Like Bartleby's refusal, it is passive and dangerous, suggesting a certain decorum while also announcing that one is

subject to power. In the ceding of power, what is left is the power to with-hold. What we might extrapolate from Balibar's reading, then, is that the *droit de cité* includes the freedom of movement for all, not simply for the "migrant" of the global South, and it also includes residential rights, the freedom not to move, to remain settled.[82] This is to say that beyond Balibar's analysis, we must also recognize the capitalist forces that compel movement and be wary of the equation of freedom with the ability to become nomadic. Mobility per se by no means endows the subject with an unconditional freedom. In fact, it is precisely the migrant's separation from the nation-state as the guarantor of human rights that places her at risk.

Flusser similarly speaks to the unmitigated celebration of free movement or nomadism as he engages the question "Is a person free simply because he is able to flee?"[83] With Flusser's own story of forced exile from Prague to Brazil at the start of the Nazi occupation in mind, we might guess, correctly, that the answer would be in the negative: "When I leave the first contingence so that I may enter another one at the same level, I am a refugee. I have become neither outraged nor engaged but have allowed myself to drift. There is no dignity in such movement. However, if I leave the first contingence and enter into a state of irony, and then enter the second contingence out of this irony, then I am both outraged and engaged, and my decision has dignity" (22–23). Flusser has recourse to the Greek *nomad* in order further to counter the notion that "the strange dizziness of liberation and freedom" might be located in all movement. To read nomads, wanderers, as "outside the law," he explains, requires the perspective of one who is settled within, and afforded rights by, a political community (47).[84] Perhaps the most resounding critique of the discourse on nomadism, however, comes from Slavoj Žižek, who charges Deleuze and Guattari with having produced the "ideology of the newly emerging ruling class."[85]

It is precisely the discourse on nomadism that informs Zygmunt Bauman's "liquid modernity" thesis, which holds that "we are witnessing the revenge of nomadism over the principle of territoriality and settlement. . . . It is now the smaller, the lighter, the more portable that signifies improvement and 'progress.' Traveling light, rather than holding tightly to things deemed attractive for their reliability and solidity—that is, for

their heavy weight, substantiality and unyielding power of resistance—is now the asset of power."[86] Liquidity, in Bauman's analysis, refers to social disintegration as both the precondition and the consequence of the new logic of power. "It is the mind-boggling speed of circulation, of recycling, ageing, dumping, and replacement which brings profit today" (14). This view of the opening up of nomadic traffic and the elimination of check or stoppage points comes at the end of the wired 1990s and extends the Kevin Kelly line of thinking to the notion that "heavy, Fordist-style capitalism" is over and a new epoch of "software capitalism" has begun (63, 116). But the liquid modernity thesis is also very much in the spirit of Hardt and Negri's synopsis of Empire's capitalist logic of power, with its assertion that the "hardware era, the epoch of weight and ever more cumbersome machines," and "heavy modernity," "the era of territorial conquest" is coming to a close (113–14). Liquidity suggests a temporal rather than spatial logic of power, a shift away from the management of material things to the management of mobility and speed. Antiliquidity, then, is the space of Electronic Disturbance Theater's intervention, as Dominguez explains: "The goal of EDT's disturbance is to block Virtual Capitalism's race toward weightlessness and the social consequences a totalized immaterial ethics creates."[87] Their object is not necessarily to emphasize the material basis of capitalism, as does Allan Sekula in his poignant photographs highlighting the sheer mass and weight of cargo shipping containers, but to disrupt the circulation and flow of virtual capitalism.[88] In fact, I will have occasion to wonder in subsequent chapters if the Society for Worldwide Interbank Financial Telecommunications (SWIFT), the computer network for global funds transfer messages, is not the logical next target for an EDT disturbance action.

The inSite_05 online exhibit, *Tijuana Calling/Llamando Tijuana*, will introduce further themes and questions.[89] The five artist teams selected were asked to construct a project that was strictly networked, though aspects of a physical installation made their way into many of the projects in spite of this mandate. Ricardo Dominguez and Coco Fusco's *Turista Fronterizo* is, as its title suggests, an exercise in border tourism presented in the form of a Monopoly-like game. Players choose one of four characters, all border crossers, and proceed on "a virtual journey through the San Diego–Tijuana borderlands," or, simply, around the board.[90] As

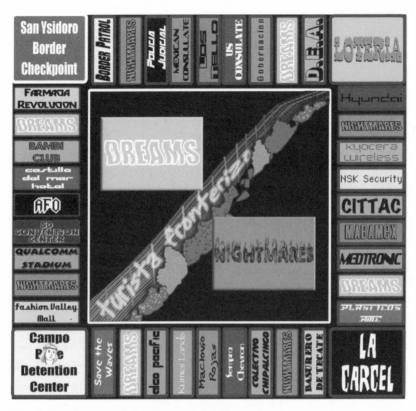

Ricardo Dominguez and Coco Fusco, Turista Fronterizo, *2005.*

Gringa Activista, El Gringo Poderoso, El Junior, or La Todológa, players
encounter various obstacles and windfalls according to type, adding to or
depleting the initial monetary stake as the case may be. So, for example,
as the binational businessman, you bribe government officials to secure
permits for refineries, buy drugs, pay lobbyists, and rebut negative press
about your company's use of toxins and pollutants. If you play in Spanish
as El Junior (characterized as *huevón,* politely translated as "lazy"), you
often end up at a strip club in Tijuana, under suspicion by the DEA, or
back in the Detention Center. Clichéd this may seem, and indeed that is
the point for a game that works with types to destabilize types. That is,
the general, categorical aspect of the gameplay alludes to the reduction
of real material lives to one-dimensional, prescripted characters. The
project does not aim to grant a voice to the migrant or the citizen; rather,

the project suggests that one cannot speak from within or outside the scripted gameplay. As with a role-playing game, players are addressed in the second person, allowing for a kind of pedagogical experience—what happens if you are caught with cocaine at the border?—limited by the absence of source or reference material; that is, players wanting concrete information about cocaine traffic, for example, must conduct their own research. Dominguez and Fusco also use the form of the game to thematize the migrant's perpetual search for work. This is most obvious in the case of La Todológa, a general worker whose profession is whatever she finds, the script for whom highlights the goal-oriented aspect of labor in the moment of neoliberal globalization. In this character's script, it is only the goal—money—that matters, rather than labor itself. As many have noted, it is this reduction of labor to an end that can partially explain why workers' rights claims no longer maintain the same force as they did under industrial capitalism; labor, that is, is no longer valued as an integral, socially significant activity. Rather, the job must be completed and the work economically compensated, in this case in order for the die to be cast for the player's next turn. Though inSite had wanted projects that were exclusively online, Dominguez also built a 1970s style Pac Man game box for the project and installed it at the Zapatista headquarters in Tijuana. The new computer that housed the game was also placed there to build up the local media lab, thus coordinating not only the material and "virtual" aspects of *Turista Fronterizo* but also *Turista Fronterizo* and digital Zapatismo. Moreover, the physical placement of the computer game at EZLN headquarters forecloses the presentation of Mexico as a stable object of border tourism.[91]

Turista Fronterizo is one of many "games with an agenda," and there are others directly concerned with the U.S.–Mexico border, two of which are Rafael Fajardo's *Crosser* and *La Migra*.[92] Modeling the games on the 8-bit aesthetics of *Frogger* and *Space Invaders*, respectively, Fajardo works with basic game mechanics to stage the scene of border crossing as one of collision detection. Thus the crosser must avoid both air and land border patrol, highway traffic, and dead bodies and other obstacles in the river; and *la migra* uses a car to block the descending bodies (an incomplete "hit" results in death). While one might think this seems a bit macabre, Fajardo self-consciously employs the garish colors and avatars

particular to many games so as to preserve a game's basic antagonistic structure. Within these game spaces, border crossing is staged in unadulterated binary terms: U.S.–Mexico, crosser–*la migra*, good-evil. This is migrancy and territorial sovereignty starkly polarized—how else are we to understand the implications of rendering border crossing as a matter of obstacle avoidance? How, further, are we to understand that successful border crossers in *La Migra*—those not swatted back à la *Pong*—fall into a detention center for deportees? We might further address the use of a game, as Fajardo notes, to "create a subtle multi-level critique" by considering his statement on the matter: "I've come to understand that the games, any games that attempt to deal with the real, will be incomplete. The map is not the territory, the stakes are not life and death, and a player can walk away when the thrill is gone."[93]

The games will be necessarily incomplete, so as a complement to the caricatured figures they present—migrants flee, and *la migra* hunts—we can consider instances of documentary self-representation produced within the Border Film Project (2005).[94] Project leaders distributed between four hundred and five hundred disposable cameras to both migrants and the Minutemen, asking them to take the photographs of their choosing and to return the cameras in a SASE (migrants had the incentive of an anonymous Wal-Mart gift card to prompt their return of the cameras once they reached the United States). For the most part, it is striking to see the extent that self-representation occurs within given narratives of subject formation: in the selected photographs, Minutemen sit and watch; migrants walk or show injurious effects of movement (one memorable shot is of horribly blistered feet). There are the requisite lone ranger shots of the Minutemen framed against the sky and the temporary camps established by migrants on their journeys. With the Border Film Project in mind, we can return to Fajardo's statement on the use of a game space as cultural critique: "Rather, I have come to understand *Crosser* and *La Migra* as poems, where the absences and silences are as important as that which is stated."[95] Invoking Baudrillard on the simulacrum, Fajardo reminds us that the "map is not the territory," that we should clearly not conflate the border games with the "real" border. We should attend to, play, *Crosser* and *La Migra* as games—this much is indicated by the design—but as poems they are intended to have a

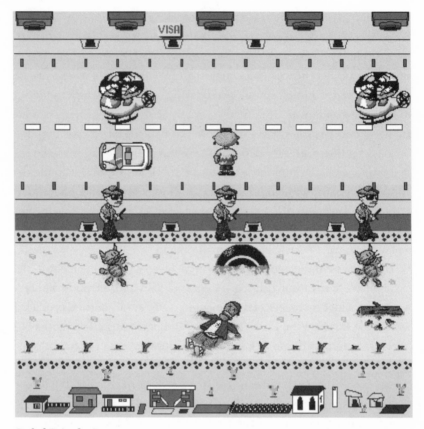

Rafael Fajardo, Crosser.

memorializing capacity as well. What they cannot capture or represent are the "absences and silences" that demarcate the difference between a game and a game of life and death.

Having examined new media art's engagement with territorial borders, I want to move by way of a conclusion to an account of the complex entanglements of the territorial and the biometric brought to the fore by Anne-Marie Schleiner and Luis Hernandez's *Corridos,* a 3-D open-source, cross-platform game also commissioned for the *Tijuana Calling* exhibit (2005). Taking its title from the *corrido,* a mestiza narrative ballad traceable to the early modern Spanish ballad form of the romance, *Corridos* maintains a parallel investment in fostering cultures of resistance. Since *corridos* functioned as a paradigmatic mode of itinerant

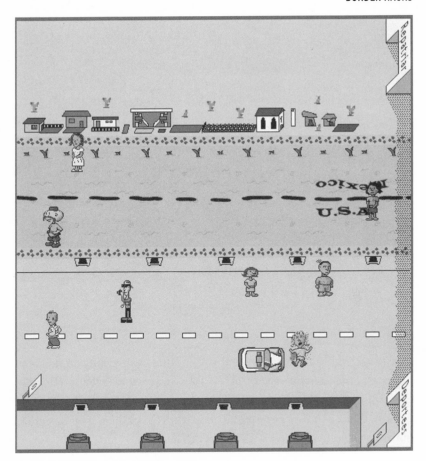

Rafael Fajardo, La Migra, *2003.*

storytelling, these ballads played a significant role during the Mexican
Revolution, their dispersal epitomizing the very decentralized modes of
dissent that now inform Electronic Disturbance Theater. As Américo
Paredes has shown, *corridos* are particular to the populations around the
U.S.–Mexico border, where the "slow, dogged struggle against economic
enslavement and the loss of their own identity was the most important
factor in the development of a distinct local balladry."[96] In the develop-
ment of a resistant local balladry in the border regions geographically
separated from Mexico's centers of power, we can see a clear antecedent
to digital Zapatismo and other tactical movements in the present.

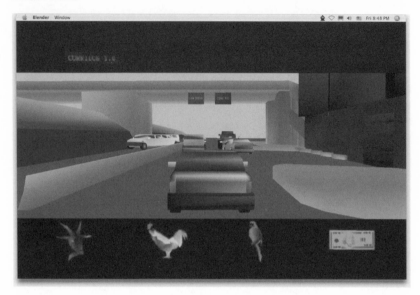

Anne-Marie Schleiner and Luis Hernandez, Corridos, *2005.*

The *corrido* has also traditionally been sung by migrants on the journey north, their narrative subjects outlaws and related legends. *Corridos* the project takes its thematic cue from narco-corridos, contemporary ballads that are often reverential toward drug traders. The designers outline the game scenario with respect to its title:

> Corrido: Oral form of communication, deeply rooted in mexican-culture, perfected during the revolution (1910), when the media was co-opted by the government, as an opensource, peer to peer efficient way of disseminating news from afar, mainly great battles and heroic gestures. In recent decades, this form has been retaken to sing about famous narcotraffickers and big trafficking operations. Narco-corrido songs tell the sometimes sad, cynical and romanticed adventures of narco traffikers who take great risks to deliver drugs across the mexican/us frontera, over a polka or waltz beat in the background. . . . Corridos are usually commissioned to norteño musicians by the traffikers themselves, who like to hear songs about their exploits, beginning at 500 USD and going up.[97]

The game *Corridos* puts the player in the position of a drug smuggler along the Tijuana–San Ysidro border. As with the ballad, the game situates the outlaw or criminal in an idealized subject position but also

reminds us of the double figuring of people and drugs as undesirable. Peter Andreas notes that "the politics of opening the border to legal economic flows is closely connected to the politics of making it appear more closed to illegal flows."[98] Indeed, both people and drug are lumped together under the rubric of "illegal traffic." The language of drugs in the game also derives from the folklore of the ballad, wherein animals stand in for substances (the three animals, goat, rooster, and parrot, refer to heroin, marijuana, and cocaine, respectively). Invoking the complex and imbricated histories of the ballad and of drug trafficking, *Corridos* links both within the context of an open-source environment that allows for modification, somewhat in the way that ballad lyrics allow for musical variation.

More important for our purposes is the objective of the game, which is to find the secret tunnels—narco-tunnels—leading from Tijuana to San Ysidro and use them to run drugs and weapons between the two countries. Modeled on two area neighborhoods, or aspects of two area neighborhoods, *Corridos* has recourse to the material real in its presentation of secret tunnels that circumvent border controls, while nonetheless insisting that it is "just a game." As the designers note: "*Corridos* is basically a computer game about driving and listening to music." The putative discrepancy between a game and the migrant, material world collapsed in the Denver airport in November 2005. En route to visit his wife and collaborator, Anne-Marie Schleiner, Hernandez was detained by Homeland Security agents after a luggage search turned up copies of both the game and the inSite_05 brochure, which together rendered him an untrusted subject. Hernandez describes the incident in detail in a post to the inSite group:

> In a luggage check at the Denver International Airport, the TSA/immigration found both a "Tijuana Calling" brochure and a copy of the game that Anne-Marie and me produced for inSite. They searched the inSite website and all of its links and loaded the game and made me play it for them, they found that the game as most of the projects were posing a threat to the U.S. national security and that they were "Anti-American," in speaking about illegal crossings and traffic, in their own words. One officer even told me to watch out who we were working for. I explained that the game as well as the other pieces of art had been commissioned by an art institution whose objective is to gain deeper cross understanding about life in the Mex–U.S. border, for both the peoples of

Mexico and the U.S. They said they didn't believe it and discredited the fes-
tival, evidently ignoring what art is. When I told them that the organisation
was run by U.S. citizens, they replied that not all U.S. citizens are prone to like
the government and its policies and that actually a lot of them were working
against it.[99]

Were this to end in a spectacular confrontation and escape, it might
even be the nonlyric text for a contemporary *corrido,* perhaps one might
even call it a *ludo-corrido.* It is in fact both a story of a "great battle"
and a story of risk but crucially lacks a romanticized ending. To wit:
after a lengthy interrogation about Hernandez's knowledge of secret
tunnels and terrorist activities in the border regions, he was deported
back to Mexico, barred from reentering the United States for a period of
five years.

From the speculation that the launch of the FloodNet applet in 1998
was a terrorist act to the charge that a computer game constitutes "a
threat to the U.S. national security," we have begun outlining the evolv-
ing relations between socially engaged new media art and the secu-
rity apparatus, more broadly between contemporary art practices and
charges of terrorism.[100] Another installment must surely address the
ongoing legal case of Steve Kurtz, the Critical Art Ensemble member
investigated on suspicion of bioterrorism and eventually charged by a
federal grand jury in June 2005 with mail and wire fraud.[101] In their
commentary on the Kurtz case, Rebecca Schneider and Jon McKenzie
pose an important question: "Is CAE's general move away from *rhetoric*
toward tactile *participation* pointedly what provoked the FBI to suspect
terrorism?"[102] We might well pose much the same question here: what
is it about the game ("tactile participation") as opposed to the brochure
("rhetoric") that brought Hernandez under suspicion? In the quotidian
exercise of risk profiling and threat assessment, it is *Corridos* the game
that renders Hernandez a dangerous, untrusted subject.[103] The brochure
and festival may be written under the sign of sedition, but the game is
written under the sign of risk. I will hazard a generalization and say
that our shared cinematic imaginary alone, much less the coverage of
the Iraq war, ought to have made us all well versed in the use of games
and simulations as training mechanisms for military activities. How else
are we to understand the TSA officials' mandate that Hernandez play

the game in their presence? In this context, the game becomes the illegal substance, the undesirable, that which cannot cross the border, and the TSA mandate becomes part of a military operation. The newly amplified practices of state securitization and the issue of material border crossings come together in this complex instance of risk assessment.[104]

InSite festival projects such as *Turista Fronterizo* might initially raise the question of a discrepancy between the migrant, material world and the computer game, but Hernandez's detention is a clear moment of conjunction between them. The distinction between Hernandez the artist and the first-person perspective of *Corridos* collapsed, and Hernandez in a sense became embedded in his own game, thrust into the world that his project portrays. The temporal, epistemological, spatial, and sociocultural gap between the "illegal" and the artist-activist closed, the latter thrown into the world of the former. The artist himself becomes enclosed within restricted borders, indicating that the radical dichotomy between the game and the real is ultimately not sustainable. It is also important to take account of another aspect of risk embedded in the game. One of the risks run by hacktivist art projects is that they go unacknowledged, that their provocations are either unseen or dismissed as mere game playing. At the very moment that Hernandez is forced to play the game in the presence of TSA officials, the game succeeds in unfolding the very risk it was predicated on. It succeeds, that is, in displaying the activist political potential coded within it. This, after all, is the audience that the game would most especially aim to provoke. It is not only Hernandez who is forced to play the game, but the TSA officials also become implicated in its structure and rhetoric. Hernandez's detention and deportation demonstrates the danger that the game presents in the eyes of the TSA officials: without this double risk of banishment and provocation, the game would fail to register any political or activist potential.

It bears repeating that *Corridos,* like the narco-corridos, was a commissioned work, its expressed pedagogical purpose, as Hernandez recounts, "to gain deeper cross-understanding" about the U.S.–Mexico border, "for both the peoples of Mexico and the U.S." Even with the awareness that the insistence on an educational mission constitutes a kind of juridical defense, *Corridos,* and the festival of which it was a part, perform the very reverse engineering called for by Critical Art Ensemble.[105] Within

a regime of signs, when border control is a "symbolic performance" of security, the (temporary) provocation of tactical media is to reveal those signs to be mutable. What DoEAT and the other artists here present is a mutability of signs, symbolic performances, that speak to material conditions that are far less plastic and mutable.

2. Virtual War: Information Visualization and Persuasive Gaming

> The lesson is that the army must fight where the war is, and the war will go where the people are. In 1814, everybody was on foot. In 1914, they were on trains. In 1940, they were in cars. In 2040, they will be in avatars.
>
> —EDWARD CASTRONOVA, *Synthetic Worlds*

> Virtuous war has taken on the properties of a game, with high production values, mythic narratives, easy victories, and few bodies.
>
> —JAMES DER DERIAN, "War as Game"

Virtual War

Anthony Lappé and Dan Goldman's near-future graphic novel *Shooting War* (online version May–September 2006) begins with a certain self-consciousness about narrative self-presentation in the age of Web 2.0. "My name is Jimmy Burns," announces the anticorporate videoblogger and Global News reporter. Having inadvertently streamed a suicide bomb attack on a Starbucks in the trendy Williamsburg neighborhood of Brooklyn, Jimmy Burns has become an overnight media sensation and has been sent to Iraq to capture, "live in hi-def," the real horror of the war that has "gone to hell in a humvee," looking "more and more like Saigon '75 every day."[1] (The emphasis on real time parallels the novel's initial weekly serialization, which to some degree allowed for authorial response to both present events and reader comments.) It is 2011, the eighth year of the war, and the United States under President McCain has become even more deeply mired in the near-apocalyptic quagmire. As Jimmy reports in his blog, "Burn Baby Burn," rumors of American-organized, Salvadoran-style death squads abound, but "the problem of trying to verify any of it is near impossible. Ever since the Pentagon got

busted enlisting Pixar to create al-Zarqawi's successor out of 0s and 1s, getting straight answers out of the military is like asking James Frey what he learned in prison."[2] Not simply ironic commentary on computer-generated imagery, this moment in the text indicates a deep understanding of the virtual aspects of war. So, too, the inadvertent live feed of the bomb, along with a forced sat-cam uplink of a beheading, points to our fascination with the capture of death events on tape and offers a sly critique of the new society of the spectacle. But the larger point here concerns the 0s and 1s, for *Shooting War* takes as axiomatic the virtuality of warfare. Thus is it the case, then, that one frame of the novel features a bored NBC correspondent at a United Nations peacekeeper's press briefing in Baghdad playing a Sony PlayStation Portable video game of the Iraq war.[3]

This is not, however, a chapter that will offer a new thesis on the spectacularization of war, the virtualization of war, or war itself as a game space. Extensive and varied critical commentary on these issues began with the first Gulf War, most notably by Jean Baudrillard, Paul Virilio, and James Der Derian. Baudrillard's provocative statement that "the Gulf War did not take place" provides us with an ideal starting point, suggesting as it does one of the primary themes of this book: the seeming antinomy between materiality and virtuality.[4] That the Gulf War should not have taken place does not for Baudrillard mean that there are not material effects—even *Shooting War*, for all of its investment in mediation and televisual spectacles, takes pains to depict the bodily in gruesome detail. It does mean, however, that the Gulf War ushered in a new era of warfare, a qualitatively different kind of enterprise, war that could no longer be understood in its conventional meaning. Baudrillard writes: "Today we see the shreds of this war rot in the desert just like the shreds of the map in Borges' fable rotting at the four corners of the territory (moreover, strangely, he situates his fable in the same oriental regions of the Empire). Fake war, deceptive war, not even the illusion but the disillusion of war, linked not only to defensive calculation, which translates into the monstrous prophylaxis of this military machine, but also to the mental disillusion of the combatants themselves, and to the global disillusion of everyone else by means of information" (68). The

Anthony Lappé
and Dan Goldman,
Shooting War,
May 2006–.

function of the fake war, nonwar, virtual war, is deterrence: "Electronic war no longer has any political objective strictly speaking: it functions as a preventative electroshock against any future conflict" (84). A line is initially drawn, then, between Virilio and Baudrillard, with Virilio betting on intensification and "apocalyptic escalation" and Baudrillard on "deterrence and the indefinite virtuality of war"; however, as Baudrillard explains, war moves simultaneously in both directions (49).

To engage the discourse of virtual war means returning to James Der Derian's *Antidiplomacy* (1992), which poignantly concludes: "I am merely offering a cautionary tale, of how the technical preparation, execution, and reproduction of the Gulf War created a new virtual—and consensual—reality: the first *cyberwar*, in the sense of a technologically generated, televisually linked, and strategically gamed form of violence that dominated the formulation as well as the representation of U.S. policy in the Gulf."[5] The echoes of William Gibson's *Neuromancer*, with its articulation of cyberspace as a "consensual hallucination," are not accidental, anchoring as they do Der Derian's analysis of "a war of simulations" in the dystopian discourse of cyberpunk: this, then, is the genealogy that informs *Shooting War*.[6] There are echoes here as well of Virilio, particularly in the examination of "technologically generated" simulations and optical regimes of management and control. In this vein, Der Derian explains: "In modern warfare, as the aim of battle shifts from territorial, economic, and material gains to immaterial, perceptual fields, the spectacle of war is displaced by the war of spectacle" (191). What I wish to stress for the purposes of my argument is Der Derian's somewhat

rueful account of the critical response to virtual warfare, to "a new war of speed, surveillance, and spectacle" (176–77). Failing to recognize the fundamental epistemological shifts that warfare had undergone, the New Left opposed the Gulf War as if it were an "old" war, one whose televisual effects were limited to the living-room screens. As we will see from an analysis of new media projects that focus on the war in Iraq, political dissent and antiwar protest have themselves evolved to become virtual, networked, and spectacular. Contemporary antiwar games, game space performances, and information visualization projects make for a striking comparison with Der Derian's lamentation of the left's misrecognition of virtual war. Unlike the street-based protest movements during the first Gulf War, these media projects match form to object. Their site for critical response is not the street but the network. As part of an embedded critical practice, simulations are answered with countersimulations.

Here I must insert the necessary proviso that I do not intend to articulate a comprehensive discourse of virtuality initiated by the first Gulf War and brought to fulfillment with the current wars in Iraq and Afghanistan, as if to erase the histories of other military campaigns. In particular, the Balkans have been an important site of research on the televisual, satellite witnessing, and other deployments of the CNN effect.[7] Rather, what I aim to do here is to put the two moments into diachronic relation. It is not simply the location, the geospatial coordinates, that provide the grounds for comparison but also the nature of the war effort (U.S. led rather than NATO sponsored) when what is at stake is U.S. military, economic, and cultural power, literally imagined as the New American Century.

The development of simulation and virtual reality technologies and the deepening of the synergy between the military and entertainment industries over the last fifteen years have contributed to the production of the military-industrial-media-entertainment network, or MIME-Net, as Der Derian has named it.[8] If the battles of Vietnam were waged on living-room screens, he explains, "the first and most likely the last battles of the counter/terror war are going to be waged on global networks that reach much more widely and deeply into our everyday lives."[9] It is in these terms that we can understand Defense Secretary Rumsfeld's repeated

emphasis on the terrorists' "media committees" and his suggestion that the United States now battles "experts at manipulating the global media to both inspire and intimidate."[10] Traditional forms of psychological operations—leaflet distribution, radio communications—and the battle for hearts and minds are no longer simply conducted "over there." The division between "here" and "there" matters little in the global battle to control the message and to stage the definitive media event, the definitive attack on the global network. This takes us into the realm of fantastic speculation, risk and uncertainty: witness the many gaming scenarios for a Chinese-led bot attack on U.S. network architecture.

Of interest, then, is that the Joint Functional Component Command for Network Warfare (JFCCNW), a relatively secret unit of U.S. Strategic Command, publicly acknowledges two missions: defense and attack. The more provocative of these, Computer Network Attack, ostensibly involves interrupting enemy communications; destabilizing enemy command and control operations; and shutting down suspected terrorist sites outside the United States, as well as those displaying videos of attacks on U.S. citizens.[11] The unit's attack mission, in other words, is to control the MIME-Net, however temporarily.

The highly touted Department of Defense doctrine of "force transformation" has seen the transformation of the battlefield from the two-dimensional phalanx with its tightly arranged rows of troops, to a four-dimensional networked space.[12] As Tim Blackmore explains in his recent *War X,* "It is expected that war will be fought not in lines but in a four-dimensional battle arena. Battlespace, as it is called, is intended to be deep, high, wide, and simultaneous: there is no longer a front or rear."[13] Hovering in the background here is the theory of fourth-generation warfare (4GW), which is to be "nonlinear, possibly to the point of having no definable battlefields or fronts. The distinction between 'civilian' and 'military' may disappear."[14] Running war games for this new battlespace requires a massive industrial investment in simulations and computer-based training systems (as of this writing, the annual sim budget alone is estimated to be $4–6 billion).[15] Manuel De Landa's account of military campaigns in the "age of intelligent machines" provides a thorough historical account of the transformations in war-gaming technologies, of

which I can only provide a snapshot: "Early war games were conducted on two-dimensional maps, with enemy and friendly forces represented by small wooden blocks. . . . After WWII, this institutional brain became the think tank (Rand) and war games changed from tabletop exercises, to computerized simulations. . . . In their latest version, the computer has replaced not only the map but the human players as well, and war games are now fought entirely by automata."[16] In the run-up to the Iraq war in the summer of 2002, the United States was somewhere in between the actual and the virtual, rehearsing for the conflict with a three-week Millennium Challenge, a $250 million war game that combined actual forces with computer-generated models.[17]

As with much of the general contracting, military investment in game-based training systems increasingly occurs through the private sector, such as the U.S. Army's partnership with the Institute for Creative Technologies at the University of South Carolina, where computer scientists and "talent" from the gaming industry work collaboratively to produce immersive training simulations for soldiers. These are not simply force training exercises, as with the real-time combat game *Full Spectrum Warrior* (2004), but also tactical and strategic exercises in biopolitical control. Indeed there are sims such as *Tactical Iraqi* that teach soldiers population management alongside language and cultural sensitivity training, these certainly part of the anthropological turn in contemporary warfare (the Human Terrain System program is an exemplary instance of such a turn).[18] What results are models of defense that do not predict or envision the future but produce it: to simulate the enemy's response is to fashion characters, scripts, narratives that have the authority of the real. One of the many lessons of Edward Said's *Orientalism* was that representations of the Orient paved the way for actual colonization and that paintings, poems, and theatrical productions were granted representational authority against which one judged one's own experience on the ground. So, too, gaming scenarios and other simulational narratives have acquired representational authority and the cultural knowledge they produce has the authority of the "real." The genre of the programmed rather than predictive simulation has many exemplars, among them DARPA's DARWARS program (a multiplayer game-based training system); VECTOR: Virtual Environment Cultural

Training for Operational Readiness (wherein the "culture of interest" is the Iraqi Kurds); and Forterra Systems' Asymmetric Warfare–Virtual Training Technology, which uses their OLIVE (On-Line Interactive Virtual Environment) Platform.[19]

What has been the artistic response to the networked battlefield, to what has been termed, variously, virtual war, cyberwar, netwar, and postmodern war? Of course, one could argue that the war in Iraq at this stage, for all its guerrilla and sectarian ground-level urban warfare, is not a virtual war at all. Rather, it is "new," as Martin Van Creveld would argue, precisely because of the absence of conventional battles and the inefficacy of sophisticated high-tech weaponry against nonstate actors whose primary allegiances are to tribe, religion, mosque, and family.[20] Or, as John Robb suggests, it is new because of the emphasis on systems disruption and the particular combination of low-tech weapons and open-source innovations.[21] Regardless, there has been a strong critical and artistic response to the *representation* of network war—the spectacularized weaponry, computer displays featured in the background in briefings from Centcom, optics of the bomb captured by onboard cameras. How have new media artists engaged the embedded representation of war and the new reality effect it has produced? There is another side to the virtualization theses of Baudrillard and Der Derian, another side to the virtual elements and aspects of war. In short, there is now a certain kind of effort to evolve the virtual effects of war into a mode of resistance. The dystopian fictional vision of the U.S. military digitally coding al-Zarqawi's successor suggests a virtual war, one that does not register in material space. However, in these projects we will see a reassertion of virtual effects not as "disillusion" (Baudrillard) but as resistance. Representation has had to catch up to the new, transformed battlefield.

From Critical Art Ensemble's recognition that the "streets are dead capital," we have moved to modes of protest such as antiwar games, the visualization of ordnance and casualty statistics, and performances of dissent within game spaces. This is not to suggest that there are not intricate hybrid modes of protest that combine the street and the network, the actual and the virtual. Witness *We Interrupt This Empire*, a collaborative video project by the San Francisco Video Activist Network (May 2003) that documents the financial district protests in San Francisco after the

U.S. invasion of Iraq.[22] Witness, further, the mobilization of smart mobs and TXTMobs for antiwar activism, as with the Web-to-SMS coordinated protests during the Republican convention in New York.[23] Though they are not my object here, there have also been isolated hacktivist attacks spreading antiwar messages through low-level government sites and seemingly random sites such as cabbagesoupdiet.com. Unlike the SWARM the Minutemen campaign, however, these have not been coordinated attacks and have not tended to hit sites such as the Department of Defense.[24] Regardless, all these artist-activists are engaging in a kind of asymmetric warfare, obliquely borrowing their rationale and strategies of action from a Rand Corporation paper on the subject:

> In its ideal and most extreme form, asymmetric warfare causes a cascading effect that is out of proportion to the effort invested. Asymmetric approaches, therefore, often seek a major psychological impact to produce shock and confusion and thereby affect the opponent's will, initiative, and freedom of action. This condition, whether it is called disruption or disorganization, in turn creates conditions whereby an inferior force can gain conventional advantage over a superior force. Such approaches are applicable at all levels of warfare—strategic, operational, and tactical—and can employ or affect one or more elements of national power.[25]

As this chapter will demonstrate, these artists are aware of the strategy of asymmetry, and their projects are at least invested with the wish-fulfillment of asymmetric effects. In gaming and visualization strategies alike, we will see an attempt to disrupt and to disorganize, to use technological expertise to advantage, to have a disarming psychological effect—in other words, to locate the "systempunkt." While some of these projects employ asymmetric strategies of disruption, competing as they do on the virtual battlefield, others engage less in terms of confrontation than in taking up the project of memorialization.

Digihad

The preceding chapter ended with the imagined threat of video games to national security, a topic that will now come more directly to the fore. *The 9/11 Commission Report* sets the stage:

Khallad adds that the training involved using flight simulator computer games, viewing movies that featured hijackings, and reading flight schedules to determine which flights would be in the air at the same time in different parts of the world. They used the game software to increase their familiarity with aircraft models and functions, and to highlight gaps in cabin security.[26]

Games and simulations are an emerging focus for InfoOp campaigns, InfoOps, like PsyOps, a set of biopolitical techniques developed to combat what goes by the name of cyber-terrorism. A topic warranting a certain gravitas, cyber-terrorism has been the stuff of both collective fantasy and think tank communiqués, particularly after 9/11.[27] Network attacks figure largely in planning scenarios, but the mission continually foregrounded almost above all else is "strategic communications"—recruitment, propaganda, and training—again, control of the MIME-Net.

On May 4, 2006, Assistant Secretary of Defense for International Security Affairs Peter Rodman appeared before the House Intelligence Committee to report on "Terrorist Use of the Internet for Strategic Communications."[28] Representative Hoekstra outlined the political stakes in his introduction to the hearing, noting that it is "critical we understand that the global war on terror is not just being fought on land, it is being fought in cyberspace as well."[29] Thus, with the expert testimony of two external intelligence contractors, Rodman presented his briefing, a survey of visual material reported to have been taken from "adversary websites," all of which was to provide the congressional audience with "a synopsis of our adversary's broad propaganda efforts beyond Iraq and, indeed, beyond the Middle East" (3–4). The synopsis, Rodman insisted, would reveal clearly coordinated extremist activities: "There is a plan. It's not just a random sampling of multimedia product that's on the Internet" (8). Such was his introduction to the presentation proper, which was prepared and delivered by two contractors from San Diego–based Science Applications International Corp. (SAIC), which has been funded with a multiyear $7 million contract from the Department of Defense to provide intelligence support for the war on terror, in this particular instance to outline the contours of the "propaganda machine" (15).

The content of that briefing on terrorist use of the Internet, specifically the treatment of games as weapons, was sensationally reported by

the Reuters writer David Morgan, whose article "Islamists Using U.S. Video Games in Youth Appeal" was picked up by wire services, newspapers, and blogs worldwide.[30] Its summary lead stated: "The makers of combat video games have unwittingly become part of a global propaganda campaign by Islamic militants to exhort Muslim youths to take up arms against the United States, officials said on Thursday." Highlighting the presentation of game play footage from *Battlefield 2: Special Forces* as evidence of the use of games for purposes of recruitment to jihadist organizations, Morgan provided this narrative account of the hearing:

> Tech-savvy militants from al-Qaeda and other groups have modified video war games so that U.S. troops play the role of bad guys in running gunfights against heavily armed Islamic radical heroes, a defense department official and contractors told Congress. . . . *Battlefield 2* ordinarily shows U.S. troops engaging forces from China or a united Middle East coalition. But in a modified video trailer posted on Islamic Web sites and shown to lawmakers, the game depicts a man in Arab headdress carrying an automatic weapon into combat with U.S. invaders. "I was just a boy when the infidels came to my village in Blackhawk helicopters," a narrator's voice said as the screen flashed between images of street-level gunfights, explosions and helicopter assaults. Then came a recording of President George W. Bush's September 16, 2001, statement: "This crusade, this war on terrorism, is going to take a while." It was edited to repeat the word "crusade," which Muslims often define as an attack on Islam by Christianity.[31]

Avid consumers of pop culture and gamers might already be in on the joke(s): the media object described is a fan film and not a mod.[32] After watching the opening minutes of the work in question, even those with a modicum of knowledge of contemporary Hollywood film would sense that something was not quite right about the claim that this is an instance of militant Islamic psy-ops. To start with, the lines beginning "I was just a boy when the infidels came to my village in Blackhawk helicopters" are lifted from the film *Team America* and spoken by *South Park* cocreator Trey Parker, whose distinctive voice is clearly audible in the footage presented during the congressional hearings. Tipped off by these oft-quoted lines, the knowledge that *Battlefield 2* allows players to switch sides, and by the visual rhetoric, Dvorak board member JulieB identified this video immediately after the publication of the Reuters article and located its real source: a fan film by BF2 player SonicJihad.[33] SonicJihad, who is

SonicJihad, Battlefield 2 *fan film, December 2005.*

actually Samir, a twenty-five-year-old Moroccan Dutch hospital worker
with a master's degree in management, economics, and law, advertised
his video on the Planet Battlefield Forum in December 2005 with the
following note: "Be sure to download it, it's my first so . . . Suggestionz
are welcome. I've also used a lot of footage from members. Like JihadJoe
(Thanxxx in advange 4 that) So be sure to check it out! It's a big down-
load though, but worth it guaranteed!!!!!!!"[34]

SonicJihad used the standard expansion pack to present gameplay
from the opposing side, and indeed the first and fairly damning critique
from the Planet Battlefield Forum has to do with the use of found foot-
age. The day after SonicJihad posted his video, Reconmaster replied:
"I like the way half your footage is other people's stuff. . . . Most of the
footage was made by EA Games, Band of Zeros Clan, and most of all
'Burn it Down' by JihadJoe/Qc/."[35] (*BF2* player JihadJoe shot most of the
Fraps video used by SonicJihad; Band of Zeros has made another *BF2*
video.) So, too, ArmageddonGuy pointed out the video's redundancies but

encourages the "first timer" to try again. The board consensus: the video is unoriginal, too long, too repetitive, even perhaps too boring. The intelligence contractors were perhaps less discriminating. In a GamePolitics interview in the wake of the publicity surrounding the misidentification and sensation surrounding the possibility of jihadists' modifying video games for training and propagandistic purposes, SonicJihad protests: "It is just in game footage from SF [BF2: Special Forces], no self made mod at all. I can't get even my own computer to work. . . . That crusade part was some audio clip with a 'combat tune' underneath it, that I found online. . . . I was just looking for music that fit a 'jihad' story and sounded middle-eastern. Most of the sounds are from the movie called *Lion of the Desert* with Anthony Quinn. And it just fit the movie that I was trying to make."[36] In this comment, we might say there is a direct echo of the SAIC enterprise: "We were just looking for a video to fit a jihad story and sounded Middle Eastern." The fundamental misidentification makes all the more ironic the contractors' professed pursuit of ethnographic truth. As they note at the outset of the congressional hearing, "Our analysts employ a method called full cultural context, where we team native speakers with fluent, culturally aware analysts."[37]

We can start, then, with the apparent surface: there is a disjunction between the importance ascribed to video games and the misinterpretation and sheer misreading of them, and the irony lies in this disjunction. But a more sinister and complicated reading is also available: what if we were to imagine that the intelligence contractors and Department of Defense officials were in fact able to read the content of the fan film ideologically and formally? What if we were to imagine that—contra Rodman's insistence that they "don't know who built the plug-ins" and that it was an unknown "Internet offer"—they were aware that at issue was the Electronic Arts' *Battlefield 2: Special Forces* add-on module, and could in fact discern the difference between an add-on and mod?[38] Would this not, then, be a cunning misappropriation and misuse of the fan film as a form of counter propaganda, necessitating a greater financial, juridical, political, and libidinal investment in the projects of national security and intelligence analysis? Far-fetched it may seem, the stuff of dystopian science fiction, which is precisely why counter-appropriation seems a plausible explanation. Or, at the least, we could

say that after the evidentiary claims made during Colin Powell's United Nations presentation on the weapons of mass destruction trailers, cultural critics are well advised to regard governmental analyses of visual materials with a certain skepticism. (It is not surprising that scholars such as Edward Tufte would have been critically interested in the form and content of Powell's evidentiary presentation.)[39]

Regardless, the incident of the video introduces a model of the "enemy" as at once amateur and professional, primitive and technologized. During the congressional hearings, the contractors emphasized simultaneously the "oral tradition" and the technological capacity of terrorist groups: "They're using that distribution network as a modern form of oral tradition, if you will."[40] SonicJihad claims not to have tech skills—"I can't even get my own computer to work," he protests—and it is notable that he used a trial version of the video capture software Fraps to produce his fan film, which includes the prominent warning "Digital Media Converter Trial Version. Please Register." Such would be the expected sign of an enemy that has been constructed as ad hoc, low-tech, nonstatist, and therefore underfinanced, on the one hand, yet, on the other, part of a coordinated, savvy, and technologically sophisticated "media committee" that stays on message. The fear of a mediatized enemy, of distributed terrorist cells and networks, is brought to the fore in the first report outlining the Bush administration's doctrine of U.S. national security one year after the 9/11 attacks: *"Shadowy networks* of individuals can bring great chaos and suffering to our shores for less than it costs to purchase a single tank. Terrorists are organized to penetrate open societies and to turn the power of modern technologies against us" (italics mine).[41] This in a nutshell is the narrative of the new generation of warfare: we have moved from great armies who bring their own formidable weaponry to the battlefield to the "shadowy networks" primitive enough to need to modify the West's technology and skilled enough to do it.

It makes intuitive sense, then, that Rodman would emphasize the threat of modding during the hearing: "What we do see is that any video game that comes out, as soon as the code is released, they will modify it and change the game for their needs."[42] Of course, as JulieB and then numerous others pointed out, SonicJihad's fan film was not a mod; rather, the first-person perspective shifts between that of the MEC (Middle Eastern

Coalition) and the U.S. Marine Corps. Switching sides, as it were, and playing from the position of "terrorist" in games such as *Counter-Strike* is common practice, and the release of *BF2: Special Forces* made it possible as well to play from the perspective of "insurgent"; in multiplayer situations, you choose among four forces. The threat perceived by the contractors is what Alexander Galloway might identify as the realism of the first-person perspective, which first establishes a connection between the social reality of the gamer and the subject position of the game.[43] That identificatory alignment makes possible a certain illicit seduction, as one of the contractors suggests: "you can see where the games are set to psychologically condition you to go kill coalition forces."[44] The misidentification of the video and the subsequent erroneous report by Reuters prompted media outlets such as the Australian Media Watch to attempt to induce a certain shame or at least humility on the part of the Department of Defense. In response to a program organizer's query, however, Lt. Col. Barry Venable continued to insist on the threat to national security posed by those we might call digihadists:

> Who made the game modification or why they made it is irrelevant to the point of the briefing or the aim of our research. What the committee was told [was] that the game modifications, as one part of the larger overall propaganda campaign being executed by these extremist groups on the internet, are BEING USED by extremists (they don't respect intellectual property rights) as a "call to arms" in conjunction with other efforts to elicit sympathy with the extremist cause.[45]

The key word here is "sympathy." As with *The 9/11 Commission Report*, which noted that training "involved using flight simulator computer games [and] viewing movies that featured hijackings," what is at stake are sympathy and identification.[46] Just as the cinematic imagination invites a certain cathexis from the viewer, so, too, does the first-person perspective. Representation, or in this case simulation, paves the way for real experience.

In a *New York Times* editorial following the July 7 attacks in London, Thomas Friedman pursues a speculation floated by the *Wall Street Journal:* al-Qaeda and the London bombers were connected by the Iqra Learning Center in Leeds, the only distributor of Islamic militant video games produced by Islamgames, a U.S.-based company.[47] Friedman is

Islamgames, Ummah Defense I, *2004.*

troubled by the bombers' patronage of the bookstore but even more so by the games themselves: "The video games feature apocalyptic battles between defenders of Islam and opponents. One game, *Ummah Defense I,* has the world 'finally united under the Banner of Islam' in 2114, until a revolt by disbelievers. The player's goal is to seek out and destroy the disbelievers." The "disbelievers," it should be noted, are robots. And, as a member of the Intergalactic Muslim Council, your mission is to defend against the Flying Evil Robot Armada (FERM).

Such is the cultural status of Friedman and the paper of record that the *Slate* columnist Chris Suellentrop set about playing the Islam games in question to weigh in on their significance: "The fact that these games are derivative, look primitive, and aren't very fun to play doesn't mean they're not important. But they're also ideologically untroubling. . . . There's an outside chance that the robots are a metaphor for the Predator drones used by the United States military, but I doubt these games are going for that level of subtlety. It's more likely that the robots are a metaphor for Space Invaders."[48] To use Galloway's terms, a game such as

Ummah Defense I fails to meet the "congruence requirement" in that there is no "fidelity of context that transliterates itself from the social reality of the gamer, through one's thumbs, into the game environment and back again."[49] Robots and infidels, in other words, somehow do not match up.

One game in which there would be such a congruence requirement is *Special Force,* a Hezbollah-produced, open-source 3-D game that simulates attacks against Israeli troops. Claimed to embody "objectively the defeat of the Israeli enemy and the heroic actions taken by heroes of the Islamic Resistance in Lebanon," the game resonates all the more strongly days into the latest war.[50] Its genre is that of the historical war game—it is based on events of 1978 and 1982 and Israeli intervention in southern Lebanon—but in the weight given to 1978, particularly because Hezbollah was not founded until 1982, the game's archive of cultural memory is situated somewhere between realism and revisionism. Such a continuum would be demarcated by *Kuma\War* (a freely downloadable first- and third-person squad-based episodic game that features playable re-creations of real events of the Iraq war) on one end and, on the other, *Daisenryaku 1941* (a PlayStation 2 game in which the player commands the Japanese Imperial Army and tries to guide it to victory).

Special Force is also of a piece with *Under Ash,* a pro-Palestinian traditional first-person shooter made by a programming team in Syria. In this ultimately unwinnable game, in which the "terrorists" are Israelis and "freedom fighters" their enemies, players must destroy Israeli Merkava tanks and save the al-Asqa mosque from arson. The incendiary controversy over radical war games and the real and imagined connections between video games and global terrorism has even led to the parodic British Organisation for the Eradication of Fundamentalist Islamic Videogame Training, which suggests a link between games such as *Counter-Strike* and *Half-Life* and militant Islam. One of the warning signs for concerned parents is typing in the secret code that terrorists use to disguise their communications. An example: "Omg lol u sux0r!! /\11ah pwnsj00 all!!!!1—Literal translation: 'You are all infidels, Allah is God.'"[51] (This is not wholly comic: in his analysis of gaming worlds, even Edward Castronova imagines the possible uses of *Counter-Strike* as a terrorist training tool.)[52] Mocking the pseudoscientific statistical calculation that characterizes such presentations as the congressional

Special Force.

hearing on terrorist use of the Internet (during which percentages of the Web dedicated to adversarial gaming and propaganda were offered), British Organisation for the Eradication of Fundamentalist Islamic Video Game Training (BOEFIVGT) announces: "By our estimates, four out of every six successful recent suicide bombers have played Islamic mods for *Doom* or *Quake*, or downloaded Infidel Blood Jihad 2000 (a popular Web game) within six months of their detonations."[53]

Friedman, though, has a larger point, which is that we are embroiled in a global "war of ideas"—at first glance this has pronounced echoes of both a "hearts and minds" campaign and Huntington's "clash of civilizations"—and that the State Department ought therefore to produce "a quarterly War of Ideas Report, which would focus on those religious leaders and writers who are inciting violence against others." To emphasize the extent to which the war of ideas, the war against terror, the global struggle against violent extremism, or however it is named is being fought on the MIME-Net, I offer two examples. First is a rap video, "Dirty Kuffar," by Sheikh Terra and the Soul Salah Crew, which

was posted to the Web site of Mohammed al-Massari, a Saudi dissident based in the UK.[54] Designed to inspire people to take up a jihad against the West, this video, we might note, would have been a better candidate for the congressional committee hearings, its clear message an exhortation to the faithful to "kill the crusaders" and "be prepared for battle with the infidels." There is a certain paradox to the balaclava-clad rapper with what seems, albeit retroactively, a faint Yorkshire accent holding the Koran with the Syrian flag in the background: the video is clearly embedded in Western culture even as it calls for a crusade against that culture. Al-Massari's claims to the contrary, we might speculate that the video's makers would probably be condemned by those who so believe in a kind of purity that they would view the filmmakers as wholly corrupted by the West.

Although I might seem to be reinforcing the radical religious split of an imagined holy war, the second example is the current phenomenon of extremist Christian games such as *Left Behind: Eternal Forces* (October 2006 release), the mission for which is to "conduct physical and spiritual warfare," in other words, to convert with extreme prejudice.[55] Within the game space, "a breathtaking, authentic depiction of New York City," your targets are all infidels, including modern Christians, who will not convert to evangelical Christianity and die to chants of "Praise the Lord" (the exact double of "Allah Akbar," audio clips of which were included in SonicJihad's video). Progressive as it is, *Eternal Forces* allows you to play either with the Tribulation Force or with the Antichrist's army of Global Community Peacekeepers.

Spectacular as the evangelical *Eternal Forces* promises to be, its powers of propaganda (which are contained for the most part in the backstory and accompanying *Left Behind* novels) will no doubt pale in comparison to the paradigmatic recruiting game: *America's Army,* a freely downloadable first-person shooter released to the public in blockbuster fashion on July 4, 2002, so that "young Americans could explore soldiering in the U.S. Army."[56] Developed by the MOVES Institute of the Naval Postgraduate School (Monterey, California) and initially aimed toward teenagers, *America's Army's* objective was to present an "accurate portrayal of a soldier's experience," to "substitute virtual experiences for vicarious insights," and to give young players an "inside perspective"

Left Behind: Eternal Forces, *2006*.

on what it is like to be a soldier. Players proceed from basic training at Fort Benning, Georgia, to Special Forces Assessment and Selection at Fort Bragg, North Carolina, and are offered both diversionary entertainment and concrete information. In the shift from a draft-based to an all-volunteer military there has been a decline from 30 percent to 10 percent of population with military service, with those numbers concentrated in the lower socioeconomic classes. Absent a sizable, and middle-class, population of veterans able to provide firsthand accounts of military experience, there was a perceived need to find the means by which such information could be transmitted. Enter the multiplayer combat simulation, which at this writing has nearly nine million registered accounts.[57] In the last section of this chapter, I address Joseph DeLappe's *dead-in-Iraq* (March 2006–), an artistic performance and intervention within the game space of *America's Army*. To fully appreciate his audience and the disruptive gesture of his work, it is necessary to understand the scale and cultural positioning of the game itself.

Antiwar Games

If the first U.S. war in the Persian Gulf inaugurated the discourse on war as a game, the second has given us the antiwar game. In a well-known analysis of an interview between Cokie Roberts and General Norman H. Schwarzkopf, Der Derian succinctly captures the cultural logic of the first historical moment. Roberts begins by asking, "Is there any sort of danger that we don't have any sense of the horrors of war—that it's all a game?" Schwarzkopf replies, "There are human lives being lost, and at this stage of the game this is not a time for frivolity." Der Derian seizes on this slip to point out that "in the space of a single sound-bite Schwarzkopf reveals the inability of the military and the public to maintain the distinction between warring and gaming in the age of video."[58] The canonical fictional text here, of course, is Orson Scott Card's *Ender's Game*, which envisioned the collapse of the distinction between war and game long before the bombing of Baghdad appeared to Roberts and CNN viewers worldwide as a video game. Along with Der Derian, Bruce Sterling responded to Gulf War I with a thorough investigative article on "modern Nintendo war" and the convergence of the American military-industrial complex and technologies of simulation and virtual reality.[59] John Naisbitt followed with the phrase "Military-Nintendo Complex," which he coined to describe the synthesis of military computer simulations and computer games.[60] It is also worth mentioning Peter Watkins's film *The Gladiators* (1970) and the strikingly similar call by Stewart Brand in his *II Cybernetic Frontiers* for the development of "softwar," by which he meant the shifting of war activities to separate, enclosed, vaguely gladiatorial arenas. For the perfect metaphor—and literalization—of the imbrication of the military and culture industries, we need look no further than the Unreal game engine, which is the basis of not only *Tactical Iraqi* and *America's Army* but also *BioShock*, *Gears of War*, and numerous other games. Thus is it the case that we have to regard the MIME-Net as a singular entity, from which it is nearly impossible to separate out the component parts.

How do new media artist-activists, particularly those already involved with game production, respond to the figuration of war as itself a game? How does an antiwar game engage the representation of real war games? The "Toywar" is instructive on this issue. Much has been written of the

battle over domain names between etoy, the European artists collective, and eToys, the online retailer, so I will not review that history here; but I do want to distill the battle into the image of a virtual attack against a virtual corporation.[61] As Ricardo Dominguez has suggested of the affair, "Electronic civil disobedience is an extremely useful tool when dealing with a *virtual* organization that is *only* virtual."[62] When one's targets are networked rather than physical and grounded, in other words, the battle has to be taken to the network. For this reason, antiwar games operate in the virtual space of war.

Various terms have been deployed to describe the category that would hold together Dominguez's *Turista Fronterizo*, Fajardo's *Crosser* and *La Migra*, and the games I address in this section: "games with an agenda," "games with a conscience," "political games," "consequential games," "serious games."[63] Regardless of nomenclature, "persuasive gaming" contains a political critique in the simulation rules. The game mechanics, in other words, make political arguments. In a co-curated show at the London Curzon Soho (October 2004), Ian Bogost describes "a new generation of artists and activists [who] are using videogames as a way to communicate their views on society, international politics and corporate power."[64] Therein we can see an insistence that games need not function as mere entertainments: just as military sims suture education and entertainment, so, too, does persuasive gaming critically comment on matters such as war, national security, and immigration while still retaining the ludic component.[65] It does so via its "procedural rhetoric," as Bogost describes it, "the way that a videogame embodies ideology in its computational structure."[66] In Bogost's analysis, procedural rhetoric is a technique both for game production and for game analysis. Linguistic and visual rhetorics, he argues, cannot adequately address computational processes—either within games or within software systems. Procedural rhetoric, then, augments an ideological and narratological critique by attending to algorithms, the rules that do not simply generate formal systems but also generate a perspective and a way of thinking about formal systems.[67] With the Tate Online–hosted *agoraXchange* project in mind, we can also look ahead to a moment in which persuasive gaming will perform an even more intricate synthesis of poiesis and praxis by widening its scope from the individual to the group. (*AgoraXchange* is

Natalie Bookchin and Jacqueline Stevens's online community formed for the public discussion and planning of a multiplayer game of global politics "challenging the violence and inequality of our present political system.")[68] At present, then, we have an art practice that is more in the realm of description than prescription. As the Newsgaming team explains, "we will use games and simulations to analyze, debate, comment and editorialize major international news."[69] Persuasive gaming advocates for social change, but it does not run the kind of gaming scenarios possible in sims-type environments.

My first object is Newsgaming's *September 12: A Toy World* (2003), in which players fire missiles onto an unnamed Middle Eastern city. Target sights suggest the precision of surgical strikes, but the target is quite large proportionate to the grid of the city, and the inevitable collateral damage causes civilians to respawn as terrorists, with sounds of wailing accompanying the deaths of civilians and the destruction of buildings. The simulation rules for *September 12* might very well have been taken from William S. Lind's primer for "Guerrilla War 101": "Air power works against you, not for you. It kills lots of people who weren't your enemy, recruiting their relatives, friends and fellow tribesmen to become your enemies. In this kind of war, bombers are as useful as 42 cm. siege mortars."[70] What the game teaches us, in other words, is that neither the game nor the war on terror can be won with the bombing strategies of modern warfare. It violates one of the basic principles of game mechanics, then, by making winning impossible. Indeed, the game designers explain: "This is a simulation. It has no ending. It has already begun. The rules are deadly simple. You can shoot. Or not. This is a simple model you can use to explore some aspects of the war on terror."[71] The basic game mechanics, its "simple model," are such that not playing is the best way to play: a clear antiwar message if there ever were one. But there are more intricate ideas communicated by the game than this basic polemic would imply. For example, the city is laid out, inscribed, on top of a manuscript page, its textuality suggesting its constructedness and the construction of the enemy. The game works closely with the figure of the visible enemy, which can be seen and therefore destroyed. On the one-dimensional space of the map there is no underground, no caves, cellars, or other sites to provide cover from precision-guided munitions and thwart the missions of surveillance and reconnaissance. In this re-

Newsgaming,
September 12:
A Toy World, *2003.*

spect, *September 12* offers the fantasy of optical power, of the ability to keep your target in constant sight, and the fulfillment of a "global vision" promised by satellite and drone technologies.[72] There are further convergences between the game and the discourse on enmity. Within this game space, the enemy proliferates as an anonymous swarm, just as the cells of al-Qaeda are imagined to reproduce. In sum, *September 12* illustrates a model of defense that strikes first against a virtual, unknown, and unknowable enemy.

If we put *September 12* into dialogue with post-9/11 games such as *New York Defender* and *War on Terror,* we can also see a clear inverse relation between the certainty of these "missions" and the inherent uncertainty of war as it has been theorized since Clausewitz. In *New York Defender,* players have to shoot down planes flying toward the twin towers of the World Trade Center. It is impossible to win the game, which in turn suggests the impossibility of a complete defense; as recompense, the game offers the tagline "Use your mouse to fight the feeling of impotence."[73] An ostensible cathartic release is similarly offered by *War on Terror* (December 2001): its three missions against the Taliban include cave reconnaissance, hostage rescue, and an attack on a terrorist camp; a fourth mission asks you to capture Bin Laden by punching him repeatedly in the face, thus offering a mode of hands-on revenge.[74] Again, we can see a relation between the predictable outcomes of these games and the unpredictable outcomes of war, a Deleuzian fantasy of using the virtual to

enact the actual. The vague feelings of gratification at having "won" the war on terror might also offer us a way to understand the ubiquity and cultural fascination with first-person shooters, which, under the academic guise of agency, subjectivity, or interactivity, allow the individual to act out in a seeming triumph of the will over both virtual actants and an environment that is less hermetically sealed than we might be predisposed to think.[75]

A shift in production environments and the use of Flash as authoring tool has made game production both easier and more common. It has also encouraged a cartoon aesthetic and led to the rendering of historically grounded situations and events in 2-D, low-tech game spaces. For example, *Wild West Bank* works with basic game mechanics in whack-a-mole style to portray the difficulties of disengaging the Jewish settlers in Palestinian areas.[76] Produced by Back to Israel, an Israeli antisettlement group, the game's object is to disband the settlements, at times by moving the guards, who respond to their removal with expressions of joy, out of the West Bank. Like *September 12*, the game cannot really be won: the settlements appear with increasing speed and frequency and eventually surround the nomadic Palestinian game characters.[77] A political cartoon it may be, but the material referent, the game designers insist, is itself "not a game." The larger question looms: what does it mean to abstract complex and situated events within the generalized structure of a game space, with its basic logic of antagonism, friend and enemy?[78] What are the consequences and political purposes of this abstraction, which is also a reduction? As I have suggested, the cartoonish game spaces have to do with the production environments and visual rhetoric in circulation now (their aesthetic is more that of the early animated .gif than that of the complex rendering of games such as *America's Army*). But just as the caricature game spaces of Fajardo's *Crosser* and *La Migra* pointed to the constructed category of "migrant," in this context they succeed in highlighting the constructed, one-dimensional categories of "enemy" and "terrorist."

I conclude this section with a look at a persuasive game that has more in common with traditional war games than it does with Space Invaders. *Antiwargame* (Josh On/Future Farmers, 2001) provides a critique of the MIME-Net that unfolds during repeated gameplay.[79] In the character of the U.S. president (either Uncle Sam or Aunt Samantha), the player

Josh On/Future Farmers, Antiwargame, *2001.*

must respond to a terrorist attack by making budgetary allocations to military/business, social spending, and foreign aid. If you make an incorrect move, for example, allocate too much to social spending, you are assassinated. Further, you are instructed to spend more on military/ business or "I can have you removed" so that "we will find a more pliable president." Gameplay has a dynamic, responsive quality, such that a budgetary decision has immediate repercussions: increased spending on military/business produces a patriotic response from the media, and presidential popularity increases with nearly every deployment. Mouseovers allow the player to see the responses of civilians, who seem to be satisfied with increased spending on domestic programs. Further, increased spending on foreign aid causes the media to pronounce your administration as fraudulent. As president, you also have the option of sending those game characters who profess patriotic fervor that ranges from the xenophobic to the merely nationalist into the U.S. Army or National Guard; or you can deploy these characters abroad, where they coalesce, drunk and stoned, in an unnamed country near a spouting oil field. If the structure of cause and effect were insufficient to communicate an argument, conceptual certainty would be communicated by the paratext: if not the game title, then external links to news organizations Democracy Now and Common Dreams and articles in the *International Socialist Review* on Vietnam and U.S. intervention in the Middle East.

The futility of gameplay and the relative simplicity of game mechanics and design in persuasive gaming brings us to the question of the ambiguity and significance of the message. We have seen media projects that stay clearly on message—the evangelical *Left Behind: Eternal Forces* would be an exemplar—and reflect the radical polarization inherent in the war on terror. However much we might labor to locate moments of internal contradiction and ambiguity, we would not be able to explain away the univocality of its mission. We have also seen instances of projects so shot through with irony and ambiguity that they would always resist the pull into certainty. SonicJihad's fan film—with its homage to the visual rhetoric of Michael Bay and its formal and ideological alignment with the first-person perspective of the Middle Eastern Coalition— would be one instance, particularly in that it is not designed with the skill required to impose a univocality, a singular style, or distinctive voice. Last, we have seen projects self-consciously situated on the line between parody and the actual, as with the BOEFIVGT, which require if not a sophisticated at least a time-intensive decoding. Such are the enigmas of persuasive gaming, which require repeated play to achieve the moment of epiphany so well articulated by Espen Aarseth in his study of ergodic texts.[80] Moreover, epiphanies can be false and deceptive, offering us a glimpse of the master hermeneutic key before quickly resolving back into aporia at best and banality at worst.

Visualizing War

My concluding section initially takes us back to one of the key axioms informing Baudrillard's provocative thesis about the Gulf War: the end of the twentieth century was also the end of representation. Although the simulacrum is not necessarily historically situated in his analysis— in theory, one could locate it on the walls of Plato's cave—there is nonetheless a clear sense that the real is now produced by simulation technologies, film, genetic engineering, television, and digital media. I would like, though, to recast the end-of-representation axiom to suggest that its disappearance coincides with the rise of information visualization as an artistic and general practice. In the next chapter, we will see projects devoted to the visualization of finance (market pricing, currency rates),

16 October 2001

John Klima, The Great Game, *October–November 2001.*

Department of Defense ordnance data, and United Nations and World Health Organization statistics. In this chapter, we will address strategies of visualizing casualty counts. In all, the object of visualization practices is data—statistical entities—rather than a concrete or "real" referent. Already abstracted by the time it reaches the artists, this data is paradoxically rematerialized in virtual environments. Information visualization projects concerned with finance can be understood as attempts to make the otherwise mysterious operations of markets generally legible; so, too, visualization projects concerned with war can be understood as attempts to produce an affective response otherwise diminished by the numbing procession of statistics: fatalities, wounded, IED explosions, suicide bombings.

John Klima's project on the war in Afghanistan, *The Great Game* (2001), was one of the first American artistic responses to 9/11 and the subsequent military campaign that neither thematized mourning nor took the razed towers of the World Trade Center as its object. Somewhat in the mode of his earlier *Serbian Skylight* (1999), which also gathered

ordnance data from the Department of Defense, *The Great Game* 3-D map project is generated by DoD records of the bombing campaign in Afghanistan. Updated daily from October 7 through November 25, the putative end of the campaign, *The Great Game* now sequentially displays this information, the daily movement of military weapons and equipment, and the transfer of territorial control from the Taliban to the UN. (As the U.S. military campaign in the Middle East spread to Iraq, Klima developed an "Iraq Expansion Pack & Campaign Maker v1.0" for the project.)[81] When viewed from this historical vantage point, the "game's" adopted directive, the takeover of Kabul and the elimination of the Taliban, structures the sequencing of the information from the military operation and gives it a teleology. The design and layout of Klima's "game" are highly suggestive of military strategy: the viewer is granted an aerial view of the nearly flattened topographical map, which itself evokes a board game. The primary colors and the icons used to signify different weapons systems, equipment, controlled cities, and troops not coincidentally echo the Cold War–era board game *Risk*, the quintessential game of war and global conquest. Since the topographical map can be rotated to alter perspective and approach, the game also assumes the optics of the video game and situates the viewer within the battle to the extent that his or her line of sight approximates that of a participating aircraft. The combined effect of the two game models is that of a caricatured war room made telepresent on one's own computer screen.

 In its echoing of Kipling and the Anglo-Russian battle for imperial and territorial control in Central Asia, which led to the British conquest and occupation of Afghanistan, Klima's title could not be more apt. The resonance of the title also extends to the area of global finance: *The Great Game* is a fantasy stock-market trading game in which the players build competitive portfolios on the UK market without risks, costs, or consequences.[82] In both instances, the gaming metaphor is suggestive of the adventure, skill, rivalry, deal brokering, and insider intelligence that characterize an ongoing contest unfolding with daily maneuvers. The inheritance of the imperial territorial game is the neocolonial game of financial speculation. And real risk is notably absented from both the stock trading game and *The Great Game*. That is to say that Klima's game is not a game at all: one can navigate through the map and recenter

it, but without having any direct effect on the events playing out on the screen.

While he self-consciously works with programmatic aspects of the game (for example, the A* algorithm), Klima's navigational structures do not quite correspond with those of the game, since there are no narratological outcomes.[83] Navigation, in other words, produces not a different event but a different data visualization; for example, one can traverse the map of Afghanistan and change its orientation, but it is not possible to initiate any action. Because the movement of the icons or game pieces across the topographical terrain is driven by the statistics that Klima collected from the DoD daily briefings in the fall of 2001, the viewer is able to watch the progression of the war and choose a certain visual perspective on the events without having a material or even ideological effect on these events. Thus viewer response is not coded into or incorporated into the system. (Similarly, one can navigate through the financial landscape environment in *ecosystm,* but such navigation only changes perspective and not the system itself.) How, then, is the viewer positioned by, and in relation to, the aesthetic-militaristic spectacle of *The Great Game*? Is its paradigm spectatorial or interactive?

Inasmuch as interacting with *The Great Game* involves limited physical engagement and does not produce outcomes that alter the course of action, we might say initially that we are positioned as outsiders, sealed off from the events and from the game itself. Can we, though, be positioned as neutral outsiders, spectators without complicity? In fact, Klima's work demonstrates our engagement in and by the game: we cannot avoid feeling powerless to change the course of it, nor can we avoid our participation in it. Moreover, the game reminds us that we cannot be removed from our position of responsibility for that participation and for our participation in the "old" empire of America. We are its audience, recipients of the communicative messages embodied in the movement of the icons around the game board. We are, then, fundamentally part of the game and not, as we may initially be inclined to believe, mere bystanders.

A physical installation and "epilogue" to *The Great Game* serves further to illustrate this interplay between detachment and involvement, distance and proximity. For two gallery shows in 2002, Klima installed

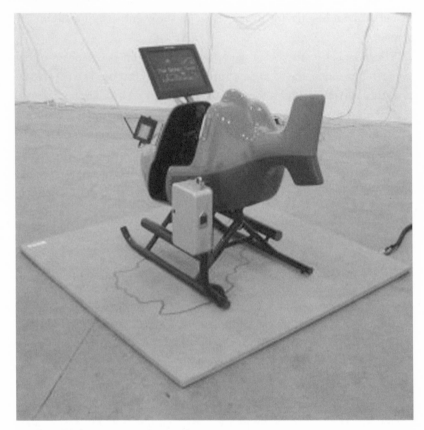

"Epilogue" (The Great Game), *installation view, 2002.*

the *Game* software onto what he calls "a coin-operated 'kiddie ride,'" to which he added video from an F-16 bombing run and a wireless audio track taken from Flight 93, the fourth, diverted plane on 9/11.[84] Situating the viewer in the seat of action in a helicopter, the physical version of *The Great Game* embodies the optics of the video game. The helicopter installation also embodies multiple perspectives in that it provisionally places the participant in the positions of passenger, hijacker, and avenger after the fact. Thus the aerial view over Afghanistan granted from the gallery helicopter ostensibly moves the "game" away from representation and closer to the thing itself. What might appear to be a greater proximity, however, is in fact a greater remove. The closer the viewer

comes to a realized battlefield, the more clearly enveloped he or she becomes by the simulation. In this sense, the board game approaches the real only through its remediation as a video game. Paradoxically, we are further distanced from the real as war moves further into the realm of simulation.

The use of ordnance statistics in *The Great Game* confirms this paradox. While these statistics form an interface for the real and animate the events that we cannot see—as we were able to with the Gulf War—this interface is by no means transparent. Rather, these real events are carefully filtered, processed, and represented. "Security" persists as the concept that legitimates the intricate management of military data: what could be more mediated at this moment than information issued by the Department of Defense? The ordnance statistics constitute a double abstraction: they stand in for the real, yet they are mediated. Klima's *Game* captures this fundamental uncertainty about the authority of the statistics that we receive and reiterates their mediated quality, even to the extent of fostering an ambiguity about the artist's own intervention into the data. As a consequence, the artist and critic Blackhawk notes, "We are asked to define, not perhaps for all time, but for this exact moment how clearly we comprehend the differences between the mediated evidence of the momentous events we are presented with and our own conditioned responses to the media itself and to the games and amusements which increasingly have so many vectors in parallel or actually in common with it."[85] In that Klima inputs statistics from an official channel, he foregrounds mediation. He generates a picture that we know to be incomplete and not readily available, and he does not claim to produce truth with the game. However, he does produce the truth of the impossibility of getting to the truth. In this respect, *The Great Game* enforces a distance from the thing, the event itself, and we are reminded that we lack proximity. As Paul Virilio suggests, telepresence absorbs immediate presence and produces distance:

> Since all presence is presence only at a distance, the tele-presence of the era of the globalization of exchanges could only be established across the widest possible gap. This is a gap which now stretches to the other side of the world, from one edge to the other of present reality. But this is a meta-geophysical reality which strictly regulates the tele-continents of a virtual reality that

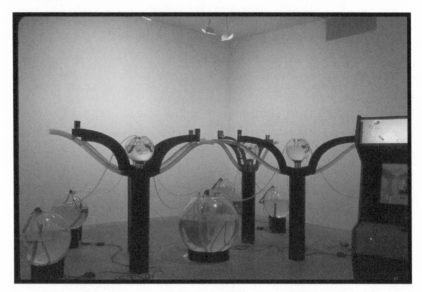

Fish, *installation view,* BitStreams *exhibition, Whitney Museum of American Art, 2001.*

monopolizes the greater part of the economic activity of the nations and, conversely, destroys cultures which are precisely situated in the space of the physics of the globe.[86]

Further, the mediated optics and tele-surveillance of *The Great Game* function as a reminder that the aim of multimedia, as Virilio explains, is "to make the computer screen the ultimate window, but a window which would not so much allow you to receive data as to view the horizon of globalization, the space of its accelerated virtualization" (16).

In contrast to Klima's usual practice of constructing gamelike worlds without actants, characters, or obstacles, the installation *Fish* (2001) invites the viewer to play a video game from the perspective of a virtual goldfish. The gallery notice explains the relationship between this game and the fish tanks to which it is attached:

> Visitors play a video game in which the outcome affects the fate of a real goldfish. A freestanding arcade cabinet is flanked by an elaborate configuration of fish tanks that, with long plastic tubes and tiers of bowls, looks as if it could be from the set of a 1950s science fiction movie. In the game . . . the player is a fish swimming through dangerous waters. Lose, and a goldfish is shot from a

bowl into a tank with menacing oscar fish, which will eat it later at night. Win, and the goldfish heads toward less carnivorous company. Players might pity the victim, but the goldfish must lose out sometimes, or the oscars will die of starvation.... More than that, it may be the reigning moral dilemma in a zero-sum system, where saving one creature means killing another and where one person's calm blue water is another's path to power.[87]

Echoing Matisse's ornate figures of goldfish, Klima denaturalizes them by rendering them in the artificial colors and forms of video game characters.[88] Emily Apter similarly suggests that Klima's work "denaturalizes digital imaging, making the viewer hyper-conscious of the technological mediation of the world and its images; extending the reach of environmental activism and providing ecosystems access to self-representation in a visual form other than landscape or nature pictures."[89] Klima's ecosystems and goldfish are indeed denaturalized, but might we not also read these fish as ultimately naturalized, reinjected into a food chain in which they will eventually be consumed? *Fish* reasserts life as a fundamentally biological, and not juridical or political, category. The moderated death event, the moment of consumption, is almost without interface. In this respect, it serves as an ultimate instance of the link between a representational system and the real.

Fish lays bare the position of responsibility implied by *The Great Game*. Moreover, it confronts the viewer with the individual decisions that are both unavailable and obfuscated in the war game, and thus opens further the issue of complicity. In contrast to the constricted interactivity of Klima's other installations, this work grants the player full responsibility over its outcomes. To play *Fish* is to assume the right to kill, the sovereign power over life and death. It is also to assume the power to determine the value of life: should the oscar fish eat, or should the goldfish die? While this level of control and responsibility may seem quite removed from the inconsequential participation allowed by Klima's other installations, none of his works escape the question of life and death. Rather, the sovereign power over life and death particular to *Fish* embodies the individual responsibility toward which the other installations can only gesture. It thus provides a situated and local instance of a problem manifest in global terms in *The Great Game*.

How do we access the events that lie behind statistics? How do we

cross the impassable gulf that lies between "here" and "there"? What are the artistic strategies befitting the foreigner's inability to grasp the experience of atrocity "over there"? As outsiders to this experience, Susan Sontag suggests, we need images to make the experience of war real. "The understanding of war among people who have not experienced war" is conditioned and constituted through images, the visual sound bites that aid the perception and memory of war.[90] "When there are photographs," she explains, "a war becomes 'real,'" in fact intensifying the reality effect (104). We do not so much remember *through* photographs, however, as remember the photographs themselves, a remembering that eclipses other kinds of understanding (89). Indeed, the war on terror has been fixed in the cultural imaginary by a certain tyranny of the image: Colin Powell's analysis of the two satellite images of the supposed chemical bunkers; the CIA artists' renditions of Iraq's supposed mobile biological weapons labs; the brutal photographs from Abu Ghraib; the framed photographs of the corpse of Al-Zarqawi; videos of beheadings; the shots of the mutilated bodies of the four contractors in Falluja; the circulation of atrocity and porn images through a Web site that I likely do not need to name.[91] Judith Butler pursues the point further to note that recognition and response depend on the photograph: "If there is no photographic evidence, there is no atrocity."[92] In her comment on the Abu Ghraib photographs, Butler takes issue with Sontag's location of ideology and subjectivity in the caption rather than the image itself. Visual culture has a critical role to play during war, Butler argues, which "is to thematize the forcible frame agreeably and eagerly adopted by journalists and photographers who understand themselves aligned with the war effort" (826). The visual frame—the embedded perspective—commands and produces an interpretation, an inflection, a way of seeing; the task of visual culture is to challenge the sense of objective immediacy that would attempt to mask that visual framing.

Our trust in the reality and authenticity of the image has been enforced by what Jordan Crandall has called "transmission vérité," wherein the conditions of production are laid bare to the viewer. Because high production values have become equated with staging, theatricality, and falsity, the production of a reality effect requires the stripping away of aspects of refinement. As Crandall explains, "The hidden substrata of

the technology are reintroduced as part of the content of the image, and a raw immediacy appears to open up a direct access to the real."[93] Mikes will become visible. Handhelds and grainy shots will become common. We will see the camera shake and hear the heavy breathing of the journalist as she runs for a shot. Rather than aestheticism, which is regarded as a kind of subjective intervention, we will have the putative objectivity of seemingly spontaneous, on-the-fly image capture. The irony, of course, is that photographers and documentarians have to be even more deliberate in their visual framing and use of the apparatus, but authenticity has become that which is constructed. Images that do not make their mechanics known are no longer trusted. Thus, Crandall notes, "the reality of representation is substituted for the representation of reality" (218).

In this light, Michael Takeo Magruder's algorithmic composition *Falluja, Iraq, 31/03/2004* makes for a particularly striking intervention (Version 1.0, October 2004; Version 2.0, June 2005).[94] Working with the sensational images of the killing of the four American contractors (mercenaries) by an Iraqi mob in Falluja, Magruder renders these images as computational processes rather than as objects. As they unfold on the screen, the images become occluded by BBC news feeds also describing the events, text that itself becomes a kind of abstract image. In its time-based structure, the project comments on the temporal structure of real-time war reporting, which endeavors to collapse the temporal and material gap between the object, the journalistic framing of the object, and the presentation of that framing. In Magruder's work, we are presented not with a linear movement from event to broadcast but a "reflexive loop" that opens up the possibilities for alteration, for hacking the circuit. Indeed, the audio track of *Falluja, Iraq,* also of news reports, is itself marked by feedback, distortion, and dissonance. It is only slightly outside the conceptual scope of the work, but there is a further significance to the use of algorithmic composition as a mode of representation of war: if war games map out rule-based scenarios and in some sense produce the future, there is something quite suggestive about algorithms that cannot entirely program or manage future outcomes.

Paula Levine's *Shadows from Another Place: San Francisco ←→ Baghdad* similarly departs from a single event: the first bombing campaign in Iraq on March 21, 2003. Developed at the Banff Centre, Alberta

Michael Takeo Magruder, Falluja, Iraq, 31/03/2004, *2005*.

(April–May 2004), Levine's project is an exercise in transpositional ge-
ographies. The *Shadows from Another Place* series poses a fundamental
question: "What if international gestures, such as acts of terrorism or
war, were like boomerangs that returned to sites of origins with an im-
pact equal to the one enacted?" With this speculative question in mind,
San Francisco ⟷ *Baghdad* imaginatively transposes the bomb and
missile attacks on Baghdad onto a map of San Francisco. (The audio
comprises sounds from the same attack.) Taking its cue from local jour-
nalist Herb Caen's naming of San Francisco as "Baghdad by the Bay,"
Levine's project gives the notion of "sister cities" an entirely different
meaning. One of the work's central themes, then, is empathy, as it helps
viewers to imagine themselves in the position of the other. It does so by
using GPS to map the longitude and latitude of each strike on Baghdad
onto matching coordinates in San Francisco, such that a missile attack
on the Presidential Palace hits in the Castro district. Here we might also
mention Alyssa Wright's locative project *Cherry Blossoms* (2006), which
follows on *San Francisco* ⟷ *Baghdad* to perform a similar exercise in
transpositional geography between Baghdad and Boston.[95] The Boston-
area participant dons a backpack outfitted with GPS receiver, micro-
controller, and confetti; when she walks into a space that corresponds
with the site of civilian casualties in Baghdad, her backpack releases

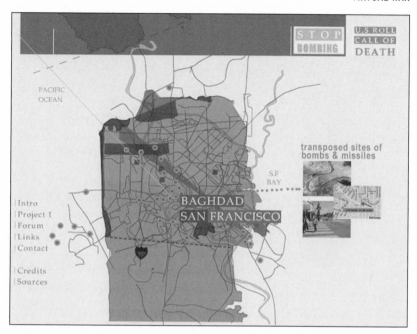

Paula Levine, Shadows from Another Place: San Francisco <=> Baghdad, *2004.*

a cloud of confetti, each piece registering and memorializing a singu-
lar death. Given their use of GPS, these projects cannot fail to invoke
the high-precision bombing afforded by weapons systems such as the
JDAM, air-to-surface smart munitions that contain GPS units reported
to be effective within nine feet with 99 percent accuracy.[96]

JDAM munitions and sorties provide the kind of visual spectacle on
which the MIME-Net feeds. Such is the cynical advantage of a war in
Iraq rather than Afghanistan. Kabul, according to a captain in the U.S.
Navy, was "not a target-rich environment."[97] This sentiment was echoed
or perhaps even suggested by Rumsfeld, who, according to Richard Clarke,
"complained that there were no decent targets for bombing in Afghani-
stan and that we should consider bombing Iraq, which, he said, had bet-
ter targets."[98] The diffused sectarian warfare into which the occupation
of Iraq has evolved has meant that open pyrotechnic displays on the
nightly news have given way to maps recording incidents of insurgent
activity. For such a war, Tim Klimowicz's visualization project *Iraq War
Coalition Fatalities* provides the perfect artistic record.

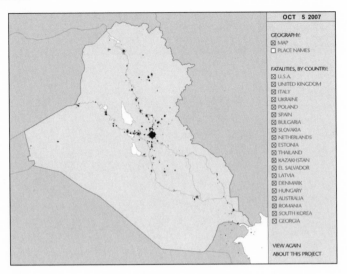

OCT 5 2007

GEOGRAPHY:
☒ MAP
☐ PLACE NAMES

FATALITIES, BY COUNTRY:
☒ U.S.A.
☒ UNITED KINGDOM
☒ ITALY
☒ UKRAINE
☒ POLAND
☒ SPAIN
☒ BULGARIA
☒ SLOVAKIA
☒ NETHERLANDS
☒ ESTONIA
☒ THAILAND
☒ KAZAKHSTAN
☒ EL SALVADOR
☒ LATVIA
☒ DENMARK
☒ HUNGARY
☒ AUSTRALIA
☒ ROMANIA
☒ SOUTH KOREA
☒ GEORGIA

VIEW AGAIN
ABOUT THIS PROJECT

Tim Klimowicz, Iraq War Coalition Fatalities, *2003–.*

Within the minimalist, monochromatic outlines of a map of Iraq, a time-based visualization of the location and date of U.S. and coalition casualties unfolds. A Flash work, it runs at ten frames per second, with each frame representing one day. Each death is registered first as a white flash, then as a red dot that turns to black and fades to gray over the course of thirty days. Each death is also keyed to a muted sound that increases in volume relative to the number of fatalities per day, such that its rhythmic effect is partly that of a typewriter or drumbeat. Audio and visuals combined—the puncturing quality of the dots—suggest that an automatic weapon is riddling the map as if it were a target that will soon be irreparably shredded. Updated regularly with statistics from icasualties.org and geographic data from globalsecurity.org, the project also has a narratological component: over the course of the previous four years, it is possible to trace waves of guerrilla attacks along major arteries and in urban areas and to read the deserts as no-go zones. Klimowicz acknowledges the limitations of these narratives, the incompleteness of his data, and the fallacy of objective reporting. He notes that at the outset, his "goal [was] to encompass the entire war in a single animation," and ultimately he "ended up showing just a tiny sliver of the much larger reality."[99] The scale and complexity of the war are such that a totality of

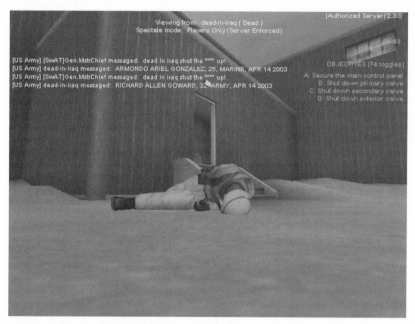

Joseph DeLappe, dead-in-Iraq, *March 2006–.*

representation would be impossible, and indeed numerous queries have
been posed about the decision to visualize coalition rather than Iraqi
casualties. Regardless, that "tiny sliver" manages to communicate dura-
tion, producing a kind of viewing fatigue even at the rate of two years
per minute. Overall, the project's intervention is to counter the statisti-
cal abstraction of casualty lists, to use the data to produce competing
narratives of the war in Iraq, and to memorialize the lives lost. Within
the context of asymmetric warfare and artistic dissent, information vi-
sualization functions as a kind of weapon, one that does not necessarily
excite the passions of recruitment or work through excited, spectacular
presentation. Instead, *Iraq War Coalition Fatalities* is a muted use of in-
formation as a form of memorialization. It works against the spectacular
effects of virtual war and the reality effect of the image. As such, it has
behind it a pronounced ethical and political potential.

So, too, does Joseph DeLappe's *dead-in-Iraq*, an online gaming inter-
vention in *America's Army*.[100] Logging into a server with the call sign
"dead-in-Iraq," DeLappe does not enter the gameplay. Rather, he proceeds

to type—not paste—the name, age, service branch, and date of death of
each U.S. serviceman and woman killed in Iraq. These text messages are
directed toward other players (approximately a dozen at a time), and he
continues to enter the names of soldiers until he is killed or vote kicked,
that is, temporarily banned by the other players. His artistic object is to
list the names of each of the dead for as long as the war continues; as of
October 2007, he had input 3,582 names out of 3,829 reported dead.
As in Klimowicz's *Iraq War Coalition Fatalities*, DeLappe derives the
names and other information from icasualties.org, a pragmatic choice,
but one nonetheless fraught in that the records are fundamentally com-
plete. It is not simply that the calculus is one-sided but also that the
Pentagon data is itself compromised by the exclusion of private contrac-
tors, who are counted as part of the forces in Iraq but not included among
casualty statistics. Indeed, casualty statistics are themselves the subjec-
tive if not outright fictional terrain that must be stabilized as objective
truth to claim the success of the latest surge campaign.[101] Again, in my
reading, both artists, along with Klima, pragmatically accept the data
to contest its inevitable abstraction but do not have a stake in produc-
ing it as categorically true or false. Further, it must be noted that these
projects of memorialization are only materially feasible in the context of
a new warfare that has seen a radical shift in soldier-civilian casualty
ratios—now 1:8—and in this sense they have what we might regard as
manageable limits.[102]

Dead-in-Iraq is of a piece with DeLappe's earlier project, *War Poetry:
Medal of Honor*, in which he entered the game space of *Medal of Honor:
Allied Assault* and proceeded to quote Siegfried Sassoon's poetry: in both
DeLappe works with the theatrical and poetic aspects of text messaging
to puncture the immersive experience of gameplay with an antiwar per-
formance. In *America's Army*, this puncturing is often met with protests
and outrage, such that his text messages are interspersed with expres-
sions of intense vitriol from fellow players; at times he is ignored and at
other times shot.[103] Game spaces are defined by prohibitions, by what
players cannot do rather than what they can. If players were granted
an all-powerful scepter, there would be no agon, no game mechanics.
In such a media environment, social conventions and rules of decorum
are quite often more vigorously enforced. One crucial question raised by

this intervention, then, concerns the public or private nature of a game space. *America's Army* is public in the sense that it was developed with funds from the U.S. Army, but is its game space a digital commons? Is a server a public or a private entity? DeLappe notes that his protest is partly directed against the game itself, which he regards, as do many, as a taxpayer-funded recruitment tool. In this respect, *dead-in-Iraq* is the contemporary equivalent of Vietnam-era protests outside of induction offices. It also invokes the long-term critical art practice of violating social conventions in public spaces, as well as street-based performances from Dada to the Happening. Regardless, DeLappe's activities strike a chord not because of historical precedent but because they draw on, and make manifest, what one might identify as a new conception of privacy, one based on private property and insularity. In other words, that the many assaults on the Fourth Amendment have met with relatively little public outrage tells us not that Americans no longer care about privacy but that we understand privacy differently—as the right not to be disturbed by the demands of others, whether that take the form of spam, telemarketing calls, or game space disruptions.

The site-specific quality of *dead-in-Iraq* should be regarded as a kind of direct engagement that we first saw with the SWARM the Minutemen denial-of-service campaign and that we can also see in the Toywar. It is a critical art practice that leaves the protected space of the museum and gallery to engage "on the site of," to transform the game space, however temporarily. There is no blood in *America's Army*—the army was intent on retaining the Entertainment Software Rating Board's rating of "Teen"—so *dead-in-Iraq* can be read as an intrusion of the real within the space of fantasy gameplay.[104] Moreover, it works with one of the basic rules of *America's Army:* when a player is critically wounded, he or she does not immediately respawn but stays down until the round is reset. In this respect, DeLappe performs a sacrifice each time he logs into the server. Since he does not act in accordance with game mechanics, this is at once an expression of pacifism and a conscientious objection to military campaigns. However, since DeLappe's sacrificial performance to some degree nullifies the ludic component of the game space, we might consider whether this substitutes aesthetics for play. At the conclusion of his book *Gaming,* Galloway notes the tendency in the "countergaming

movement" (Jodi, Anne-Marie Schleiner, et al.) to perform this substitution, which, he argues, nullifies both the political and artistic potential of gaming.[105] Schleiner's intervention within the game space of *Counter Strike*—her *Velvet Strike*, shown at the Whitney biennial (2004)—is not play per se; but it is certainly a performance of dissent, and her treatment of a game space as a composition environment maintains no less a purchase on the political than Galloway's vision of radical games of the future.[106] That is to say, we might reassert the political significance of aesthetic practices such as reverse engineering, the appropriation of gaming software for critical and creative purposes. Witness Critical Art Ensemble and Carbon Defense League's collaborative reverse engineering of a Nintendo Game Boy for their *Super Kid Fighter,* a text-based role-playing game modeled on Wilhelm Reich's writings about children's sexual rights so as to reflect critically on the false Puritanism in the U.S. social context.[107]

So what links projects such as *dead-in-Iraq* and *September 12,* and what can they tell us about the logic of tactical media with respect to war? They are both to a certain extent positioned against play: the best way to play the persuasive game *September 12* is, as I have noted, not to play; and DeLappe's intervention, though confined, of course, to the early rounds of the game, has the effect of disrupting, interrupting, and thwarting play. Play, after all, is structured by rules of engagement, by protocols. But we can push further: what we see from these two projects is not necessarily an attempt to cease play but a kind of play against play. Or to put this another way, they provide instances of playing to strip play, to the extent that one can, of its militarized content. How to work against the state's co-opting not only of the content but also of the actual activity of play remains itself the objective for more tactical operations.

Suffice it to say that *dead-in-Iraq* is so provocative as to necessitate DeLappe's reminding his commentators that his object is not only disruption but also memorialization. The dead, "have been forgotten," he insists, so "the piece is intended as a memorial and a protest. . . . Part of it was thinking about the nature of what is a memorial. . . . A memorial is to remember sacrifice and heroism and death. Why wait for when it's [the war] over? Why not do it now?"[108] Memorials, as James E. Young has explained, become meaningful when viewers engage with them: in that the

hermeneutic, historical, and aesthetic significance of memorials is pro-
duced by the viewer's interaction with that object, they are processual
objects.[109] The process of memorialization situates events in temporal
sequence, bringing them "into some cognitive order."[110] Notwithstanding
the revivifying capacity of memory, the physical memorial is fixed and
subject to a certain stasis. On the other hand, the new media memorials
I discuss here are dynamic, both in the sense that they are continuous
performances and in the sense that they are computable. In that docu-
mentation will continue for the duration of the war, their temporality is
not that of the retrospective but that of a real-time, continuous present.
The *Iraq War Coalition Fatalities* project is continuous in another sense:
unlike the memorial that records the names of the dead, here the deaths
themselves generate their own memorial in that the statistics make up
the data feed that produces the work. It is precisely the aesthetics and
politics of information visualization that I move now to address in the
next chapter.

3. Speculative Capital: *Black Shoals* and the Visualizing of Finance

> Instead of creating a computer model of a market, ecosystem or computer network, by using a small set of mathematical functions (that capture the behavior of an idealized whole), we need to create virtual environments in which we can unleash a population of virtual animals and plants, buyers and sellers, or clients and servers, and then to let these creatures interact and allow the self-organized whole to emerge spontaneously.
>
> —MANUEL DE LANDA

Virtual Money

Exhibit A for this chapter is Laura Kurgan's *Global Clock No. 1* (2000), which provides a temporal interface for currency exchange rates of the dollar, euro, and yen at the turn of the millennium.[1] Using a Reuters data feed, the clock visualizes the shifts in exchange value during the densest five-minute periods of trading activity from the last business day of 1999 and the first of 2000. As it is with the market itself, the value of each currency is established not by reference to some entity outside the system but only through its fluctuating relation to the others. In its foregrounding of "the luminous immateriality of money and its mutable media," as Kurgan describes it, the clock is an illustrative and literal instance of millennial capitalism in operation.[2]

Millennial capitalism is one of a series of names for a new economic and epistemological order in which money capital is said to have "reached its ultimate dematerialization, as messages pass instantaneously from one nodal point to another across the former globe, the former material world."[3] With its multilingual commentary on capital as a series of transactional messages, *Global Clock* establishes a direct relation between linguistic exchange and monetary exchange. Moreover, as the

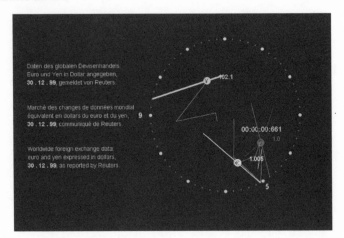

Laura Kurgan, Global Clock No. 1, *2000.*

Jenny Holzer–like scrolling text of *Global Clock* announces in English, French, and German: "The universally recognized temporal grid—the clock—to some degree literalizes this instantaneity by allowing transactions to occur in a common virtual space regardless of geography."[4] The approximate effect of the instantaneity and dematerialization of monetary exchange is also produced by the compression and acceleration of the ten minutes of trading activity. The clock, however, also serves as a reminder of the difference between the temporal scope of the project and the temporal scope of the user's experience of the project, a difference that reinstantiates geography and materiality.

Exhibit B, the primary evidence, is Lise Autogena and Joshua Portway's *Black Shoals: Stock Market Planetarium,* which uses real-time market data to visualize the market as an astronomic system that is both complex and adaptive.[5] In development since 1998, the project has been installed twice: as part of the Tate Britain *Art and Money Online* exhibit (2001) and at the Nikolaj Contemporary Art Center (2004), where it was cosponsored by the Copenhagen Stock Exchange. Deriving its title from Myron Scholes and Robert Merton's formula for pricing derivatives, the planetarium is an immersive virtual environment programmed with Reuters data feeds from the FTSE 100 and CAC 40 indices, as well as from the NASDAQ. (Because the planetarium provided real-time finan-

Lise Autogena and Joshua Portway, Black Shoals: Stock Market Planetarium, *installation view, 2001.*

cial information, albeit in figurative form, the artists had to obtain security clearance from all of the major stock exchanges.) The gallery installation at the Tate, with its high domed ceiling, reinforces the viewer's sense of smallness in relation to the simulated universe and thus introduces a certain self-consciousness about his or her relation to the work. When confronted with what is actually on display, a skyscape of financial data the scope of which one cannot cognitively grasp, one might then experience something like the sublimity of a complex numerical system.[6] Through the homonymic play of "Scholes" and "Shoals," however, the project suggests the inverse: shallow shores where one can perceive, and read, the assembled mass of four thousand stars, which in this case were indexed to the top publicly traded companies on the London Stock Exchange. (Due to their concern that the installation might function as a trading hall, however, Reuters prohibited the naming of the stars in the Tate exhibit.)

The allegory of the planetarium thus offers a kind of telescopic lens that brings the market into view: in this regard, the project is situated on the line between representation and information visualization. Arranged

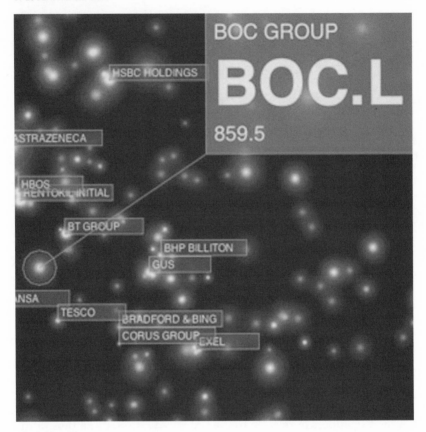

Black Shoals.

in constellations based on market sector or corporate relations, such as the "Enron nova" or the "biotech cluster," the stars produce light and energy in relation to trading activity: "Starbursts are generated whenever trades for an individual company are received from the market, leading to cascades of illumination when live news events trigger trading activity in the various clusters."[7] Enron, then, would have gone nova in the fall of 2001. The astronomic paradigm makes such corporate implosions all the more spectacular and also provokes more complicated questions about referentiality. We might notice, for example, that constellations such as the Enron cluster appear to be figurative but, like the big Dipper, can only allude to a figure that is itself figurative, an abstraction of the real perfectly suitable for a moment in which value is produced by ever

Enron-nova

Biotech cluster

Black Shoals.

less visible processes. Enron, after all, sold not only energy itself but also the licensing of energy, Jeffrey Skilling's "big idea" being the transformation of energy from a material entity into a financial instrument and the creation of a stock market for natural gas.[8]

To begin to understand the significance of *Black Shoals*, we might first ask how its visualization of capital differs from that of Martin Wattenberg's SmartMoney *Map of the Market*, a visualization tool for five hundred publicly traded companies.[9] What does its modality of financial data visualization communicate that one could not locate in Wattenberg's map or in a rendering of quantitative information informed by Edward Tufte, a comparably aestheticized and interpretative display of data along horizontal and vertical axes designed to facilitate legibility without

SmartMoney,
Map of the
Market.

sacrificing wonder? Both reflect the abstraction inherent in networked financial exchanges, particularly in the case of derivatives. But the one-to-one equivalences of Wattenberg's commissioned work operate within a modernist representational aesthetic that differs from the allegorical, postmodernist, and critically reflective and self-reflexive aesthetic of *Black Shoals*. Both use financial statistics to generate a design, but, as we will see in this chapter, *Black Shoals* is not only an allegorical project but also one that incorporates ALife creatures that use the energy emitted by the stars to survive and grow. As Cefn Hoile, the designer of the evolving creatures, notes, "the ecosystem in which they are embedded implements a decentralized evolutionary algorithm, applying competitive selective pressure to the population through conservation of energy. It also couples them to a larger complex system. The opportunities in their world derive from real time stock market information."[10] In this respect, the project also provokes questions about the feedback circuit that links a system to its environment.

In the translation of numerical data to figurative entity, we can locate the signs of critical reflection. It is with the issue of critical reflection that I want primarily to situate a difference between a visualization tool and the work of art. In this chapter, we will see how some computational artists critique, use, and also reflect the speculative mechanism that underlies and operates informational capitalism. Indeed, my contention will be that we should think of computational artists themselves

as speculators or at least as engaging with the practices of speculation. These speculative practices include not only information visualization but also the composition of computational and algorithmic works that surrender some artistic control over the outcomes. What differentiates this form of artistic speculation (i.e., intellectual examination) from that of capitalist speculation is that these artworks are not only generative but intellectually responsive to unrestricted capitalist circulation. Their meditation on the abstract qualities and material consequences of finance capitalism is at once critical intervention and cultural critique. In that these projects attempt to make the mysterious workings of financial capitalism comprehensible to the viewer, we can also understand them to be participating in a Deleuzian project of using the virtual to enact the actual. That is to say, the old axioms about the material significance of models and narrative frames apply: with critically reflective visualization tactics, we might produce countersimulations and, as a result, new modes of understanding the past and imagining the futures of finance capitalism.

How is it that new media art and the critical discourse on finance capital alike might reflect a plurality of possible futures, an openness to the unexpected and to social change? Both discourses or fields have had practical and theoretical recourse to the principle of complexity. Cellular automata and self-organizing systems hold a certain fascination for data visualization artists in particular and allow them to imagine data systems that are truly dynamic: the algorithmically generated forms of Casey Reas would be one example.[11] Likewise, economists and political scientists might equate the movements of financial markets to emergent behaviors or, like Manuel De Landa, call for the development of new economic paradigms informed by theories of self-organization so as to think more productively about social change.[12] The point of correspondence between the two discourses is that of agency: just as it can be said that "there is no one entity which controls the workings of the entire market," so, too, can it be said that the work of new media art is to some degree autogenerative, with control and performance no longer the exclusive provenance of producer and user. Instead of a programmed system with a centered, controlling agency, we have a programmable system with spontaneous interactions among users and machines, clients and servers.

Another point of correspondence between the two discourses, therefore, is the distributed network as both literal entity and organizational model. It is not simply that there are correlations between neoliberal globalization and new media art, or that the one provides the context, the tools, and the need for the other, but that the writers and artists considered in this chapter present a critique of informational capitalism, even as they are caught up within its very logic.

New media art that represents or otherwise addresses the actual operations of financial markets requires a certain economic literacy from its audience. Indeed, much of what follows in this chapter—the evidentiary presentation—will be precisely the kind of historiographic and critical labor these works demand. Their work is not only reflective but also educative. When viewed as a "mere" planetarium, a visual spectacle, as Julian Stallabrass notes, *Black Shoals* might risk "participating in the regular run of art-world entertainment, comprising works that 'raise' issues without ever saying much interesting about them." But *Black Shoals,* along with John Klima's *ecosystm,* Kurgan's clock, and Lynn Hershman Leeson's *Synthia,* demand that we engage with the intricacies of capital. They gesture in two directions: toward making markets as complex systems legible and within our reach and toward the impossibility of our ever being able to perceive and manage the totality of these complex systems.

Can the new media art projects concerned with finance capital go further and actually disrupt the imposing of the structure of capital on the world? I say disrupt rather than defeat because the question need not depend on a particular understanding of capital either as inventive, fluid, and adaptive, as Deleuze would have it, or as inherently reactive to the contrasting power of the multitude, as Hardt and Negri suggest.[13] One possibly attainable endgame, that is, would not be to destroy capital but to disrupt or obstruct its progress. We might say, then, that artists who visualize financial data are particularly well positioned to, so to speak, beat capital at its own game, which would require anticipating and "decoding its flows."[14] As with Klima's work, the aesthetic of *Black Shoals* and related financial visualization projects must be understood to be grounded in the material realities of global capitalism. In his study of contemporary art and money, Olav Velthuis has coined the phrase "imaginary economics" to speak of the communication of alternative eco-

nomic knowledge via the visual arts. Imaginary economics "goes beyond observation and description," he explains. "It sooner opts for a strategy of imitation, simulation, magnification and parody."[15] It is in these terms that we can understand *Black Shoals* and the other visualizations of finance: the work their art performs is perhaps less disruptive and interruptive than it is interpretative, but we can understand that interpretative gesture as itself a kind of interruption. Their allegorical renderings of finance capital offer us a different set of narratives and paradigms with which to see the present and imagine alternative futures.

Ecosystems

John Klima is most widely known for two works, *The Great Game*, which I addressed in chapter 2, and *ecosystm*. Commissioned by Zurich Capital Markets, New York, exhibited in the Whitney Museum, and reviewed in *Business Week* and *Forbes*, this large-scale and site-specific work generates a simulated ecosystem out of real-time global market data. In this respect, it gives capital a graphic quality and renders money as an aesthetic object. *Ecosystm*'s display consists of virtual birdlike creatures whose movement occurs in relation to the value of different currencies, and the work includes a joystick that allows the viewer to navigate the environment, its terrain dotted with trees representing global stock market indexes.[16] The real-time currency data that animates the flocks of birds comes from the CNN Web site, rendering a continuous visual picture of global capitalism. Klima describes the ongoing evolution of the quasi-biological financial system:

> In *ecosystm*, daily volatility determines the territory the flock occupies. If a currency is stable, the flock has an expansive territory and can fly throughout it in a graceful manner. If, however, the currency is volatile, the flock becomes very "excited", and their available territory is considerably reduced in size. . . . If the daily volatility exceeds twice the yearly volatility, the flock is "hungry" and it "feeds" on its country's leading market index (as represented by the trees). If the daily volatility exceeds three times the yearly, the flock becomes "aggressive" and attacks a neighboring flock.[17]

This is digital Darwinism at work: in this ecosystem, which is at once ecological and economic, the strongest and most stable flocks survive and expand, as does their food supply (the trees as leading market

index). With a suggestion, too, of ALife and self-evolution, Klima's work is situated within a discourse linking economics and biology.[18] In the *ecosystm* environment, "strong" trees and stable, if not expansive, territorial boundaries suggest economic power. A stable currency allows for the imperial expansion of the birds; stability is the condition of possibility for the movement of one national economic system into the territory of another. In that the flocks of birds—embodying national currencies—have no fixed ties to the landscape, the *ecosystm* environment can be read as an implicit challenge to the spatializing of money described and predicted by optimum currency area (OCA) theory, the predominant economic paradigm used to consider monetary geography.[19] Moreover, *ecosystm* suggests a species body whose regime and mechanism of control are not individuating discipline but a biopolitics of the population. To follow the paradigms of power charted by Foucault, power over life assumes two forms: bodies are disciplined through institutions, and populations are regulated through mechanisms such as public health initiatives, migration patterns, and housing. In this context, the population of virtual creatures is regulated through the global financial market, as, by implication, are we.

As an additional design and conceptual element, Klima introduces real-time weather data from JFK airport into this ecosystem. As he notes, "runway visibility and cloud cover directly affect visibility and cloud layering in *ecosystm*."[20] The use of weather data effectively brings the quasi biological back into the realm of the socioeconomic. As *ecosystm* suggests, it is not optimum environmental conditions that allow the flocks, or currencies, to thrive and grow. Rather, optimum conditions for growth are attributable to the market and the supranational organizations and institutions of the nation-state that assist its functioning. As Hardt and Negri note of the transition from the disciplinary to the control society, "new" imperial command is exercised through political institutions and juridical apparatuses whose objective is essentially the maintenance of global order, that is, a stable and universal peace that allows the normal functioning of the market economy.

ALife research is another general context for the *ecosystm* project. The behavior of Klima's creatures, however, is neither self-stabilizing nor emergent. Rather, the virtual creatures are entirely responsive to speci-

John Klima, ecosystm, *2001. Courtesy of Zurich Capital Markets.*

fied data streams, the currency data with which they are associated (one implication is that life itself might be conceived as a set of responsive processes). *Ecosystm,* then, is composed not of quasi-intelligent, sentient, or animate agents but of animated agents programmed to operate within a delimited environment, the area of much current applied and original ALife research. (*Creatures* and *Tierra* are among the better-known examples.) ALife ecosystems, however, have a kind of naturalistic impulse, an ideology that Klima consciously refuses. This would complicate Emily Apter's reading of his media environments as predicated on the transformation of "raw digital processes" into "naturalist imagery."[21] Although his forms look organic, and the depth perspective of his landscape suggests a horizon, the intensified pastel hues are those of a gaming

environment rather than of a landscape painting. Indeed, the creatures look vaguely militaristic at different moments in their life span. These landscapes, then, are artificial and mathematical rather than ecological. That Klima refuses the naturalistic is evident even from the title, which orthographically separates the mediated, constructed "ecosystm" from the naturalized, organic ecosystem. There is an organicism to the piece, which is highlighted in the *Business Week* review of its theme of "economic Darwinism," yet the virtual birds, generated as they are by the algorithm used for the bird imagery in the movie *Jurassic Park*, are apposite figures for a mediated system.[22] Further, Klima engages with the ideological naturalization of money both latent and manifest within the tradition of the "design" of financial environments (which integrates architecture and landscape architecture), yet he refuses this motivated connection of money and natural ecology.[23]

This is an ecosystem, too, on which the sun never sets. That is, *ecosystm* adheres to the dominant temporal schema now: the time of the global markets. As Virilio notes, the phenomena of telecommunications, telesurveillance, and telepresence all contribute to a "temporal compression," the loss of temporal and time intervals. In their place, we negotiate an alternative temporal structure: world time. "With this false day, produced by the illumination of telecommunications, an artificial sun rises, an emergency lighting system which ushers in a new time: world time, in which the simultaneity of actions should soon gain precedence over their successive character."[24] The colors of *ecosystm* are those of the artificial sun that perpetually illuminate the landscape. The flocks may indeed become so volatile as to contribute to their own extinction, but the global market itself never experiences a systems crash. Its temporal structure is singular, homogeneous, and unified, its unity formed from the integration of all other kinds of time.[25] The display screen used in the Whitney was eight feet square, heightening the effect of immersive enclosure and visually suggesting not only an all-encompassing world time but also the absence of an externality to capital, an outside where labor power is situated. Articulating the idea that there is no outside to capital is one of the hallmarks of the contemporary discourse on globalization, as is manifest in Hardt and Negri's *Empire:* "There is nothing, no 'naked

life,' no external standpoint, that can be posed outside this field perme-
ated by money; nothing escapes money."[26]

In this respect as well, ecosystm offers a fitting visual representation
of finance capital after Bretton Woods. Rather than molded curren-
cies analogically tied to a standard, we have what Deleuze, again in his
commentary on the control society, describes as modulation, "floating
exchange rates, modulations depending on a code setting sample per-
centages for various currencies."[27] The universal market system does
not achieve equilibrium but accomplishes its obverse, metastability.[28]
Indeed, the use of weather data as a stabilizing element serves as a re-
minder of the absent currency standard. But the mobility in this work is
not only that of the continually modulated exchange rate but also that
of capital. In this sense, its allegory encompasses what Fredric Jameson
terms "free-floating capital, in its frantic search for more profitable
investments."[29] Giovanni Arrighi, too, notes that the decoupling of the
dollar from the gold standard and the increased mobility of capital cor-
relate: the "tendency since 1970 has been towards greater geographical
mobility of capital."[30] This is a mediated visual representation of na-
tional economies disturbed out of their "stationary state" and set into
constant motion: volatility, instability, growth, and destruction are all
coexistent and simultaneous.[31] Moreover, the project provides an image
of the plasticity and dynamic aspects of capital and captures the essence
of money as Georg Simmel would describe it: "When money stands still,
it is no longer money according to its specific value and significance. The
effect that it occasionally exerts in a state of repose arises out of an an-
ticipation of its further motion. Money is nothing but the vehicle for a
movement in which everything else that is not in motion is completely
extinguished."[32] With its paradigms of growth, mutation, and hyper-
mobility, ecosystm provides a visual image of the plasticity of capital,
noted by Arrighi, working from the hermeneutic framework of Fernand
Braudel as he analyzes the "long twentieth century" as a particular stage
of capitalist history: "The essential feature of historical capitalism over
its longue durée—that is, over its entire lifetime—has been the 'flexibil-
ity' and 'eclecticism' of capital rather than the concrete forms assumed
by the latter at different places and at different times."[33]

This fundamental logic of finance capital has a precursor in Gertrude Stein's oft-quoted axiom on the durability and perpetuity of money—"The money is always there but the pockets change"—a sentiment accepted as axiomatic even now. It is not just the pockets that change, however, but also the form, matter, and function of capital, as well as its mode of circulation. On this point, the contemporary CEO-turned-financial-guru Walter Wriston suggests that the virtual and immediate changing of pockets in the late twentieth century constitutes a theoretical, essential, and ontological difference, such that money is in fact still here but now has a qualitatively different power of mutability: "The increased volition of money gives you a difference in kind—not just degree. It's like a piece of lead: you put it on your desk, it's a paperweight; put it in a gun, it's a bullet."[34] Although it is not my primary concern here, more substantive academic commentary on the range and targets of these guns is required—on the damage inflicted on "human material" by the mechanisms of production—and this is largely the province of an article by Jerry Harris, who, in the context of an exposé of the operations of informational capitalism, as well as of its comparatively underdocumented material consequences and abuses, hits upon a particularly apt metaphor for the regenerative operation of capital: "Like a man in a sinking ship looking for a way out, capitalism found in information technology a life boat to a new world of profits."[35] It would indeed be a ship seeking passage to a "new world of profits," suggestive as it is of other inaugural moments of Empire and world economy. On the issue of material consequences, I will give Sean Cubitt the final word. His article is roughly coterminous with Harris's and in spite of its presentist rhetoric remains equally pertinent now: "Today we treat the El Niños of uncontrolled speculative capital as just such forces of nature, out of the reach of human command, and mistake global injustice for the necessary nature of global communication. However, it is precisely those who are marginalized and excluded from the immateriality of the information economy who are its final referent, its final content, and its final mediation."[36]

One such discursive feature is the dialectic between materiality and immateriality with particular regard to capital: informational capitalism, as it is articulated in the discourse on Empire, globalization, and

global capital, has produced a certain abstraction. Capital has detached from a concrete, material context and become speculative.[37] Symbolic goods and services have qualitatively superseded material goods. Since the collapse of the Bretton Woods agreement and the decoupling of the dollar from the gold standard, currency no longer circulates with a solid material basis. The referent has been evacuated, the sign now wholly self-referential and circulating in the order of the hyperreal. As Jameson notes of the new economic and epistemological order, "globalization is rather a kind of cyberspace in which money capital has reached its ultimate dematerialization, as messages that pass instantaneously from one nodal point to another across the former globe, the former material world."[38] (We might think of globally networked financial telecommunications systems such as SWIFT as an example of capital as a series of transactional messages.) Imperial territory has also been dematerialized and overcoded by the circuits of Empire.[39] While still conceived in terms of embeddedness, the global city nevertheless also commands a global city function, as the industrial and regional industrial complexes have been replaced by network transactions and "multiple specialized circuits."[40]

In contrast to the many and varied readings of finance capital as nonconcrete, if not immaterial, the photo-essayist Allan Sekula insists on the materiality of the movement of goods, labor, and bodies in his artistic project, which is to represent the "imaginary and material geographies of the advanced capitalist world."[41] Particularly in the series of photographic works focused on the maritime industry, Sekula captures the messy and analog component of finance capitalism: "If the stock market is the site in which the abstract character of money rules, the harbor is the site in which material goods appear in bulk."[42] He writes also of the "slow movement of heavy and necessary things," the "concrete movement of goods," and a "certain stubborn and pessimistic insistence on the primacy of material forces."[43] Very much in sympathy with this position, Zillah Eisenstein juxtaposes the "REAL of hauling water" with the putative immateriality of the flows of cyber-media capital.[44] And in her reading of the "global city," Saskia Sassen similarly comments on the "embeddedness" of place: "Capital even if dematerialized is not simply hypermobile or that trade and investment and information flows are not

only about flows."[45] In their summary review of this very problematic, Andrew Leyshon and Nigel Thrift read information technology and telematics spaces such as the City of London not as abstract and inhuman but as precisely the reverse: information spaces that are distinctly social and comprised of actor networks.[46] Capital may be speculative, they argue, but neither the social nor the human can be thought as dematerialized. Leyshon and Thrift write, further, of the idea that "money is itself a geography," more broadly on the spatial distribution and construction of monetary economies (3). Within the context of these new "geographies of money," whereby space-time relations are reconfigured, Klima's ecosystem virtually evacuates geophysical space and operates at the level of the meta-geophysical, the virtual environment superseding that of the cartographic and the planetary. His mapping projects and financial ecosystems alike are postgeographic, demarcated not by continents but by "tele-continents."[47] Yet the work paradoxically insists on the materiality and material effects of capital and currency.[48] *Ecosystm* thus establishes an explicit relation between the abstraction of currency markets and the material consequences of finance capital.

Given the importance of the viewer to *ecosystm* and indeed to much of Klima's work, a full analysis of its commentary on the materiality of capital should require a site analysis to engage the work and to see how users engage with it. In July 2005 I tried for the last time to enter the lobby of Zurich Capital Markets in New York, in its new headquarters in Washington Square. Zurich Capital Markets, we might remember, commissioned the work in what was a fairly ordinary acquisition of symbolic capital, all the richer, perhaps, for having linked its brand to that of the Whitney. Here, I thought, I would be able to see the installation in its designated site, with an audience not of gallery visitors but of financial workers. After a polite yet heated encounter with the security guards in the lobby—a civil affair of the kind one has with petty officers of the new security state in airports, transport stations, and offices around the United States—I was refused entry. The building and its contents are no longer open to the public, a sign of national security in its privatized form. From this anecdote, we might conclude that Klima's *ecosystm* is situated at a certain moment in the history of finance capitalism. While only recently offering a consuming public a visualization of the power of

financial markets, its inaccessibility at present manifests the forces of privatization and security.

Bionomics

This section takes its cue from a plant, more specifically, from a Yucca plant. Even more specifically, it takes its cue from a Yucca plant connected by electrodes to a computer and fed a strict diet of stock market pricing data. Exhibited as part of the "Best Before" show at Tensta Konsthall in Stockholm, Ola Pehrson's *Yucca Invest Trading Plant* (1999) provided a paradigmatic instance of irrational exuberance at the peak of the millennial dot-com market.[49] The wired plant was set atop a worktable in the gallery, the electric impulses it emitted translated into purchase or sell orders and its successes rewarded with sunlight and water. Currents then become currency: if the plant says buy Enron at $90, one buys. This is at one level a characteristic representation of investment decisions as imbued with a kind of divination, lacking the historicity of the *I Ching* or astrology but nonetheless operating with the same principles of chance, intuition, and the mystical hidden hand. In this respect, the trading plant figures the market "as the nervous and irrational system that it is, in which every decision is dependent on gut feeling as on intellectual and technical calculations."[50] The plant also links organism and market in a symbiotic embrace, as its investment decisions have material consequences for its own welfare. If Enron starts to dip and profits evaporate, water and light are withheld, the effects of a market decline materializing in wilting or yellowing leaves. The trading plant is thus self-generating, wired into a feedback loop with the market and situating organism and market under the paradigm of growth. Pehrson's plant will be the illustrative figure for this component of my analysis, which focuses on the naturalizing of markets as ecosystems such as we see in *Black Shoals* and Klima's *ecosystm*. To understand fully the significance, the critical importance, and the disruptive effect of the ALife creatures in *Black Shoals*, as well as the project's treatment of the feedback loop that links system and environment, we need to delve more deeply into the long-term discourse on the market as self-regulating and homeostatic.

Ola Pehrson, Yucca Invest
Trading Plant, *1999*.

The Black-Scholes formula (also known as option pricing theory and derivatives pricing theory) owes a certain debt to Louis Bachelier, who, even before Einstein, was the first to model Brownian motion in the fluctuations of financial markets. Bachelier's important thesis, "Theory of Speculation" (1900), contributed to the random-walk hypothesis, the notion that changes in stock prices could best be understood in terms of random movements.[51] Popular studies of finance leading up to the 1929 crash often tended to appraise the market as somewhat predictable given proper techniques and careful study—as befits the moment of the "common investor," which saw a flood of titles instructing readers in the "art" and "technique" of speculation.[52] But the notion that one could apply advanced mathematics to finance also gave rise to equilibrium theories of mathematical finance, which hold that risk and return are related to each other. As M. M. Osborne notes in a 1958 paper, "Brownian Motion in the Stock Market": "Common-stock prices, and the value of money can be regarded as an ensemble of decisions in statistical equilibrium, with properties quite analogous to an ensemble of particles in statistical mechanics."[53] For the purposes of my discussion, the introduction to Paul H. Cootner's edited volume *The Random Character of Stock Market Prices*, which brings together the work of Bachelier, Osborne, and other literature on efficient markets and the efficient-market hypothesis, is particularly instructive. Here Andrew Lo speaks to the different theoretical models for the financial markets: "One of the most promising directions is to view financial markets from a biological perspective and, specifically, within an evolutionary framework in which markets, instruments,

institutions and investors interact and evolve dynamically according to the 'law' of economic selection."[54] How this "biological perspective" plays out in the discourse on speculative capital is my particular concern.

Arrighi's analysis of finance capital holds it to be fundamentally cyclical and, as such, "a recurrent phenomenon which has marked the capitalist era from its earliest beginnings in late medieval and early modern Europe."[55] The moment when capital takes flight from production and becomes speculative constitutes its third and final stage. This last and highest stage is recurrent, and the long twentieth century—the title of Arrighi's study—is just one of four systemic cycles of accumulation that he identifies within capital's life span.[56] So it is that we have the basic operational logic of capital for Arrighi: regeneration, a thesis that comes from his exegesis of Marx. According to Marx's formula for capital, value had an "occult" power of self- and automatic expansion, that of being able to augment or "add value to itself." Such a quality of self-reproduction would, in the mid-nineteenth century, almost necessarily be described in quasi-biological terms: so, value "brings forth living offspring, or, at the least, lays golden eggs" and operates in the guise, mode, and form of money so as to bring about "its own spontaneous generation."[57] Marx suggests that value, while always linked to material labor, nonetheless postures as capital and commodity and implicitly emerges as autogenerative and "self-multiplying," as that which lays its own golden eggs.[58] Jameson's amplification of the third stage of Marx's formula, C-M, extends these animal metaphors. In his commentary on the passage from commodity-form to money-form—"it must spend some time as a cocoon before it can take off as a butterfly"—and on Arrighi's own exegesis of this stage, Jameson notes: "Capital itself becomes free-floating. It separates from the concrete context of its productive geography. . . . Now, like the butterfly stirring within the chrysalis, it separates itself from that concrete breeding ground and prepares to take flight."[59]

These biological metaphors for the evolutionary movements of capital are appropriately creative in their vision of birth via metamorphosis and the shedding of a decayed structure, echoing as it does Joseph Schumpeter's famous theory of the birth, regeneration, and essential truth of capital, that of "creative destruction."[60] In concrete terms, creative

destruction suggests the dislodging of one product or process by another, such as the replacement of mimeograph machines by photocopiers. For Schumpeter, capital operates according to a biological process of "industrial mutation," whereby the economic structure "incessantly revolutionizes . . . *from within*, incessantly destroying the old one, incessantly creating a new one."[61] But what exactly is the relation between revolution and a biological paradigm? Schumpeter's formulation suggests that a certain degree of destruction is inherent to any systemic change and that there can be no change without energy, but situating capital within a biological paradigm allows him also to speculate both on genesis and its corollary, termination or degeneration. It places him within a dialectical model of growth and decline.[62] Linking capital to organic matter lends it continuity and coherence on a path from genesis to decay and eventual death. It further suggests a process of self-reproduction, with capital giving birth to its own offspring, laying its own golden eggs, or decomposing and reorganizing its own larval tissues.

Such a vision of autogeneration reaches an apotheosis in Marx's figural reading of commodities and money's power both of accrual and origination, which is part of the same general formula for capital. "However scurvy they may look, or however badly they may smell," he writes, commodities "are in faith and in truth money, inwardly circumcised Jews, and what is more, a wonderful means whereby out of money to make new money."[63] This is of course value's "occult" power: literally hidden, concealed, and secret. Circumcision here may serve as an identificatory marker, but an inward circumcision is also suggestive of Schumpeter's mutation "from within." By implying that the potential for procreation lies almost exclusively within the system, Marx suggests that capital has the capacity, perhaps the genetic material, both to reproduce and to destroy itself.[64]

In chapter 1, I introduced the tension between a territorial and a capitalist logic of power, which we can see in the discourse on finance capital as well. As a strong reminder of the continued material force of imperial and territorial power, for example, Giovanni Arrighi and Beverly Silver ask whether the "phoenix of high finance" will be able to "rule the roost without the support of strong states more effectively than it has in the

past."[65] Mixed avian metaphor notwithstanding, the use of the phoenix as figure is significant because finance capital is continually imagined as emerging in a new form from the ashes, shell, structure, or chrysalis of the old. It is these properties of malleability, mutation, and adaptation that will lead Jameson to link capital to a virus in his reading of Arrighi, wherein he describes the movements of late capitalism in similar terms, with metaphors drawn from biology and genetics: "The system is better seen as a kind of virus (not Arrighi's figure), and its development is something like an epidemic (better still, a rash of epidemics, an epidemic of epidemics)."[66] In the displacement of capital onto a battle of viruses, or their exponential magnification as epidemic, or better still, a plague, there is an attendant promise that capitalism might indeed carry a fatal disease and bear within itself the elements of its own destruction. Michael Pryke and George Allen articulate the potential for disruption in similar terms: monetized time-space is that "through which 'infections' may pass simultaneously."[67] Indeed, the promise of a future vaccination against this infectious disease and the very idea of biological mechanisms of self-protection and self-preservation serve as a screen for the whole repertoire of tactics Armand Mattelart and others have in mind when they speak of resistance to the forces of global media and capital. But as Hardt and Negri suggest via their commentary on the viral spread and regeneration of the imperial order, not only is vaccinating against the global network of capital impossible, but transmittal and contamination are inevitable: *"The age of globalization is the age of universal contagion,"* they note, and the Empire is formed partly "on the basis of its capacity to develop itself more deeply, to be reborn, and to extend itself throughout the biopolitical latticework of world society."[68]

This is the terrain of Michael Rothschild's *Bionomics*, which, as its subtitle, "The Inevitability of Capitalism," suggests, has a certain investment in figuring the financial markets as self-regulating rather than requiring state control. As my discussion so far indicates, Rothschild's study of economics in relation to ecosystems is part of a broader discourse linking corporations and capitalist economies to biological entities and naturalizing financial markets: "Capitalism flourishes wherever it is not suppressed, because it is a naturally occurring phenomenon,"

he notes. It is "the inevitable, natural state of human economic affairs."[69] (Indeed, even De Landa observes that "markets are quite similar to ecosystems in many respects.")[70] Situating information, broadly conceived, as the core unit of complex capitalist and ecosystems and arguing that evolution is the engine driving both biological and economic life, Rothschild develops an extended analogy that suggests that capitalism and the market economy spontaneously emerged at one moment in history and have since been perpetually mutating and self-organizing. The notion that organisms and organizations alike maintain complex internal hierarchies and therefore run themselves legitimates his free-market, anti-regulation stance. In other words, if markets, corporations, and financial systems are complex biological entities (or evolved artificial systems) and thereby internally self-regulating—that is, if "a flexible economic order emerges spontaneously from the chaos of free markets"— then it follows that external rules and regulations are superfluous. The internally self-regulating mechanism is not the genes but "accumulated technical knowledge."[71] In the principles of self-organization in biological systems, free-market ideologists have found their ideal model.

The limitations of organic metaphors within economic discourse have been identified by J. K. Gibson-Graham, who focuses on the representation of the economy as an organic body. In a collaborative study of capitalism "as we know it," Gibson-Graham (Katherine Gibson and Julie Graham writing in one voice) critiques the dominant articulation of capitalism within the Marxian tradition as unified, singular, and totalizing.[72] This tendency to read capitalism as a unified, self-reproducing organism is manifest, Gibson-Graham suggests, in the physiological metaphors used to characterize the economy.[73] Such a reading, in her view, fails to account for capitalism as a "disaggregated and diverse set of practices unevenly distributed across a varied economic landscape."[74] Reconceptualizing capitalism in terms of heterogeneity, fragmentation, and permeability, rather than organic unity, requires that we recognize noncapitalist economic practices, and it also allows for a more widely integrative notion of revolutionary praxis. Such is it the case, then, that Otto Imken would provide this vision of the structures of financial markets, which maintains a similar insistence on multiplicity rather than singularity:

The market has been fetishised by equilibrium-seeking, neo-classical econo-
mists as the magical balance sheet which automatically equalizes supply and
demand, while the anti-market has been simplified as the authoritarian power
of the monarch or elites dictating orders. Instead, the market and anti-market
should be seen as multiplicities, as complex, non-linear dynamics in which real
processes interact and are shaped, coerced and enabled by their either smooth
or striated environment; together composing an environment which is never
fully one type or the other, which is always changing itself.[75]

Why else should we be seeking new economic models, as Gibson-
Graham, De Landa, and Imken all suggest? For this we can turn to
Mark C. Taylor, whose analysis of Long-Term Capital Management will
be important in a later section. At the close of *Confidence Games: Money
and Markets in a World without Redemption,* Taylor notes: "If we have
learned anything from the economic crises of the late 1990s, it is that
models matter. When the models informing policies and guiding strate-
gies are at odds with new emerging realities, the consequences can be
devastating."[76]

To understand further why economic models matter, one need only
consider the intimate connections between neoliberal market ideology
and social Darwinism: both have their roots in Adam Smith, and the pe-
culiar brand of conservatism each espouses not only values the individ-
ual over the community but adamantly opposes the idea of revolutionary
practice as a means of producing social change. In a midcentury analy-
sis that remains strikingly relevant, *Social Darwinism in American
Thought,* Richard Hofstadter is concerned to show why Darwinian poli-
cies in the social sphere were tremendously popular in the early twenti-
eth century.[77] In the decades before the Great Depression, the popularity
and influence of eugenics coincided with the increasing number of immi-
grants and racial minorities in the United States. The culture school of
William James and John Dewey led to certain changes in that there was
a growing institutional investment in the study of the cultural and en-
vironmental, rather than the biological, conditions that shaped an indi-
vidual. However, in our current moment of creationist assault on school
curricula, there is a substantive disconnect between the biological and
the social: the very politicians and right-wing public intellectuals who
offer up creationism and intelligent design as "alternatives" to scientific

Darwinism are simultaneously offering us social Darwinism as a legiti-
mating narrative for neoliberal politics. No need even to give lip service
to the welfare state any longer: if the poor cannot lift themselves up out
of poverty, then of course it is merely natural selection and the survival of
the fittest at work, natural laws that government cannot purport to con-
travene. And if we do not need regulation of either financial markets or
the information society—because these entities are self-regulating and
self-modifying—then we certainly do not need to regulate the environ-
ment either, which, after all, is a natural system. Finally, if the income
gap between the rich and the poor grows wider and the Faustian pact
made by the neoconservatives and fundamentalist Christians intensifies
global political and religious conflicts, then all we are able to do is *just
let it be*. The idea of revolutionary structural transformation, after all,
is anathema to an ideology that holds that competition between races,
societies, and species is a natural, organic process and that social hierar-
chies are genetically predetermined.

The Age of Electronic Networks

The war on terror, and the war on terrorist finance, has brought the op-
eration of networks such as CHIPS under the purview of the National
Security Agency (NSA) and into public view. CHIPS is a private-sector
clearinghouse and money-movement system that handles over 242,000
bank-to-bank transactions and business payments per day, which corre-
lates to an average daily circulation of $1.2 trillion.[78] An electronic sys-
tem that purports to handle over 95 percent of all global dollar payments
must necessarily turn for its administration to software specialists, pro-
grammers, and systems analysts, but in some respects the system au-
thenticates, regulates, and generates itself. It does so partly by assigning
every participant a net position of debit or credit at the end of the day
so as to stabilize the instantaneous movement of stateless money. (The
CHIPS system assigns each participant a universal identification num-
ber [UID] that tracks account and bank information.) The system also
operates as an information database that helps to set monetary value
and coordinates the very financial transactions that it needs to operate.
As the latest NSA controversy has informed us, the worldwide finan-

cial telecommunications system called SWIFT (Society for Worldwide Interbank Financial Telecommunication) functions alongside CHIPS by standardizing and facilitating the automation of payment messages between networked banks. Access to the transaction database would ostensibly allow the Treasury Department and the CIA to track the funding of terrorist cells; it is clear, then, why these networks are primary targets in the war on terrorist finance.[79] The sensation surrounding the *Los Angeles Times* and *New York Times* stories of June 2006 reminds us of the extent to which these networks are meant to be both invisible and self-regulating. That is, everyday life does not require our understanding them. Both systems regulate transactions, financial data, and themselves; both are purely instrumental and commodifiable.[80] As is the case for Claude Shannon's mathematical theory of communication, neither can account for either the creation or the significance of financial information. Both are in a sense meaningless; rather, their function and performance are their meaning.

We might move from this specific instance of economic self-regulation and self-governance to more general conceptions of the operational principles of the global financial markets. Pryke and Allen draw on Georg Simmel's philosophy of money in their analysis of derivatives, the merger of technology and money, speed, and the new forms of money after Bretton Woods, and they suggest that money "has made itself adaptable to a new set of circumstances and, in so doing, seeks to 'impose its rhythm and pace' on the contents and co-ordinates of life."[81] Strongly echoing Lyotard's commentary on the status of truth and knowledge in a postmodern moment, Jean-Marie Guéhenno further argues that functionality constitutes the significance and structure of the principal financial markets, which lack a "clear architecture," generally lack a "territorial logic," and are, as he notes, "increasingly defined by the rules by which they run themselves."[82] Such operationalism is precisely the mode of the network: an autotelic, autogenerative, and autodidactic "smart" system that drives the global economy and provides its most appropriate figure.[83]

Informational capitalism, we might thus conclude, mutates not as an unavoidably communicable virus but as a nonorganic entity whose operative criterion is performativity. Lyotard notes that the computer "could

become the 'dream' instrument for controlling and regulating the mar-. ket system, extended to include knowledge itself and governed exclusively by the performativity principle. In that case, it would inevitably involve the use of terror."[84] The electronic network operates according to the Lyotardian technological performative in that its very nature and truth are constituted by its performance and efficiency.[85] The networked structure of information and technologies exists in the moment of "the great unknown," Arrighi and Silver suggest, and is differentiated and defined by its rules of operation. It has its own operating force, and thus Lyotard's conception of terror is also a necessary component: the function is that which rules the waves. The general belief at the end of the long twentieth century is that capital itself is given to mutation and flexibility, not to self-destruction but to autotelic reproduction and regeneration. This is the mode of the network, which is forced to function or else risk being destroyed. It must perform, not optimally or creatively, but basically. A complex, adaptive network, moreover, retains an inherent plasticity and carries along with it the power to reconstitute itself.

That my own rhetoric in the preceding paragraphs should seem general, that it should eschew the intricacy and specificity of Paul Baran's important research on centralized, decentralized, and distributed networks—and the contemporary discourse on Baran and related Rand research—for the metaphoric and singular network, is conscious.[86] It offers an apposite parallel with the dominant ideology of "cyberspace" in the mid-1990s: digital Darwinism, whether it be manifest as Kevin Kelly's "cyberevolutionism," the figuring of the Internet as a self-evolving, natural system, or Nicholas Negroponte's commentary on the Internet as an "example of something that has evolved with no apparent designer in charge, keeping its shape very much like the formation of a flock of ducks."[87] Digital Darwinism is of a piece with the treatment of the market as an ecosystem: if one conceives of the Internet as an organic entity, one that can regulate itself, then there is no need for government regulation and intervention. In other words, as is manifest in Kevin Kelly's cyberlibertarian treatise, these metaphors are far from disinterested, as many critics have demonstrated. For Kevin Robins and Frank Webster, for example, the ubiquity of the "new biology" in technological utopianism implicitly reinforces the claims that the progress of information technology is inevitable and reinforces the "ideology of industrializa-

tion," which suggests that technology functions as the hidden and neutral hand in social development.[88]

Tiziana Terranova similarly charts the use of organic metaphors in the early work of cyberlibertarians Kelly and Howard Rheingold, attending, for example, to the moment in *Out of Control* when Kelly figures the Internet as "a nest of snakes," and investigating "the rhetoric of the Net as a self-evolving organism, with a 'natural' ecology of its own."[89] For Kelly, military systems, computer networks, and the global financial system alike maintain a complexity that is "taxing our ability to steer them" and thereby require more efficient management strategies (308). Terranova argues that a neobiological discourse was invoked to defend against governmental infringement of privacy rights, as with the Clipper Chip controversy, which would have resulted in encryption standards that allowed governmental access with a universal master key.[90] If virtual communities and the "Information Superhighway" were understood to be self-regulating and self-modifying, however, then regulation would not be necessary: "This 'electronic' evolutionism reshuffles the hundred year old history of evolutionary theory to accommodate netcitizens' demands for decentralization, self-regulation, and independence from institutional intervention."[91] At issue, then, is the control of information flows. Terranova's argument is that informational networks are not internally regulated but in fact constituted and shaped by "external" socioeconomic systems: "Electronic communication, far from being a self-evolving natural system, is history-laden and socially determined. It is also well inside the complex dynamic of economic and cultural stratifications built by another natural, self-evolving system, the market."[92] We might also note that Darwin's theory of evolution did not strictly address changes internal to a species but recognized environmental and ecological factors. The further point here, one alluded to by Terranova and echoed by Slavoj Žižek, is that evolutionary discourse and the naturalization of informational networks occlude the material dynamics of labor and power.[93]

The End of the American Century as We Knew It

In his wide-ranging study of world economies, Fernand Braudel meditates on the periodic movements and conjunctural rhythms of history,

contemplates our existence in both the short and the long term, within periods that precede and outlive us, and then asks whether it is "possible to identify a finite plane or body which, being the site of a movement, fixes its time-span."[94] In other words, can we identify a point of closure, an end, an afterlife—epistemological, temporal, geographic, psychic, or otherwise—perhaps a post-American century, or a fourth wave? Can we say that the American century or U.S. hegemony or U.S. capitalism is an infinitely expanding idiom, or has the idiom and its time expired, its spectacular and apocalyptic conclusion elegiacally captured on tape on September 11? A different version of these questions comes from Arrighi in *The Long Twentieth Century*, in which he addresses the most recent systemic cycle of accumulation, the temporal unit named in the title of the book, and asks whether capitalist history has reached its ends with U.S. capitalism, whether "the structures of U.S. capitalism constitute the ultimate limit of the six centuries-long process through which capitalist power has attained its present, seemingly all-encompassing scale and scope."[95] The answer he gives is no: the ends are more imaginable than realizable, and capitalism will undoubtedly survive in new forms, in new guises.[96] Both its "own spontaneous generation" and its own destruction are, as Arrighi says elsewhere, coded into capital's "genes."[97]

If it is the case, as it is also for Arrighi and Jameson, that capital is bound to inevitable regeneration, doomed to repeat and exhaust the three stages of accumulation, production, and speculation (M-C-M), the question before us is what lies beyond the limit of U.S. capitalism and the American century. The question is even whether they have in fact reached their limit, since one could argue that recent displays of U.S. military power have been compensatory and suggest that U.S. economic and cultural hegemony is coming to an end.[98] With which critical models might we then project along a diachronic axis to imagine the ends and the futures of capital, U.S. capitalism, and historical epoch? An analysis of this problem of the future must necessarily veer into the imaginative rather than the descriptive and, appropriately enough, into speculation.[99] It makes perfect conceptual sense, then, that Arrighi and Beverly Silver together figure the afterlife of U.S. hegemony as "a yet unknown destination."[100] Terence Hopkins and Immanuel Wallerstein also comment on the dynamic and diachronic quality of a historical system, which

"is evolving second by second such that it is never the same at two successive points in time."[101] Further, they suggest that the "trends" that disturb the equilibrium of the system eventually destabilize it in a permanent fashion, in effect creating a "real 'crisis,' meaning a turning point so decisive that the system comes to an end and is replaced by one or more alternative successor systems" (8). The form and content of this crisis—the disequilibrium and bifurcations of the system—is unpredictable and approximately Borgesian: as Hopkins and Wallerstein note, "There is always more than one possibility at this point, and there is no way of determining in advance what the outcome(s) will be. All one can do is assess the likelihood that we are approaching a bifurcation (or are already in the midst of one)" (8–9). It is also the case for Arrighi that the futures of world systems should resemble forking paths, that the regeneration of capital comes with an escape clause, a set of parenthetically noted alternative futures (which I will come to) for the histories and futures of capital. Capitalism's futures, in other words, are marked by a significant degree of indeterminacy. Because the outcomes of capitalist history are essentially unknowable, the moment of its end, its futures, the afterlife, and the subsequent cycle of accumulation have all been thought in terms of crisis, turbulence, unpredictability, chaos.[102]

For both Hobsbawm and Wallerstein, this crisis is prefigured in the upheavals of 1989.[103] And though the outcomes of capitalist history are not determinable in advance, for Arrighi, the ends of capitalism are imaginable in bifurcating apocalyptic visions:

> Finally, to paraphrase Schumpeter, before humanity chokes (or basks) in the dungeon (or paradise) of a post-capitalist world empire or of a post-capitalist world market society, it may well burn up in the horrors (or glories) of the escalating violence that has accompanied the liquidation of the Cold War world order. In this case, capitalist history would also come to an end but by reverting permanently to the systemic chaos from which it began six hundred years ago and which has been reproduced on an ever-increasing scale with each transition.[104] (356)

For Arrighi, as for Braudel in his meditation on the beginnings of world economies, the ends of capitalism haunt it from its inception in the fourteenth century. Schumpeter's rhetoric of internal mutation is apropos here: capitalism bears within itself the elements of its own destruction

and the capacity to bring itself to crisis. Schumpeter's main argument holds that it is the successful and regenerative runs of capitalism, not its crises and failures, that damage and potentially short-circuit it, much like the successful run of the butterfly, which dies shortly after its metamorphosis. The power of this insight notwithstanding, Schumpeter's basic premise about capitalism still holds, even through the doubts of Arrighi and other theorists of late capitalism and economic globalization on the question of its ultimate survival: capitalism "not only never is but never can be stationary."[105] Capitalism's dynamic quality and tendency toward destructive biological shifts were, for Schumpeter, understandable in terms of extreme weather: creative destruction manifests as a "perennial gale."[106] In that he theorized the evolutionary movements of capitalism in terms of cataclysmic discontinuity, then, Schumpeter's organic paradigm was fundamentally unstable.[107]

The rhetoric of "systemic chaos" and of complexity was not available to Schumpeter, but it permeates the discourse on finance capitalism and globalization. For example, Bill Maurer draws on the discourse linking economics to computer science and evolutionary biology to understand the architectures of offshore finance as "complex, networked, evolving, and adaptive systems."[108] As another example, Fernando Coronil similarly critiques the new forms of wealth by citing Bankers Trust CEO Charles Sanford's disquisition on "particle finance," which analogizes the speculative futures of capital to quantum physics and modern biology, with the attendant implication of unpredictability.[109] The discourse of complexity theory has also been incorporated into the discourse on Empire, which, for Hardt and Negri, "cannot be represented by a juridical order, but it nonetheless is an order, an order defined by its virtuality, its dynamism, and its functional inconclusiveness."[110] And for Guéhenno, the age of networks is in fact "the age of complexity . . . an age of incompletion and disequilibrium."[111] Richard Lee also works with the dialectic of order and disequilibrium to outline the conceptual and critical links between computer systems and world systems: "Since the late 1960s, dynamical-systems research has led to a reconceptualization of the world as one of complexity, determinate but unpredictable: order within chaos (strange attractors); order out of chaos (dissipative struc-

tures); visual representation of pathological functions and natural forms exhibiting non-integer dimensions (fractal geometry)."[112]

While a delineation of the analytic conjunctions between scientific paradigms, specifically those related to computer systems, and those of world systems would require a more detailed study, we may say by way of an overview that it seems particularly appropriate that the dynamism and flexibility of financial markets, world system, and network society alike should find their descriptive embodiment in complexity theory: both turn to excess and the remainder, that which cannot be captured by, or forecast within, the system. The global system, in other words, cannot ultimately be contained in, or explained by, discursive structures. Linking system, category, and historical period alike to complexity theory marks a productive and powerful anxiety about both knowing everything and about the unknown. As Manuel Castells notes in *The Power of Identity*, "The turbulence of information flows will keep codes in a constant swirl"—an energy and movement that is nonorganic by interpretation and not by essence.[113] Arrighi, again, performs a similar analysis with his explicative suggestion that capital already has an inherent "'flexibility' and 'eclecticism'" rather than consisting of "concrete forms."[114] Given the sheer range of disciplinary schemata brought to bear on the problem of the "global," it is not surprising that it lacks a certain semantic and analytic clarity, but the more germane and also ubiquitous models for our historical period, the current cycle of accumulation, the world system, and even global culture comment directly on this lack of clarity and suggest that the "global" and the global economy are best understandable in terms of abstraction, elasticity, and unknowability.[115] Such is it the case, then, that the unpredictability, uncertainty, and indistinctness of the "afterlife" of the current cycle of capitalist accumulation—the long twentieth century marked by the ascendance of information as a commodity—would be understandable in terms of complexity theory.[116]

I would be remiss if I were to conclude this section without introducing Jean and John Comaroff's strong critique of economic models based on complexity theory.[117] To think in terms of "particle finance," for example, would be to erase the social. We might still recognize that market behavior

is unknowable, unpredictable, and mystificatory, the Comaroffs suggest, by thinking in terms of the occult. That is, figuring markets in terms of the occult puts it back within the realm of the human; equally important, though not stated in their argument, the occult hearkens back to Marx's notion that value has an "occult" power of self-expansion.[118] Thus economics begins to resemble magic as referentiality falls away and industrial production gives way to finance. In that it has to do with human perception and apprehension of external events and processes, the occult maintains a greater purchase on the social and then is particularly well poised to combat the quintessential neoliberal pronouncement that "there is no such thing as society."[119] So, too, have other critics theorized the IMF and the World Bank as belief systems (Fabricio Sabelli) and capitalism as a religion (Susan George).[120] In these models, we can see a similar investment in maintaining human agency. As I would like to suggest, however, the principle of feedback has no less of a purchase on the social, signifying as it does the intricate relations between a system and its environment, with both wielding the power to impact the other. On this score, it is instructive to turn to George Soros, who has been a vocal critic of the efficient-market hypothesis; as he dryly notes, "the idea that financial markets tend toward such an equilibrium seems to be contradicted by the evidence."[121] What he calls market fundamentalism—the contemporary version of laissez-faire that is a "dangerous" and "convenient ideology for the rich and powerful"— holds that government interference is the only force preventing markets from achieving equilibrium.[122] His alternative paradigm is based on a theory of reflexivity, a feedback loop in a general sense between situation and participants' perception of that situation, and one that alludes as well to Heisenberg's uncertainty principle, Gödel's theorem, and evolutionary systems theory.

Speculative Capital

As I have tried to demonstrate, Marx's philosophical appraisal of the speculative departure of capital from the material conditions of production and circulation lies at the heart of the by-now-extensive discourse on the abstractions of millennial or informational capitalism, which holds

that derivatives are more valuable than physical securities, and symbolic goods and services have qualitatively superseded material goods. Since the collapse of the Bretton Woods agreement and the decoupling of the dollar from the gold standard, currency no longer circulates with a solid material basis; capital instead has become a series of transactional messages. It should, I hope, be patently clear that "speculative departure" does not necessarily suggest that the real conditions of production have been eclipsed. As the expansion of assembly lines makes evident, productive activity has by no means disappeared.[123]

The historical precondition for the moment of speculative capital is the end of international fixed currency standards in the 1970s, when Nixon moved the dollar off the gold standard (August 1971) and the dollar was devalued and exchange rates were henceforth "floated," that is, were determined by markets (1973).[124] But the major shift in financial policy occurred in 1979–80, when Paul Volcker, chairman of the Federal Reserve, broke with Keynesian principles and allowed the markets to control interest rates in an attempt to curb inflation (conventional wisdom also holds that it was not until the Reagan and Thatcher administrations that neoliberal economic policies were adopted and the United States and UK began systematically deregulating and privatizing markets and industries). The end of international fixed currency standards was the beginning of the end of regulating the flows of international capital.[125] The consequence of "a single system of capital and monetary exchange, operating in real time and tying together all financial markets" (103), is that national and supranational monetary policy "have become totally dependent upon the fluctuations of financial markets, which themselves are determined by the anticipated profitability of stocks and bonds" (103). Finance capital is thus read as virtual, mobile, "footloose," even "friction-free."[126] The ascendance of finance over real material goods and the separation of capital from the "concrete context of its productive geography" facilitate this shift from imperial territory to "modulating networks of command."[127]

A quantitative and qualitative shift in the geo-economy was anticipated by Marx in *Grundrisse*. Describing what he called the "velocity of turnover," Marx "showed how speeding up the circulation of capital will actually create more capital, along with a new form of capitalism: not

only an accelerated one, but an economic process less attached to the physical unit value of labour input."[128] In one of his many comments on the dematerialization of money, Žižek notes that "money fetishism will culminate with the passage to its electronic form, when the last traces of its materiality have disappeared—it is only at this stage that it will assume the form of an indestructible spectral presence."[129] Another representative claim for the wholly immaterial aspect of electronic money is made in an early book by Mark C. Taylor: "Electronic money is pure image, which is nothing but the play of fleeting figures on a video screen" (a claim he would no doubt retract after more than a decade of scholarly work on the material traces of electronic data).[130] It is this seeming antinomy of materiality and virtuality that data visualization projects engage. Kurgan's clock and *Black Shoals*, for example, make visible one component of the material substrate of electronic money—light—which is to say that virtual money in the form of encoded data must adhere to physical laws. It moves quickly but never faster than the speed of light, its putative instantaneity belied by the spatiotemporal coordinates of the clock.

Fernando Coronil's critique of the global market and its reduction of material entities to numbers bears repeating here.[131] That the global market absorbs commodities and transforms them into stock market entities has been discussed earlier in the chapter. Such technological rationalization appears to distill the West and the global North into virtual financial networks, but in so doing, it also occludes the real modalities of power. To a certain extent, these new media projects provide visual representations of this logic of the global market, the transformation of material bodies into statistics, assets, even geometric icons. But they also insist on a rematerialization: capital may be speculative, these projects suggest, but neither the social nor the human can be thought as dematerialized. All these works thus establish an explicit relation between the abstraction of markets and the material consequences of finance capital.

This is evident not only in the growth and predatory behavior of the artificial creatures but more strikingly perhaps in Lynn Hershman Leeson's *Synthia* (2000–2002), which inscribes the psychological effects of market fluctuations onto the body of a simulated character who smokes, sleeps, manically dances, and enters into a kind of depressive

state in response to market data from the Dow Jones, NASDAQ, and Russell 2000 indices.[132] First commissioned for the lobby of the Charles Schwab offices in San Francisco, *Synthia* was later modeled on the Edison stock market ticker, with output in the form of a video rather than stock tape. In all versions, the Synthia character exhibits a range of behaviors keyed to 2 percent changes in the market: when elated, she dances or shops at Christian Dior; when depressed, she sits anxiously at her desk, drinks, shops at Goodwill, or goes to bed. What better illustration of the symbiotic relationship between markets and people and of the extent to which capital has become biopolitical? The kinetic temporal interfaces, artificial creatures, and naturalized environments of *Synthia*, John Klima's *ecosystm*, and *Black Shoals* all suggest the flexibility of capital and the continually evolving nature of data, a plasticity that would not necessarily be communicated by a static map of the market. All render the material effects and consequences of the markets visible via a kind of embodiment, whether through Synthia's manic-depressive behavior, the predatory behavior of the flocks of birds in *ecosystm*, or the survivalist tactics of the artificial creatures in *Black Shoals*. In this sense, these projects prompt us to consider the relations between materiality and virtuality not in terms of a historical progression—with money becoming increasingly dematerialized and abstract in the passage from gold to notes to digital bits—but, as Kojin Karatani suggests, in terms of parallax.

Mary Poovey joins Mark C. Taylor in reading Long-Term Capital Management as the imagined fulfillment of the dream to abstract both the form and the content of money. Her essay "Residual Materialities" critiques the historical and contemporary understanding of the shift from materiality to abstraction as a natural progression and ends with a cautionary note about pure speculation, the imagined separation of money from materiality: at risk, Poovey notes, is "our future well-being."[133] To further suspend the teleological and subvert the economic determinism inherent in the historiographic paradigm offered by Alexander Bard and Jan Söderqvist's *Netocracy*—whereby Western socioeconomic systems are understood to have evolved from feudalism to capitalism to informationalism, with land, property, and information as the primary objects of wealth—we can employ the discourses on complexity and emergent

behaviors.[134] Emergence offers a different model of temporality, an alternative to progressivist and linear historical narratives. It also offers an engagement with futurity and a means by which we might imagine the inchoate, indeterminate abyss beyond the long twentieth century. In other words, we might account for the ubiquity of this rhetoric in the discourses on finance capitalism—and account for the significance of a data visualization project that explores the evolution of artificial creatures in relation to finance—by noting that emergence offers an escape from the paralysis of the "now," the now that makes the futures of rights, social demands, and social change seem impossible.

Animaris Speculatrix

We are now ready to return to the most significant component of *Black Shoals:* ALife. With the design assistance of Cefn Hoile, the virtual environment within the planetarium has been populated by artificial and evolving creatures that feed on the stars' energy. The algorithms that drive their evolution reproduce those found in natural environments: to survive, in other words, the organisms must compete with each other for limited resources. As Lise Autogena and Joshua Portway explain:

> The creatures who survive will be those whose behaviour and knowledge about their world allows them to find food more easily. The final results of this process are impossible to predict, but we can guess at the likely course of evolution. It's likely that early on creatures will develop simple "beliefs" about the world—for instance, that a stock which is proving fruitful today will probably also produce food tomorrow. Later, more sophisticated behaviour may emerge, for instance some creatures will probably develop "grazing" techniques—based on the belief that similar stocks (those in the immediate vicinity) will be behaving similarly. Still more sophisticated models may develop—such as the ability to recognise periodic movements or patterns of cause and effect.[135]

To a certain extent, then, the creatures were set loose, created, with the expectation that they would learn to game the market, to coordinate and implement their own rules for growth and development. (Hoile notes, however, that "we were unable to determine if any creatures were able to predict the zones of trading activity. That secret has gone with them to their graves." So we remain well within the realm of speculation.)[136]

Within the context of the virtual planetarium, both the artificial crea-
tures' survival and success on the financial market appear to depend
on the ability to predict and control the system and to manage risk.
Profit with minimal risk was precisely the fantasy offered by the Black-
Scholes formula, which garnered the inventors the Nobel Prize in 1997
and provided Scholes and Robert Merton the rationale for their ill-fated
company, Long-Term Capital Management, whose losses spectacularly
included a billion dollars in two days in 1998.[137] LTCM made one cru-
cial error: in the pursuit of their "vision of zero capitalism and infinite
leverage," the fund managers failed to account for their own effect on
the financial markets.[138] Autogena and Portway speak to the "feedback
effect" in this instance:

> There are many theories about the cause of the crash, but the main reason
> seems to be that their formula had no self-reflexiveness—they didn't take into
> account their own impact on the market. For instance, because they were so
> successful, other investors would copy what they were investing in, which led
> to a kind of "feedback effect" often seen in biological systems. This kind of ef-
> fect is often the precursor to chaos in complexity theory, and the company had
> to ride closer and closer to this edge of chaotic collapse. . . . We saw this story
> as a kind of Icarus parable for those attempting to control complex systems.[139]

In other words, fund managers failed to notice the extent to which
LTCM seemed to make real "Marx's notion of capital as an infinitely
productive self-reflexive loop."[140] Within the context of this visualization
project, we can see a parallel between the LTCM fund managers and the
artificial creatures in the shared impulse to run scenarios on the mar-
ket and attempt to predict future pricing activity. Conventional wisdom
now understands that this kind of predictive simulation exercise has an
actual material effect on the market, and herein lies a crucial distinc-
tion between a colonization of the futures of financial markets (as with
shorting stock) and the creatures' evolution, "the final results" of which
are "impossible to predict."

"Feedback" means that system and environment are both altered as
a result of their interaction.[141] Within a feedback loop, information is
not simply circulated; rather, the environment affects the system (input),
and in turn the system affects the environment (output). Both input
and output are bound up in a loop, such that each in turn receives and

First ALife, Black Shoals, *2001*.

then sends back information that transforms the other. There is a tempo-ral division between the two, but each wields a material, performative, and generative power. Often generally discussed in terms of distortion, dissonance, and interruption, the feedback loop within this particular context might be understood in terms of the interaction between fund and market on the one hand and between the creatures and their vir-tual environment on the other. What we of course should never forget is that, far from being a wholly self-sufficient or hermetic system, what appears to be the purely internal function of the markets that govern the creatures' growth is itself dependent on seemingly invisible but indubi-tably operative sociopolitical forces. In this regard, what we might see in *Black Shoals* is an exemplary instance of Jacques Rancière's critique of

what inhibits the possible work of politics today. As Rancière observes, there is a perception that "the work proper to politics simply [involves] an opportune adaptability in terms of the demands of the world marketplace and the equitable distribution of the profits and costs of this adaptability."[142]

Our historical moment, the speculative stage of finance capital, thus finds its paradigmatic figure in *Black Shoals:* a virtual environment populated by ALife creatures that in effect realizes De Landa's vision of a spontaneously self-organizing model of a financial market. During World War II, Schumpeter suggested that when we are dealing with capitalism, "we are dealing with an organic process."[143] However, sixty-plus intervening years have brought us to a point where we must now consider capitalist processes and financial markets as not inorganic but nonorganic. The nonorganic is a complex system that has energy, movement, and dynamism. It is not biologically alive, but neither is it an inert, inanimate, material structure: it functions like an organic entity, yet it is not. The process by which the creatures came "alive" is instructive.

> The primary results are discernible with the naked eye. Creatures evolved which could coordinate muscular stretching and relaxing with foot control, leading to energy-efficient, natural looking gaits which allowed them to explore and discover pockets of trading activity within the star space. Some creatures developed sensorimotor control, responding to food in their environment by modifying their gait, turning, and heading towards food. A large variety of strategies were seen to emerge.[144]

Dubbed *Animaris Speculatrix,* or "speculating animal," by Hoile, the creatures trace their lineage back to William Grey Walter's *Machina Speculatrix.*[145] Walter, the "pioneer" of ALife, was, as Anders Michelsen persuasively argues, integral to the development of postwar computational research, his robotic tortoise "Elsie" providing the audience of *Scientific American* with an image of the domesticated robot-as-child and Hoile with a model for an artificial creature programmed to seek out light.[146] On this point, too, we might note that stars are precisely that—light, traces of prior presence.[147] The project thus maintains a complex engagement with the seeming antinomy of virtuality and materiality. Because of the physical limitations of disk space, Hoile explains, the population of creatures was deliberately controlled. As a result, "no data

exists on the many thousands of species who lived and died in the dome" and "the results largely remain in the minds of the visitors to the exhibit." *Black Shoals,* then, is ultimately a performance, a quintessential work of virtuosity for which there is no finite, consumable product.

I want to conclude by highlighting one aspect of the critical response to *Black Shoals:* that the project potentially runs the risk of hyperaestheticism, particularly in that gallery viewers do not know quite what to do when first encountering the work. In this respect, the planetarium might be in danger of mimetically reproducing the mysterious operations of capitalism. Might we, though, turn this around and suggest that placing the viewer in a position of uncertainty is precisely the point? And that the project maintains a certain investment in denying the kind of mastery it initially seems to offer (with the capture of all of the world's major stock exchange data feeds in a containable physical space)? The planetarium dome reminds us of galaxies unseen; all we are offered is a kind of astronomic slice. As Jaime Stapleton notes in his response to the project, the biological "model holds out the possibility that it will provide a key that will reduce the messy, discontinuous, contingent and subjective experience of life into a regular, and mappable, set of operations. . . . The promise offered by such a faith is that either through scientific rationality, or the intuition of beauty, an individual may attain a perspective unobtainable to the rest of society, and with it, a measure of power over that society."[148] *Black Shoals* provides an implicit indictment of that conservative promise, that we await the one—a Neo character, perhaps—who is able to see the patterns inherent in the streams of data. Viewers are implicated in the work not only via that fantasy of mastery and via their role as audience members who receive and complete the signifying chain of the performance, but also by the encouragement of an empathetic, identificatory relationship between us and them, viewer and creature:

> It was vital that the viewers were able to empathise with the creatures and their small existence. The creatures' relationship with their artificial world of stars is a mirror image of our relationship with the financial markets—they strive to survive, competing with each other in a world whose complexity they are too simple to fathom. To encourage the viewer to identify with the creatures, lifelike and purposeful behaviours had to emerge.[149]

SPECULATIVE CAPITAL 149

When a viewer enters the space of the planetarium, she is not immediately certain of her place in relation to the (financial) universe and she is presented with a sense of her own inconsequentiality, a sense that the universe has preceded her and will outlast her. She inserts herself within the space of the work then via her identification with the artificial creatures. Or, rather, naming the creatures *Animaris Speculatrix* allows Hoile and the artists to suggest that the viewer empathizes with the creatures not by imagining herself elsewhere but by situating the creatures within the space of the domestic, the human, as was the case with Grey Walter's *Machina Speculatrix*, the robotic tortoise introduced to the world as his child. This sense of domesticating the system, however, is itself illusory because, just as the creatures "strive to survive, competing with each other in a world whose complexity they are too simple to fathom," we as functionaries of the capitalist market are placed in the same position as the creatures themselves. The creatures function according to an evolutionary paradigm, but they lack the reflexivity that allows them to manipulate that paradigm; so, too, we "strive to survive" but lack sufficient reflexivity not to be managed by it at the same time. That is to say, while we may each hold to the illusion of our agency in relation to the market, the illusion of our capacity individually to manage capitalist markets, we are always caught within a paradigm that is too complex and that in effect manages us. It is this overarching insight that lies behind *Black Shoals* as a project.

In what, after all, is a virtuoso performance of the effects of capital, the viewer is a necessarily significant component of the work. As with the figuring of speculative capital as occult, we are reminded in this context of the importance of human perception of financial markets. So, too, we might regard the conceptual weight given to the viewer in light of Paolo Virno's thesis and note that living memory substitutes for extrinsic product. *Black Shoals* does not produce revolutionary change, nor does it offer a formula for the overthrow of capitalism. What it does offer is a socially engaged, participatory, and pedagogical intervention into the discourse on financial markets. As with many of the projects discussed in this book, it is a symbolic performance, a temporary disruption of dominant semiotic regimes.

Coda

By this point, readers will no doubt perceive that tactical media occupies a spectrum ranging from direct action (e.g., denial-of-service attacks and game space interventions) to symbolic performance (e.g., data visualization). There is no absolute distinction between the two poles of the spectrum; instead I suggest we think in terms of gradations of difference. *Black Shoals* is clearly not disruptive in the sense of a full-scale attack on the financial-computing networks that structure contemporary capitalism. Its visualization tactics may not reach the level of action in the most ordinary sense of the word, but in that the project uses capitalist machines against themselves, it is on the way to becoming such. It is tactical media in the sense of virtuosic performance and cultural critique. However, in at least two respects, a project such as *Black Shoals* is possible only with the assistance of the financial markets themselves. Reuters data feeds are extraordinarily expensive, to start, and because the data feeds provided real-time information, security clearance had to be obtained from all exchanges, and the names of the stars had to be omitted from the Tate exhibit.[150] Here we can ask a set of perhaps-familiar questions: How meaningful can such an intervention be from the belly of the beast? What difference does corporate sponsorship make for anti-corporate and anticapitalist art projects? What is the social function of art in the context of late capitalism? What, if any, are the relations between ideologies of the free market and ideologies of aesthetic autonomy?

Such questions might best be addressed through the artworks themselves. *Black Shoals*, again, is a financial visualization wholly embedded within the structures of finance capital. The installation is nothing if not subtle, and my overarching suggestion here is that subtlety and virtuosic technicity can be a kind of tactics. Moreover, my admiration for the subtlety of *Black Shoals* as an aesthetico-political intervention into the discourses and practices of finance capitalism derives from the sense that the possibility for critical awareness under capitalism requires more than ironic consumption, alternative branding, and parodic play, notwithstanding the occasional flash of genius from Adbusters and others. *Black Shoals* is not a withdrawal from markets but a tactical engagement and confrontation on the terrain of capitalist power itself. No doubt there is a long-term tradition of such engagement, and no one is likely to claim

otherwise. Indeed, we might look no further for analogous art practices than to Peter Bürger's commentary on the avant-garde's work within the institutions of art to undermine those very institutions. However, this book is by no means alone in noticing that socially engaged and activist-art practices not only continue to proliferate but also maintain a critical and cultural relevance.[151] What my primary themes—immigration politics, war, capital—should indicate is that these practices, whether written under the sign of art, culture work, or guerrilla tactics, are strongest when informed by, and responsive to, an intellectual discourse that allows them to rise to the level of legitimate cultural critique. In this regard, when we consider the range of countermeasures and counterpressures that can be brought to bear against the neoliberal world order, I do not think we need to balk at evaluative distinctions between the two ends of the tactical media spectrum—between, for example, cybersquatting battles and hoaxes (Etoy, Vaticano.org, GWBush.com) and the algorithmic sophistication of *Black Shoals:* the difference, again, is virtuosity, technological expertise exhibited in a publicly organized space.

While tactical media has clearly evolved from its emergence in the 1990s to the virtuosic art practices of today, there is one important point of continuity: tactical media activities provide models of opposition rather than revolution and aim to undermine a system that, as de Certeau reminds us, "itself remains intact."[152] What I wish to stress is that we need not, and indeed should not, think of political engagement strictly in terms of concrete action, organizational movements, or overt commentary. Such a statement is certainly informed by the kind of sensibility that I articulate in this book's opening lines—that of a generation lacking an uncompromising faith in the efficacy of street-based protest, but well aware of the participatory force of smart mobs, Googlebombing, and peer-to-peer networking. The temporal horizon of tactics by no means obviates the need for strategic campaigns or precludes the possibility of long-term structural transformation. It remains the case, however, that a belief in the possibility of revolution as an event singularly located in space and time has been supplanted by an investment in a multiplicity of actions, practices, performances, and interventions. Tactical media contests the future terrain of the political, but it does so via virtuosic performances deployed and experienced in the present.

Notes

Introduction

The chapter epigraph is from http://www.serpicanaro.com. For brief commentary on the Serpica Naro trademark, brand, political project, and hoax, see Matteo Pasquinelli, "Operation Serpica Naro: Milan Fashion Industry Spoofed by Anti-precarity Activists," Nettime post, February 28, 2005; and "An Assault on Neurospace (Misguided Directions For)," July 2005, http://info.interactivist.net/article.pl?sid=05/07/19/0441211&mode=nested&tid=9&tid=15.

1. http://www.theyrule.net. Also see Next Five Minutes, "Tactical Cartography: Diagrams of Power," http://www.next5minutes.org/article.jsp?articleid=749 (September 2003).

2. One brief anecdotal note will suffice to suggest the extent to which Lombardi's drawings, and by extension *They Rule*, can be regarded simultaneously as "art" and as investigative journalism: after 9/11, the FBI contacted the Whitney to see Lombardi's last work, *BCCI, ICIC & FAB* (1996–2000).

3. On the role of laughter and the carnivalesque in political dissent, see Marieke de Goede, "Carnival of Money: Politics of Dissent in an Era of Globalizing Finance," in *The Global Resistance Reader*, ed. Louise Amoore (London: Routledge, 2005), 379–91.

4. http://turbulence.org/Works/oilstandard.

5. Daniel Bell, *The Coming of Post-industrial Society: A Venture in Social Forecasting* (New York: Penguin Books, 1973); and Manuel Castells, *The Rise of the Network Society* (Oxford: Blackwell, 1996), 18–21, 143–44. In a related analysis, Dan Schiller focuses on the role of neoliberal policies in facilitating "an epochal political-economic transition" into "digital capitalism." See Schiller, *Digital Capitalism: Networking and the Global Market System* (Cambridge, Mass.: MIT Press, 1999), xvii. Nick Dyer-Witheford also points out that the expansion of the global financial markets is "inseparable from the expansion of information technology." Nick Dyer-Witheford, *Cyber-Marx: Cycles and Circuits of Struggle in High-Technology Capitalism* (Urbana:

University of Illinois Press, 1999), 139. The lesson we can glean from these later studies is that privatization policies, particularly of telecommunications networks, have facilitated electronic commerce and laid the foundations for a global network economy.

6. See http://www.molleindustria.org/en/tuboflex.

7. Michael Rush, *New Media in Late Twentieth-Century Art* (London: Thames and Hudson, 1999); Lev Manovich, *The Language of New Media* (Cambridge, Mass.: MIT Press, 2001); Stephen Wilson, *Information Arts: Intersections of Art, Science, and Technology* (Cambridge, Mass.: MIT Press, 2002); Christiane Paul, *Digital Art* (London: Thames and Hudson, 2003); Julian Stallabrass, *Internet Art: The Online Clash of Culture and Commerce* (London: Tate, 2003); Rachel Greene, *Internet Art* (London: Thames and Hudson, 2004); Lucy Kimbell, ed., *New Media Art: Practice and Context in the UK, 1994–2004* (Manchester: Arts Council England, 2004); Bruce Wands, *Art of the Digital Age* (London: Thames and Hudson, 2006); Mark Tribe and Reena Jana, *New Media Art* (London: Taschen, 2006); Joline Blais and Jon Ippolito, *At the Edge of Art* (London: Thames and Hudson, 2006).

8. Representative texts on the topic of network-based activism include Tim Jordan, *Activism! Direct Action, Hacktivism, and the Future of Society* (London: Reaktion Books, 2002); Graham Meikle, *Future Active: Media Activism and the Internet* (New York: Routledge, 2002); Martha McCaughey and Michael D. Ayers, *Cyberactivism: Online Activism in Theory and Practice* (New York: Routledge, 2003). On smart mobs see Howard Rheingold, *Smart Mobs: The Next Social Revolution* (Cambridge: Perseus, 2002); and http://www.smartmobs.com.

9. Critical Art Ensemble, *Digital Resistance: Explorations in Tactical Media* (New York: Autonomedia, 2001), 7.

10. Geert Lovink, *Dark Fiber: Tracking Internet Culture* (Cambridge, MIT Press, 2002), 271.

11. Ibid., 256. The site for the fourth edition of the conference is available at http://www.next5minutes.org/index.jsp. Other festivals and shows devoted to tactical media include Upgrade Montreal (April 2006), http://theupgrade.sat.qc.ca.

12. Critical Art Ensemble, *Digital Resistance*, 5.

13. Lovink, *Dark Fiber*, 258.

14. Critical Art Ensemble, *Digital Resistance*, 8.

15. Critical Art Ensemble, *The Electronic Disturbance* (New York: Autonomedia, 1994), 12.

16. Quoted in Armand Mattelart, *Networking the World, 1794–2000*, trans. Liz Carey-Libbrecht and James A. Cohen (Minneapolis: University of Minnesota Press, 2000), 118.

17. http://bureauit.org/cab.

18. See http://www.critical-art.net/tactical_media/eyebeam/index.html.

19. http://www.netbase.org/t0.

20. http://bureauit.org/kit.

21. http://www.carbondefense.org/projects.html.

22. CAE/CDL, "Child as Participant" video documentation, http://www. carbondefense.org/video/ChildAsParticipant.mov. That a purchase on certain outcomes should be surrendered is similarly indicated by one of Randall Packer's self-reflexive comments as part of his blog-chronicles as secretary-at-large of the U.S. Department of Art and Technology: "I then armed myself against justice, and declared, 'Where Art can contribute to the Perpetual Fight against Authoritarianism, I shall confront the Powers that be.' I announced I would 'see the artistic process through . . . whatever its outcome.'" "A Season in Hell," January 15, 2005, http://www.usdat.us/ secretary/archives/crushed_by_reality.

23. Nathan Martin, "Parasitic Media: Invisibility and Other Forms of Tactical Augmentation," *Subsol*, http://subsol.c3.hu/subsol_2/contributors3/martintext.html.

24. Jon McKenzie and Rebecca Schneider, "Critical Art Ensemble: Tactical Media Practitioners," *TDR: The Drama Review* 44, no. 4 (Winter 2000): 140. Also see Lovink, *Dark Fiber*, 259.

25. Critical Art Ensemble, *Electronic Civil Disobedience and Other Unpopular Ideas* (New York: Autonomedia, 1996), 24.

26. Lovink, *Dark Fiber*, 261.

27. This is not to say that all those who think about and practice tactical media have abandoned both the rhetoric and the idea of revolution. For example, Gene Ray concludes his plea for the reinvigoration of tactical media via a return to thinking about totality and structural transformation: "Proclaiming revolution a dead letter got us nowhere, and to continue to do so now is to condemn in advance all those who have renewed anti-capitalist struggle." Ray, "Tactical Media and the End of the End of History," *Afterimage* 34, nos. 1–2 (2006), revised version at http://www.linksnet.de/ textsicht.php?id=2723.

28. See, for example, Slavoj Žižek and Glyn Daly, *Conversations with Žižek* (London: Polity Press, 2004), 104.

29. Josh On, comment at http://grandtextauto.gatech.edu/2004/05/24/antiwargame.

30. Richard Barbrook and Andy Cameron, "The California Ideology" (August 1995), http://www.alamut.com/subj/ideologies/pessimism/califIdeo_I.html.

31. Critical Art Ensemble, *Electronic Civil Disobedience*, 22.

32. See Michael Hardt and Antonio Negri, *Multitude: War and Democracy in the Age of Empire* (New York: Penguin, 2004), 92; and Paolo Virno, *The Grammar of the Multitude*, trans. Isabella Bertoletti et al. (New York: Semiotext[e], 2004), 25.

33. McKenzie Wark also comments on this aspect of Lovink and Garcia's manifesto in "The Weird Global Media Event and the Tactical Intellectual [Version 3.0]," in *New Media, Old Media*, ed. Wendy Hui Kyong Chun and Thomas Keenan (Cambridge, Mass.: MIT Press, 2006), 273.

34. Lovink, *Dark Fiber*, 257. On this theme of resistance from within, one can clearly see the influence of Michel de Certeau's theorizing of tactics on early practices of tactical media: "Wasting of products, diversion of time, 'la perruque,' turn-over or

inactivity of employees, etc., undermine from within a system which . . . tends to become a form of imprisonment in order to prevent any sort of escape." De Certeau, *The Practice of Everyday Life,* trans. Steven Randall (Berkeley: University of California Press, 1984), 179.

35. John Robb, *Brave New War: The Next Stage of Terrorism and the End of Globalization* (Hoboken, N.J.: John Wiley and Sons, 2007), 96.

36. Alexander Galloway and Eugene Thacker, *The Exploit: A Theory of Networks* (Minneapolis: University of Minnesota Press, 2007), 81.

37. Nicolas Bourriaud, *Relational Aesthetics,* trans. Simon Pleasance and Fronza Woods (Paris: Les Presses du Réel, 2002), 14.

38. Ibid., 61.

39. Critical Art Ensemble, *Digital Resistance,* 9.

40. Ibid., 10.

41. Lovink, *Dark Fiber,* 261, 267.

42. Chris Atton, *An Alternative Internet* (Edinburgh: Edinburgh University Press, 2004).

43. http://www.0100101110101101.org/home/vaticano.org/index.html.

44. For the special issue of *Subsol,* see http://subsol.c3.hu/subsol_2/index.html. Echoes of de Certeau make their way into Mackenzie Wark's *A Hacker Manifesto* (Cambridge, Mass.: Harvard University Press, 2004) as well, particularly in his suggestion that we have "an alternative practice of everyday life" instead of a moment of violent rupture (257).

45. Tactical Media Crew, http://www.tmcrew.org/enghome.htm.

46. "Contestational Robotics: Critical Art Ensemble and the Institute for Applied Autonomy," http://www.appliedautonomy.com/objectors.html.

47. http://www.we-swipe.us.

48. See, for example, "pôle financier," http://bureaudetudes.free.fr/images/banques .gif.

49. Nato Thompson and Gregory Sholette, eds., *The Interventionists* (Cambridge, Mass.: MIT Press, 2004).

50. Neither is my book a regional study necessarily, as is the study of Italian hacktivism and Net art by Tatiana Bazzichelli, founder of the AHA, *Networking: La rete come arte* [Networking: The Net as Artwork] (Milan: Costa and Nolan, 2006).

51. See http://www.vote-auction.net/ and http://www.gwei.org.

52. See http://www.amazon-noir.com/books.html.

53. The two artists translate "Ubermorgen" in these terms on their bio page, http://www.ubermorgen.com/2007/index.html.

54. John Klima, *Political Landscape, Emotional Terrain,* commissioned by the "Mapping Transitions" conference at the University of Colorado (September 2002), http://www.cityarts.com/colorado. Klima's original plan was to use mental health statistics as the index for the emotional map, but these statistics are incomplete.

55. Klima, "Description," *PLET*, http://www.cityarts.com/colorado/release/index .html.

56. The Spritelab has an example of A* in lingo at http://www.spritelab.dk/beta/ Astar.html. For the implementation of the A*, see Elaine Rich and Kevin Knight, *Artificial Intelligence*, 2nd ed. (New York: McGraw Hill, 1991).

57. "Proposal: Mapping Transitions."

58. Michel Foucault, *The History of Sexuality: Volume I*, trans. Robert Hurley (New York: Random House, 1978), 137.

59. Stephen Wilson classifies artistic engagements with science and technology as the "information arts," which encompass robotics and kinetics, ALife, VR, body monitoring, position sensing, AI, telepresence, genetics, algorithms and mathematics, Internet visualization, ecology and physical phenomena, information systems, and telecommunications. *Information Arts: Intersections of Art, Science, and Technology* (Cambridge, Mass.: MIT Press, 2002).

60. See, for example, Lisa Jevbratt, *Out of the Ordinary* and *1:1*, at http://jevbratt .com/projects.html.

61. John Klima, "Proposal: Mapping Transitions" (July 2002), http://www.cityarts .com/colorado/proposal/index.html.

62. John Klima, "Project Description" (January 2002), http://www.cityarts.com/ langlois/teramachine.html#project.

63. The phrase "neoliberal globalization" makes clear that globalization is a political project rather than an inevitability. It suggests economic restructuring, the opening of national economies to the IMF and World Bank, and policies of deregulation and privatization.

64. Gilles Deleuze, "Postscript on Control Societies," in *Negotiations: 1972–1990*, trans. Martin Joughin (New York: Columbia University Press, 1995), 181.

65. Fernando Coronil, "Toward a Critique of Globalcentrism: Speculations on Capitalism's Nature," in *Millennial Capitalism and the Culture of Neoliberalism* (Durham, N.C.: Duke University Press, 2001), 63–87.

66. Fernanda B. Viégas and Martin Wattenberg also suggest such a difference in their coauthored essay "Artistic Data Visualization: Beyond Visual Analytics," http:// www.research.ibm.com/visual/papers/artistic-infovis.pdf.

67. "The ABC of Tactical Media," Nettime post, May 16, 1997.

68. Valdis Krebs, "Political Patterns on the WWW," http://www.orgnet.com/ leftright.html.

69. Hardt and Negri, *Multitude*, 69.

70. See Pit Schultz, "The Final Content," Nettime post, April 4, 1997; Alvin Toffler, *Powershift: Knowledge, Wealth, and Violence at the Edge of the 21st Century* (New York: Bantam, 1990), 75; Geert Lovink, *"Data Trash:* The Theory of the Virtual Class (Arthur Kroker in Conversation)," in *Uncanny Networks: Dialogues with the Virtual Intelligentsia*, by Geert Lovink (Cambridge, Mass.: MIT Press, 2004), 50–57.

71. Michael Hardt and Antonio Negri, *Empire* (Cambridge, Mass.: Harvard University Press, 2000), 211.

72. Benjamin Arditi, *Politics on the Edges of Liberalism* (Edinburgh: Edinburgh University Press, 2007), 104.

73. Perhaps the preeminent cyberlibertarian statement is John Perry Barlow's declaration that national governments have no authority over online communities, the new tribe of the mind. An earlier study of the politics of cyberlibertarianism is *Cyberfutures: Culture and Politics on the Information Superhighway*, ed. Ziauddin Sardar and Jerome Ravetz (London: Pluto Press, 1996).

74. Hakim Bey, *T.A.Z.: The Temporary Autonomous Zone, Ontological Anarchy, Poetic Terrorism* (New York: Autonomedia, 2003), 127.

75. Maurizio Lazzarato, "Time to Back Up?" Knowbotic Research (June 29, 2000), http://io.khm.de/back-up/alles/links.html.

76. Alan Liu, *The Laws of Cool: Knowledge Work and the Culture of Information* (Chicago: University of Chicago Press, 2004), 294.

77. Ibid., 293.

78. Deleuze, "Postscript on Control Societies," 176.

79. See, for example, the call for works reflecting on the theme of "transvergence" at ISEA (International Symposium on Electronic Art) 2006, http://01sj.org/content/view/76/71.

80. Bourriaud, *Relational Aesthetics*, 13.

81. Lovink and Ned Rossiter, "Dawn of the Organised Networks," Nettime, October 17, 2005.

82. Virno, *Grammar of the Multitude*, 52.

83. Hannah Arendt, *Between Past and Future*, quoted in Virno, *Grammar of the Multitude*, 53.

84. Virno, *Grammar of the Multitude*, 53.

85. Pierre Bourdieu, "The Historical Genesis of a Pure Aesthetic," in *The Field of Cultural Production: Essays on Art and Literature* (London: Polity Press, 1993), 254–66.

86. "Precarity" was the term given to the condition of intermittent work at the time of the Marches against Unemployment, Job Insecurity, and Social Exclusion (2000).

1. Border Hacks

1. "CAUTION" (DoEAT). San Diego Indymedia (September 2, 2005), http://sandiego.indymedia.org/en/2005/09/110862.shtml.

2. A thorough catalog of the icon's repurposing can be found in Leslie Berestein, "Highway safety sign becomes running story on immigration," *San Diego Union-Tribune*, April 10, 2005, http://www.signonsandiego.com/uniontrib/20050410/news_1n10signs.html.

3. Shannon Spanhake of DoEAT cites the Situationists as an influence, along with Dada, Hans Haacke, the Yes Men, Electronic Disturbance Theater, and others. "A Short Interview with artist Shannon Spanhake about the DoEAT group," July 22, 2005, http://post.thing.net/node/394.

4. DoEAT's particular art performance was both physical and networked, in that the circulation of the images is an integral component of the work.

5. For an expansive articulation of the two logics of power, see David Harvey, *The New Imperialism* (New York: Oxford University Press, 2003), 31; Fredric Jameson, "Culture and Finance Capital," *Critical Inquiry* 24 (Autumn 1997): 251; and Michael Hardt and Antonio Negri, *Empire* (Cambridge, Mass.: Harvard University Press, 2000), xii.

6. For a study focusing on the period between 1848 (when the border is established by treaty) and World War I, see Juan Mora-Torres, *The Making of the Mexican Border* (Austin: University of Texas Press, 2001).

7. See Ted Robbins, "San Diego Fence Provides Lessons in Border Control," *NPR*, April 6, 2006, http://www.npr.org/templates/story/story.php?storyId=5323928. Events are unfolding too quickly for me to keep the references current, but I will note that my thinking on issues pertaining to the wall between the United States and Mexico crystallized in December 2005, at the time of the congressional approval of H.R. 4437 (sponsored by Representative F. James Sensenbrenner [WI-5], introduced on December 6, 2005), the stated purpose of which is to amend the Immigration and Nationality Act to strengthen enforcement of the immigration laws, to enhance border security, and for other purposes. In the same month, the Department of Homeland Security was given clearance by way of the Real ID Act to continue construction of the wall, which had been held up for environmental review. See Eilene Zimmerman, "Against the Wall," *Salon*, December 12, 2005, http://archive.salon.com/news/feature/2005/12/12/border_wall/index.html.

8. The U.S. Border Patrol only began recording migrant deaths in 1998, so all statistics are necessarily estimated. *Stop Gatekeeper!* http://stopgatekeeper.org/English/index.html; Marc Cooper, "On the Border of Hypocrisy," *LA Weekly*, December 4, 2003, http://www.laweekly.com/general/features/on-the-border-of-hypocrisy/2157.

9. See http://stopgatekeeper.org/English/index.html.

10. "U.S. Border Patrol Strategic Plan for 1994 & Beyond." Discussed in http://www.stopgatekeeper.org/English/facts.htm.

11. On the bidding for federal contracts to develop the virtual fence, see Eric Lipton, "Bush Turns to Big Military Contractors for Border Control," *New York Times*, May 18, 2006, A1.

12. For a thorough account of the failures of biometric testing, see Charlotte Epstein, "Biopolitics, Governmentality, and the North-South Divide," ISA Workshop Paper (March 2006).

13. Étienne Balibar, "Europe: An 'Unimagined' Frontier of Democracy," *diacritics*

33, nos. 3–4 (Fall–Winter 2003): 40. Balibar has long argued for the democratization of borders, "not only as in their opening (and not as their generalized abolition, which in many cases would simply lead to a renewed war of all against all in the form of savage competition among economic forces), but above all as a multilateral, negotiated control of their working by the populations themselves (including, of course, migrant populations)." See *We the People of Europe? Reflections on Transnational Citizenship*, trans. James Swenson (Princeton, N.J.: Princeton University Press, 2004), 117.

14. Peter Andreas, *Border Games* (Ithaca, N.Y.: Cornell University Press, 2000). Also see Andreas, "A Tale of Two Borders: The U.S.–Canada and U.S.–Mexico Lines after 9-11," in *The Rebordering of North America: Integration and Exclusion in a New Security Context*, ed. Peter Andreas and Thomas J. Biersteker (New York: Routledge, 2003), 1–23.

15. Ulrich Beck, "The Terrorist Threat: World Risk Society Revisited," *Theory, Culture, and Society* 19, no. 4 (2002): 41.

16. Ibid.

17. Joanne Richardson, "The Language of Tactical Media," *subsol* 2, http://subsol .c3.hu/subsol_2/contributors2/richardsontext2.html.

18. Jon McKenzie and Rebecca Schneider, "Critical Art Ensemble: Tactical Media Practitioners," *TDR: The Drama Review* 44, no. 4 (Winter 2000): 137.

19. Gloria Anzaldúa, *Borderlands/La Frontera: The New Mestiza* (San Francisco: Aunt Lute Books, 1987).

20. No doubt there are many studies of post-European cinema with respect to migrants and asylum seekers still to come, addressing such films as *Since Otar Left* (Dir. Julie Bertucelli, 2003). This is not to suggest, however, that there is no narrative video or film dedicated to the U.S.–Mexico border. See, for example, Ursula Biemann's video essay "Performing the Border" (1999), http://www.medienkunstnetz .de/works/performing-the-border.

21. Geert Lovink, *Dark Fiber: Tracking Internet Culture* (Cambridge, MIT Press, 2002), 255.

22. The privileging of Anglo-Protestant culture in Samuel Huntington's *The Clash of Civilizations* manifests as an outright defense in his *Who Are We? The Challenges to America's National Identity* (New York: Simon and Schuster, 2004).

23. Carl Schmitt, *The Concept of the Political*, trans. George Schwab (Chicago: University of Chicago Press, 1996), 28.

24. Judith Butler, *Precarious Life: The Powers of Mourning and Violence* (New York: Verso, 2004), 39.

25. Giorgio Agamben, *State of Exception*, trans. Kevin Attell (Chicago: University of Chicago Press, 2005), 43. On Agamben's reading of the role of *consuls*, proxy sovereignties, and the collapse of the "distinction between public and private authority," see Louise Amoore, "Economies of Exception: Consulting, Culture, the Camp," ISA Workshop Paper (March 2006), 9.

26. "Web Users to 'Patrol' US Border," *BBC News,* June 2, 2006, http://news.bbc .co.uk/1/hi/world/americas/5040372.stm.

27. "Homeland Security to Build Detention Camps in the United States," *Business Wire,* January 24, 2006.

28. Butler, *Precarious Life, 33.*

29. The May 2006 action was one of a long-term series directed against the Minutemen and related organizations; see http://swarmtheminutemen.com. For a description of the 2005 SWARM campaign, for example, see the interview with Ricardo Dominguez, "A Transparent and Civil Act of Disobedience," June 12, 2005, http:// post.thing.net/node/304.

30. For a thorough overview of Electronic Disturbance Theater, electronic civil disobedience, and the first deployments of FloodNet, see Graham Meikle, *Future Active: Media Activism and the Internet* (New York: Routledge, 2002), 140–72.

31. "How This Action Works," http://swarmtheminutemen.com/cartography/how .html. For another description of FloodNet actions, see the interview with Raphie Frank and Mindy Bond, "Ricardo Dominguez, Artist and Electronic Civil Disobedience Pioneer," *Gothamist,* November 29, 2004, http://www.gothamist.com/ archives/2004/11/29/ricardo_dominguez_artist_and_electronic_civil_disobedience_ pioneer.php.

32. Oxblood Ruffin, "Hacktivism, from Here to There," Yale Law School Conference on Cybercrime (2004), http://islandia.law.yale.edu/isp/digital%20cops/papers/ ruffin_hacktivism.pdf.

33. The commentary on the question of hacktivism as terrorism is extensive, focusing often on the Electronic Disturbance Theater attacks against the Pentagon and the White House sites. As just one example, see Dorothy E. Denning, "Hacktivism: An Emerging Threat to Diplomacy," *Foreign Service Journal,* September 2000, http:// www.afsa.org/fsj/sept00/Denning.cfm. Also see Alan Liu's discussion of Critical Art Ensemble and terrorism in *The Laws of Cool: Knowledge Work and the Culture of Information* (Chicago: University of Chicago Press, 2004), 367–68.

34. See, for example, the InfoSecurity archives at http://www.attrition.org/ pipermail/isn.

35. Michael Dartnell, *Insurgency Online: Web Activism and Global Conflict* (Toronto: University of Toronto Press, 2006).

36. Coco Fusco, "On-line Simulations/Real-Life Politics," *TDR: The Drama Review* 47, no. 2 (Summer 2003): 155. Dominguez also notes that in its institutionalization as "art," "EDT has only been absorbed [into gallery spaces] as documentation and not as a hosted performance." Quoted in Jenny Marketou, "Where Do We Go from Here?" Net Art Commons, July 23, 2002, http://netartcommons.walkerart.org. There is a certain link here between art as documentation and the situation of art and argument alike within the simulation rules of a game (wherein the work is less the entity of the game than its scenario, rules, and code).

37. FloodNet Foyer, http://www.thing.net/~rdom/zapsTactical/foyer3.htm.

38. John Arquilla has described FloodNet specifically as "the info age equivalent of the first sticks of bombs dropped from slow-moving Zeppelins in the Great War." Quoted in Meikle, *Future Active*, 157.

39. "What This Action Is About," http://swarmtheminutemen.com/cartography/about.html. To fill out a taxonomy of wired activism on the issue of borders, one must mention other activist organizations that use new media for organizational purposes: deleteTheBorder.org, the Organic Collective, and noborder.org. The slogans and core principles of these (often civil-disobedience-based) campaigns are as follows: an end to deportations and detentions; freedom of movement; papers for all.

40. In his analysis of the war machine as a watching machine, Paul Virilio quotes William Perry, former U.S. secretary of defense: "Once you see the target, you can expect to destroy it." *War and Cinema: The Logistics of Perception*, trans. Patrick Camiller (New York: Verso, 1989), 3.

41. They begin with the concept of "cyberwar" and eventually settle on "netwar." See John Arquilla and David Ronfeldt, "Cyberwar Is Coming!" *Comparative Strategy* 12 (April–June 1993): 141–65; *Networks and Netwars: The Future of Terror, Crime, and Militancy* (Rand, 2001). A growing number of humanities researchers are turning their critical attention to Arquilla and Ronfeldt's work. See, for example, Samuel Weber, *Targets of Opportunity* (New York: Fordham University Press, 2005), 90–108.

42. John Arquilla and David Ronfeldt, *The Zapatista "Social Netwar" in Mexico* (Rand, 1998), 15. Also see their *Swarming and the Future of Conflict* (Rand, 2000).

43. Ricardo Dominguez, Stefan Wray, Brett Beestal, and Osea, "SWARM: An ECD Project for Ars Electronica Festival '98," http://www.thing.net/%7Erdom/ecd/swarm.html.

44. For a thorough review of some of these aspects of Critical Art Ensemble, see Alan Liu, *The Laws of Cool*, 364–67.

45. Critical Art Ensemble, *The Electronic Disturbance* (New York: Autonomedia, 1994), 111. Žižek makes a similar point in his contrarian analysis of Naomi Klein in *Organs without Bodies*.

46. Critical Art Ensemble, *Electronic Civil Disobedience and Other Unpopular Ideas* (New York: Autonomedia, 1996), 11; and *The Electronic Disturbance*, 24. As I put the finishing touches on this chapter, news came of the successful student protests in France and the mass protests against immigration policy across the United States (including protests in Washington, Los Angeles, New York, San Francisco, and Phoenix in the spring of 2006). We are reminded, then, that street-based protests are far from obsolete and can in fact have a material effect on public policy. With issues of party allegiance and voter registration in mind, it will be interesting to see how the political establishment responds to mass protests from the Latino voting bloc.

47. Michael Hardt and Antonio Negri, *Multitude: War and Democracy in the Age of Empire* (New York: Penguin, 2004), 68.

48. Critical Art Ensemble, *Electronic Civil Disobedience*, 23.

49. Ibid., 31, 32. In their manifesto for tactical media, David Garcia and Geert Lovink link the mobility of tactical media to migrant culture.

50. Stefan Wray, "On Electronic Civil Disobedience" (1998), http://www.thing .net/~rdom/ecd/oecd.html.

51. Stefan Wray, "Electronic Civil Disobedience and the World Wide Web of Hacktivism: A Mapping of Extraparliamentarian Direct Action Net Politics," *Switch* 4, no. 2 (1998): http://switch.sjsu.edu/web/v4n2/stefan.

52. McKenzie and Schneider, "Critical Art Ensemble," 144.

53. Critical Art Ensemble, *Electronic Civil Disobedience*, 13.

54. *In Athena's Camp: Preparing for Conflict in the Information Age* (Rand, 1997), 30.

55. Borderhack!—a camping-activist event organized by Mexican Net activists for Labor Day 2000—also focused on critical awareness rather than outright destruction, as the attendant manifesto makes clear: "We propose this Borderhack, a camp that does not pretend to destroy the border, but, in a worst case scenario, only to make us conscious of it." Luis Humberto Rosales and Fran Ilich, "Borderhack 2000," http://web.archive.org/web/20010629030310/www.neuroticos.com/borderhack/ab2.html.

56. It should be noted that disruption per se is not an unqualified good and certainly not always tactical. In fact there is a certain capacity for banality and pettiness in the obstruction of network traffic or specifically intraoffice network communications, as Kok-Chian Leong's project *Corporate Sabotage* indicates. See http://01sj.org/content/view/251/49.

57. Meikle, *Future Active*, 154.

58. Wray writes in 1998 that the power of FloodNet applets perhaps "lies more in the simulated threat," though greater participation has meant greater efficacy. Dominguez notes in an interview that "to actually flood a server so that it cannot run properly, literally hundreds if not thousands must engage in the action at a given time; in that sense, collective use of the software constitutes the critical mass needed for the action to be 'felt.' But being able to down a server and actually doing it are two different things." See Fusco, "On-line Simulations," 154.

59. Quoted in Meikle, *Future Active*, 170.

60. Michel Foucault, *The History of Sexuality*, vol. 1, *An Introduction* (New York: Random House, 1978), 96. Louise Amoore has written on the momentary aspect of dissent in the Foucauldian tradition specifically in relation to biometric borders and the regulation of the movement of people. See her "Biometric Borders: Governing Mobilities in the War on Terror," *Political Geography* 25 (2006) 336–51. She has also written brilliantly of the impossible ideality of the great refusal, which promises a singular, cohesive, and locatable enemy. See "'There Is No Great Refusal': The Ambivalent Politics of Resistance," in *International Political Economy and Poststructural Politics*, ed. Marieke de Goede (London: Palgrave Macmillan, 2007), 255–74.

61. Critical Art Ensemble, *The Electronic Disturbance*, 130. Dominguez, cited in McKenzie and Schneider, "Critical Art Ensemble," 139.

62. Critical Art Ensemble, *The Electronic Disturbance*, 24. McKenzie and Schneider, "Critical Art Ensemble," 139.

63. Lovink, Nettime post, May 16, 1997.

64. Also see Lovink, *Dark Fiber*, 264.

65. Vilém Flusser, *The Freedom of the Migrant: Objections to Nationalism*, trans. Kennett Kronenberg (Urbana: University of Illinois Press, 2003), 106.

66. Cited in Amy Carroll, "Incumbent upon Recombinant Hope," *TDR: The Drama Review* 47, no. 2 (Summer 2003): 147.

67. Critical Art Ensemble, *The Electronic Disturbance*, 120.

68. Rhizome project description, http://rhizome.org/object.rhiz?4069.

69. http://noborder.org/about.php.

70. Hardt and Negri, *Empire*, 328–29.

71. http://stopgatekeeper.org/English/deaths.htm.

72. See http://www.treborscholz.squarespace.com/tuesday-afternoon.

73. The incorporation of a first-person voice or perspective is by no means absent in the art and literature of the Chicano migrant experience. As just one example, Tomás Rivera's oral narrative . . . *y no se lo tragó la tierra* / . . . *And the Earth Did Not Devour Him* (1970) incorporates the voices of Mexican American migrant workers of the 1940s and 1950s through internal monologue.

74. "BorderXing Guide," Tate Online (November 23, 2004), http://www.tate.org .uk/netart/borderxing. See http://irational.org/cgi-bin/border/clients/deny.pl. Also see Benedict Seymour, "Real Politik versus Real Fantasy: Review of the Tate Modern's Border Crossing Seminar," *Metamute*, January 2002.

75. "Border Crossings," Tate seminar (October 1, 2002), http://www.tate.org.uk/ onlineevents/archive/border_crossings.

76. See http://status.irational.org.

77. Elizabeth Bard, "How to Cross Borders, Social or Otherwise," *New York Times*, October 27, 2004, http://tech.nytimes.com/2004/10/27/arts/design/27iden.html.

78. "Interventions / Artist - Judi Werthein / Brinco (Jump)," *inSite_05* (August 28, 2005), http://www.insite05.org/internal.php?pid=7-214.

79. Hardt and Negri, *Empire*, 213, 212.

80. Balibar, "Europe," 42.

81. For Hardt and Negri's noted treatment of Bartleby as a figure of refusal, see *Empire*, 203–4.

82. Balibar's thinking here echoes his treatment of "the right to have rights" in *We the People of Europe?*

83. Flusser, *Freedom of the Migrant*, 22.

84. There is a certain correlation here between Flusser and Hannah Arendt's treatment of refugees in the post–World War II period in that she, too, speaks to the

political community (the nation-state) as the guarantor of rights. Further, she notes that refugees are not produced by an event; rather, they take on that status through their relation with a sovereign state. See Hannah Arendt, *The Origins of Totalitarianism* (New York: Harcourt, Brace, 1951).

85. Slavoj Žižek, *Organs without Bodies: Deleuze and Consequences* (New York: Routledge, 2004), 193.

86. Zygmunt Bauman, *Liquid Modernity* (Cambridge: Polity Press, 2000), 13.

87. Quoted in Marketou, "Where Do We Go."

88. See, for example, *Fish Story* (Düsseldorf: Richter, 1995).

89. "Tijuana Calling/Llamando Tijuana," *inSite_ 05*, curated by Mark Tribe (November 5, 2005), http://www.insite05.org/auxillary/tjcalling2.htm.

90. See http://www.turistafronterizo.net.

91. Installing the gamebox at the EZLN headquarters was for Dominguez a crucial component of the *Turista* project, though it meant working against the notion that the net.art component of inSite_05 be strictly digital. The gesture of technology transfer formed a circuit "from material society to immaterial society and back if you will." Personal e-mail communication with Dominguez, May 30–31, 2006.

92. For a partial overview of some of these games, see <re:Play>, http://www.radioqualia.net/replay/players.html.

93. See http://www.sudor.net/games/crosser_lamigra/index.html.

94. See http://www.borderfilmproject.com.

95. See http://www.sudor.net/games/crosser_lamigra/index.html.

96. My discussion of the *corrido* is informed by Américo Paredes, *"With His Pistol in His Hand": A Border Ballad and Its Hero* (Austin: University of Texas Press, 1958); and Ramón Saldívar, *Chicano Narrative* (Madison: University of Wisconsin Press, 1990), 26–45.

97. See http://www.ungravity.org/corridos/htm/situation.htm. I have not altered any of the spelling or capitalization in the passage.

98. Andreas, *Border Games*, x.

99. I have standardized the capitalization for legibility. See http://post.thing.net/node/619.

100. Hernandez comments on his detention in a post at SWEATblog (November 23, 2005): "We don't want to be part of a witch hunt in which artists are the target of organizations such as the above mentioned, and showing some knowledge about the life in the border is considered to hide information on terrorism." http://www.sudor.net/blog/archive/2005/10/corridos_at_ins.html.

101. For details on Kurtz's case, see Critical Art Ensemble Defense Fund, http://www.caedefensefund.org.

102. Rebecca Schneider and Jon McKenzie, "Keep your EYES on the FRONT and WATCH YOUR BACK," *TDR: The Drama Review* 48, no. 4 (Winter 2004): 9.

103. There are echoes of Bunting and Brandon's *Status Project* here, in that both

are imagined to aid and abet activities that putatively threaten U.S. national security, whether it be the changing of legal identity or the support of a criminal-terrorist organization operating literally underground at the U.S.–Mexico border. That Hernandez explained that all of the factual information in the game derived from published sources matters little once we remember that the FBI is accustomed to studying contemporary art for clues to terrorist networks. (After 9/11, the FBI contacted the Whitney to see Mark Lombardi's last work, *BCCI, ICIC & FAB* [1996–2000].)

104. For a more detailed commentary on risk management in the context of the war on terror, see de Goede and Amoore's introduction to their coedited volume *Governing by Risk in a Time of Terror* (New York: Routledge, 2008).

105. Similarly, in his SWARM chronology, Stefan Wray offers critical awareness as a kind of "third way," neither cynicism nor conformity: "To show the world what is / Really happening—to have a critical worldview and to become / Interested in the truth of what happens to the people of this World." http://web.archive.org/web/20021021081320/http://www.nyu.edu/projects/wray/CHRON.html.

2. Virtual War

1. Lappé and Goldman, *Shooting War* (May 2006–), *SMITH Magazine*, chapters 2.13 and 3.3, http://smithmag.us/shootingwar.

2. http://smithmag.us/shootingwar/chapters/chapter-6/5.

3. http://smithmag.us/shootingwar/chapters/chapter-5/8.

4. Jean Baudrillard, *The Gulf War Did Not Take Place*, trans. Paul Patton (Bloomington: Indiana University Press, 1995).

5. James Der Derian, *Antidiplomacy: Spies, Terror, Speed, and War* (Cambridge: Blackwell, 1992), 175.

6. Ibid., 179; William Gibson, *Neuromancer* (New York: Ace, 1986), 5, 51.

7. See, for example, Lisa Parks, *Cultures in Orbit: Satellites and the Televisual* (Durham, N.C.: Duke University Press, 2005).

8. James Der Derian, *Virtuous War: Mapping the Military-Industrial-Media-Entertainment Network* (Boulder, Colo.: Westview Press, 2001). Also see Tim Lenoir, "All but War Is Simulation: The Military-Entertainment Complex," *Configurations* 8 (2000): 289–335; and the research initiative *InfoTechWarPeace* started by Der Derian at the Watson Institute, Brown University, http://www.watsoninstitute.org/infopeace/index2.cfm.

9. "9.11: Before, After, and in Between," http://www.ssrc.org/sept11/essays/der_derian.htm.

10. See, for example, "Secretary Rumsfeld Interview with the Neal Boortz Show," November 29, 2005, http://www.defenselink.mil/transcripts/2005/tr20051129-secdef4381.html; and Jim Garamone, "Rumsfeld Speaks on Process behind Budget, QDR," February 7, 2006, http://www.defenselink.mil/news/Feb2006/20060207_4137.html.

11. See John Lasker, "U.S. Military's Elite Hacker Crew," *Wired*, April 18, 2005, http://www.wired.com/news/privacy/0,1848,67223,00.html; and "The Hackers You Haven't Heard About,"*Salon*, http://www.salon.com/politics/war_room/2005/04/19/hack/index.html.

12. See http://www.oft.osd.mil.

13. Tim Blackmore, *War X: Human Extensions in Battlespace* (Toronto: University of Toronto Press, 2005), 5.

14. William S. Lind et al., "The Changing Face of War: Into the Fourth Generation," *Marine Corps Gazette*, October 1989, http://www.d-n-i.net/fcs/4th_gen_war_gazette.htm. Also see "Fourth Generation Warfare," *Defense and the National Interest*, December 24, 2005, http://www.d-n-i.net/second_level/fourth_generation_warfare.htm.

15. Jose Antonio Vargas, "A 'Sim' That's Dead Serious," *Washington Post*, April 13, 2005, C1. Also see the archives of DefenseTech.org (Noah Shachtman, ed.).

16. Manuel De Landa, *War in the Age of Intelligent Machines* (New York: Zone Books, 1991), 95. For an historical overview of war games leading up to late-twentieth-century nuclear scenarios, see Thomas B. Allen, *War Games: The Secret World of the Creators, Players, and Policy Makers Rehearsing World War III Today* (New York: McGraw-Hill, 1987).

17. Julian Borger, "Wake-Up Call," *Guardian*, September 6, 2002. Alex Dragulescu has produced a visualization of the Millennium Challenge; see http://www.sq.ro/havoc.php.

18. Official *Tactical Iraqi* site, http://www.tacticallanguage.com/tacticaliraqi. Elizabeth Losh, "In Country with Tactical Iraqi: Trust, Identity, and Language Learning in a Military Video Game," Proceedings of the Sixth Digital Arts and Culture Conference (2005), http://eee.uci.edu/faculty/losh/virtualpolitik/DAC_Presentation .html. Also see Paul Rincon, "U.S. Troops Taught Iraqi Gestures," *BBC*, February 19, 2006, http://news.bbc.co.uk/2/hi/technology/4729262.stm; Gretchen Cuda, "Troops Learn Not to Offend," *Wired*, April 11, 2006, http://www.wired.com/news/technology/0,70576-0.html?tw=wn_culture_1. On the Human Terrain System (HTS) program, see David Rohde, "Army Enlists Anthropology in War Zones," *New York Times*, October 5, 2007.

19. See http://www.darwars.net/systems/; http://vector.chisystems.com; and http://www.forterrainc.com.

20. Martin Van Creveld, *The Transformation of War* (New York: Free Press, 1991). So, too, one could suggest that the presence of nonstate actors means that it is no longer a war per se. This is no minor rhetorical point: "war" provides a certain ideological cover necessary to our not seeing that it has become an occupation.

21. For Robb's account of global guerrilla warfare, see *Brave New War: The Next Stage of Terrorism and the End of Globalization* (Hoboken, N.J.: Wiley, 2007), along with http://globalguerrillas.typepad.com.

22. http://www.videoactivism.org/empire.html.

23. The TXTMob service was developed by the Institute for Applied Autonomy and used for protests during both the Democratic and Republican conventions in 2004. See http://www.appliedautonomy.com/txtmob/txtmobPR2.html.

24. Becky Worley, "Hacktivists Promote War Messages," *G4: TechTV Vault*, April 9, 2003, http://www.g4tv.com/techtvvault/features/44250/Hacktivists_Promote_War_Messages.html.

25. Richard Brennan, *Protecting the Homeland: Insights from Army Wargames* (Santa Monica, Calif.: Rand, 2002), 19–20.

26. National Commission on Terrorist Attacks upon the United States, *The 9/11 Commission Report* (2004), 157–58, http://www.9-11commission.gov/report/911Report.pdf.

27. Cyber-terrorism and cyber-security have received notable fictional treatment in Dan Verton, *Black Ice: The Invisible Threat of Cyber-Terrorism*, a journalistic account that opens with a somewhat sensational futurist narrative (Emeryville, Calif.: McGraw-Hill Osborne Media, 2003), and in Bruce Sterling's *The Zenith Angle*, his 9/11 novel (New York: Del Ray, 2004).

28. On the topic of terrorist use of the Internet, with a focus on communication, publicity, and information gathering, see Gabriel Weimann, *Terror on the Internet: The New Arena, the New Challenges* (Washington, D.C.: United States Institute of Peace Press, 2006). Also see the affiliated report, "How Modern Terrorism Uses the Internet," hosted by the United States Institute of Peace, http://www.usip.org/pubs/specialreports/sr116.html.

29. Panel 1 of the Hearing of the House Select Intelligence Committee (May 4, 2006), 1. Transcript available from "Mediawatch: Video Game Jihad," ABC Television, http://www.abc.net.au/mediawatch/transcripts/s1644639.htm.

30. Retrieved from *ZDNet* (May 5, 2006), http://news.zdnet.com/2100-1040_22-6068963.html. See the discussion of this incident at *Water Cooler Games* (May 12, 2006), http://www.watercoolergames.org/archives/000556.shtml.

31. The transcript of the hearings does not indicate how much of the eleven-minute film the panel watched, but Morgan's account indicates that they made it through the first two minutes at the minimum.

32. Ben Kuchera, "Fan-Made *Battlefield 2* Video Mistaken for Terrorist Propaganda," *Ars Technica*, May 7, 2006, http://arstechnica.com/journals/thumbs.ars/2006/5/7/3874.

33. http://cagematch.dvorak.org/index.php/topic,130.0.html. SonicJihad took his board name from the hip-hop album by Paris (2003), the cover of which depicts a plane flying into the White House. Paris is perhaps best known for the controversial 1992 track "Bush Killa," a self-styled "revenge fantasy about the assassination of then-president George Bush (Sr.) for neglect of poor conditions in oppressed communities nationwide." http://www.guerrillafunk.com/paris/sleeping_with_the_enemy.

34. http://www.forumplanet.com/planetbattlefield/topic.asp?fid=13670&tid=1806909&p=1.

35. Ibid.

36. http://gamepolitics.livejournal.com/285129.html.

37. Panel 1 of the Hearing of the House Select Intelligence Committee (May 4, 2006), 4.

38. Ibid., 17.

39. http://www.edwardtufte.com/bboard/q-and-a-fetch-msg?msg_id=0000YU&topic_id=1.

40. Panel 1 of the Hearing of the House Select Intelligence Committee (May 4, 2006), 4.

41. George W. Bush, "Introduction," *The National Security Strategy of the United States of America* (September 2002), http://www.whitehouse.gov/nsc/nss/2002/index.html.

42. Panel 1 of the Hearing of the House Select Intelligence Committee (May 4, 2006), 21.

43. Alexander Galloway, *Gaming: Essays on Algorithmic Culture* (Minneapolis: University of Minnesota Press, 2006).

44. Panel 1 of the Hearing of the House Select Intelligence Committee (May 4, 2006), 8.

45. Personal e-mail from Venable Barry to Sara Willett (May 20, 2006), "Video Game Jihad," *Media Watch*, http://www.abc.net.au/mediawatch/transcripts/s1644639.htm.

46. National Commission on Terrorist Attacks upon the United States, *The 9/11 Commission Report* (2004), 157–58, http://www.9-11commission.gov/report/911Report.pdf.

47. Friedman, "Giving the Hatemongers No Place to Hide," *New York Times*, July 22, 2005, A-19.

48. Chris Suellentrop, "The War on Terror's Least-Frightening Video Games," *Slate*, August 12, 2005, http://www.slate.com/id/2124363/. Islamgames defines the player's mission: "As a member of the Intergalactic Muslim Council (IGMC), your job is to help coordinate Dawa efforts on other planets. You couldn't be happier with your work, until the Flying Evil Robot Armada (FERM) attacks your home planet of Earth. It seems there was one disbeliever, known as Abu Lahab XVIII, left on Earth, and in his desperate attempt to deny the truth of Islam, he has constructed a whole army of robots to destroy the Earth and all of its Muslims." http://islamgames.com/ud1.html.

49. Galloway, *Gaming*, 78.

50. See http://www.specialforce.net/english/indexeng.htm. See http://www.underash.net/eshots.htm. The sequel to this game, *Under Siege*, is available in demo version from http://www.underash.net/en_download.htm. See Kim Ghattas, "Syria

launches Arab war game," *BBC News*, May 31, 2002, http://news.bbc.co.uk/2/hi/middle_east/2019677.stm.

51. http://www.boefivgt.org.uk/signs.htm.

52. Edward Castronova, *Synthetic Worlds: The Business and Culture of Online Games* (Chicago: University of Chicago Press, 2006), 231.

53. http://www.boefivgt.org.uk/threat2.htm.

54. See Antony Barnett, "Islamic Rappers' Message of Terror," *Observer*, February 8, 2004, http://politics.guardian.co.uk/redbox/story/0,9029,1143691,00.html.

55. http://www.leftbehindgames.com/pages/the_games.htm. For a thorough account of Left Behind Games and *Left Behind: Eternal Forces*, see Jonathan Hudson's six-part series at *Talk to Action*, May 29–June 21, 2006, http://www.talk2action.org/story/2006/5/29/195855/959.

56. For design, development, and audience information see Margaret Davis, ed., *America's Army PC Game: Vision and Realization* (San Francisco: Yerba Buena Art Center, 2004). On *America's Army* and the military-entertainment complex, see Timothy Lenoir, "Programming Theaters of War: Gamemakers as Soldiers," in *Bombs and Bandwidth: The Emerging Relationship between IT and Security*, ed. Robert Latham (New York: New Press, 2003), and "Fashioning the Military Entertainment Complex," *Correspondence: An International Review of Culture and Society* 10 (Winter–Spring 2002–3): 14–16. Related games include the commercial, U.S. Army-sponsored *Full Spectrum Warrior* and *Soldier of Fortune*, which has a modified Quake II engine.

57. Alfred Hermida, "War Vets Feature in U.S. Army Game," *BBC News*, May 18, 2006, http://news.bbc.co.uk/1/hi/technology/4991306.stm. *America's Army: Special Forces (Overmatch)* (scheduled for release in summer 2006) will feature the stories of nine soldiers who have served in Iraq or Afghanistan in a special "heroes section," with the sale of plastic soldiers as a tie-in to the game.

58. Der Derian, *Antidiplomacy*, 183.

59. Bruce Sterling, "War Is Virtual Hell," *Wired*, March–April 1993, http://www.wired.com/wired/archive/1.01/virthell.html?topic=&topic%20set=;.

60. Although Naisbitt's primary concern is the U.S. "culture of violence" and the relations between first-person shooters such as *Doom* and material events such as the Columbine shooting, he also addresses Marine Doom and the extent to which military simulation training imbricates function and play. See John Naisbitt, *High Tech/High Touch* (New York: Broadway, 1999), 65–112.

61. For critical commentary and historical overview of the toywar, see Graham Meikle, *Future Active: Media Activism and the Internet* (New York: Routledge, 2002), 168–72; and Adam Wishart and Regula Bochsler, *Leaving Reality Behind: etoy vs. eToys.com and Other Battles to Control Cyberspace* (New York: HarperCollins, 2003).

62. Dominguez, quoted in Meikle, *Future Active*, 170.

63. An overview of these games is available from the *<re:Play>* exhibit, http://www.radioqualia.net/replay/players.html. Also see Daniel Terdiman, "Playing Games

with a Conscience," *Wired*, April 22, 2004; and the Activism Games archive at http://www.watercoolergames.org/archives/cat_activism_games.shtml.

64. Ian Bogost, "They Rule: Videogames with an Agenda," didactic from the exhibit at London Curzon Soho (October 2004), curated by Ian Bogost and Gonzalo Frasca.

65. On play as activism and activism as play, see Douglas Rushkoff, *Open Source Democracy* (2003).

66. Ian Bogost, Michael Mateas, Janet Murray, and Michael Nitsche, "Asking What Is Possible: The Georgia Tech Approach to Game Research and Education," *International Digital Media and Arts Association Journal* 2, no. 1 (Spring 2005): 63.

67. See Ian Bogost, *Persuasive Games: The Expressive Power of Videogames* (Cambridge, Mass.: MIT Press, 2007).

68. http://www.agoraxchange.net/index.php?page=218.

69. http://www.newsgaming.com.

70. William S. Lind, "On War #171: Aaugh!" *Defense and the National Interest*, June 19, 2006, http://www.d-n-i.net/lind/lind_6_19_06.htm.

71. http://www.newsgaming.com/games/index12.htm.

72. Paul Virilio, *War and Cinema: The Logistics of Perception*, trans. Patrick Camiller (New York: Verso, 1989).

73. http://www.uzinagaz.com/index.php?entry_point=wtc. It was followed by *Baghdad Defender* (2003), in which players defend the city against incoming missiles.

74. http://www.newgrounds.com/portal/view.php?id=40095.

75. We might also consider the first-person shooter in this regard in light of Chris Crawford's commentary on *Space Invaders* as a metaphor for the subject's frustration: "All the social rules and institutions are arrayed against us; they march in lockstep as they threaten to suffocate us. They rain their nasty poop onto our heads; we can only dodge them. But we do have one gun with which to shoot back, and if we dodge quickly, we can defeat them. It's a compelling metaphor for the predicament with which we all struggle; that's why it was such a huge success." Crawford, *On Game Design* (Indianapolis: New Riders, 2003), 30.

76. http://www.brand.co.il/unik/westbank. "Disengagement, the Video Game" *Ynetnews*, June 11, 2005, http://www.ynetnews.com/articles/0,7340,L-3097902,00.html; Ian Bogost, "Israeli Anti-Settlement Game," *Water Cooler Games*, June 17, 2005, http://www.watercoolergames.org/archives/000420.shtml.

77. For commentary on no-win games, see Shuen-shing Lee, "'I Lose, Therefore I Think': A Search for Contemplation amid Wars of Push-Button Glare," *Game Studies* 3 no. 2 (December 2003): http://www.gamestudies.org/0302/lee.

78. Bogost poses a similar question about the representation of conflict in game spaces: "What portion of revolutions can escape historical, cultural, and regional specificity enough to be computationally modeled?" See http://www.watercoolergames.org/archives/000371.shtml.

79. http://www.antiwargame.org.

80. For a detailed discussion of ergodic texts, those that require the reader to engage in significant physical activity, see Espen Aarseth, *Cybertext: Perspectives on Ergodic Literature* (Baltimore, Md.: Johns Hopkins University Press, 1997).

81. See http://www.cityarts.com/iraq/index.html.

82. See http://www.thegreatgame.com.

83. Many of his works are modeled on the gaming multiuser environment, but his mode is one of borrowing rather than of foundational research. That is, he uses algorithms operative in gaming environments, but his own programming is unlikely to be reinvented or applied for commercial, industrial interests in the future.

84. http://www.cityarts.com/lmno.

85. Blackhawk, "John Klima: Shrinking Afghanistan," October 2001, http://www.cityarts.com/shrink/crit.html.

86. Paul Virilio, *The Information Bomb,* trans. Chris Turner (New York: Verso, 2000), 9.

87. See http://www.cityarts.com/lmno/postmasters.html.

88. I am indebted to Russell Samolsky for his insights about Matisse and Klima.

89. Emily Apter, "The Aesthetics of Critical Habitats," *October* 99 (Winter 2002): 42.

90. Susan Sontag, *Regarding the Pain of Others* (New York: Picador, 2003), 21.

91. One could also point to the controversy over claims that the images of torture and atrocity are a form of artistic production, specifically the journalist's misunderstanding about Karlheinz Stockhausen's comments on the destruction of the Twin Towers as a work of art. See http://www.stockhausen.org/message_from_karlheinz.html.

92. Judith Butler, "Photography, War, Outrage," *PMLA* 120, no. 3 (2005): 824.

93. Jordan Crandall, "On Warfare and Representation," in *Under Fire: The Organization and Representation of Violence,* ed. Jordan Crandall (Rotterdam: Witte de With, 2004), 218.

94. http://www.takeo.org/nspace/ns011.

95. Alyssa Wright, *Cherry Blossoms,* http://web.media.mit.edu/%7Ealyssa/about.html.

96. "Battle Plan under Fire," *Nova,* May 2004, http://www.pbs.org/wgbh/nova/wartech.

97. Cited in William Merrin, "Total Screen: 9/11 and the Gulf War Reloaded," *International Journal of Baudrillard Studies* 2, no. 2 (July 2005).

98. *Against All Enemies: Inside America's War on Terror* (New York: Free Press, 2004), 31.

99. http://www.obleek.com/iraq.

100. Joseph DeLappe, *dead-in-Iraq,* http://www.unr.edu/art/DELAPPE/Gaming/Dead_In_Iraq/dead_in_iraq%20JPEGS.html.

101. See Karen DeYoung, "Experts Doubt Drop in Violence in Iraq Military Statistics Called into Question," *Washington Post,* September 6, 2007, A16.

102. James Der Derian, "War as Game," *Brown Journal of World Affairs* 10, no. 1 (2003): 39–40.

103. DeLappe regards "the ongoing spread of information regarding this work as part of the work." "Dead-in-iraq," *Terra Nova* comment thread, May 5, 2006, http://terranova.blogs.com/terra_nova/2006/05/deadiniraq_.html. The rage directed toward DeLappe is also present in online gaming forums such as WomenGamers. As we saw with the SonicJihad video, forum commentators are among the most intensely critical of objects and performances enacted within their particular communities.

104. One paradox is that *America's Army* is already modeled on the real, particularly in the forthcoming *Special Forces* edition, which is designed to "put a human face on the war."

105. Galloway, *Gaming*, 115–25.

106. http://www.opensorcery.net/velvet-strike/about.html.

107. They outline the project in the following terms: "By finding representations and processes to stimulate the desires that the enriched privation of product consumption and alienated labor cannot, tactical media practitioners can help children visualize the possibilities that are withheld from them, and to realize these possibilities in language and performance." http://www.carbondefense.org/writing_4 .html. Video documentation available from http://www.carbondefense.org/video/ ChildAsParticipant.mov.

108. Kathleen Craig, "Dead in Iraq: It's No Game," *Wired*, June 6, 2006, http://www.wired.com/news/culture/games/0,71052-0.html?m_E; and Li C. Kuo, "A New Kind of Art Form Leads to a New Kind of Protest," *GameSpy*, May 23, 2006, http://www.gamespy.com/pc/americas-army/709854p1.html.

109. See James E. Young, *At Memory's Edge: After-images of the Holocaust in Contemporary Art and Architecture* (New Haven, Conn.: Yale University Press, 2000).

110. James E. Young, *The Texture of Memory: Holocaust Memorials and Meaning* (New Haven, Conn.: Yale University Press, 1993), 7.

3. Speculative Capital

The chapter epigraph is from Manuel De Landa, "Markets, Antimarkets, and Network Economics" (1996), http://www.fundacion.telefonica.com/at/edelanda.html.

1. *Global Clock No. 1* was exhibited as part of *The Fifth Element, Art or Money,* Kunsthalle Düsseldorf (January–May 2000). *Global Clock No. 2* was exhibited at the Swiss National Exhibition (2002). See *Short Circuit, a.k.a. Global Clock*, http://www .l00k.org/globalclock1/global-clock.

2. Kurgan, *Global Clock*, http://www.l00k.org/clock_project/clockinfo.htm.

3. Fredric Jameson, "Culture and Finance Capital," *Critical Inquiry* 24 (Autumn 1997): 260.

4. http://www.l00k.org/clock_project/clockinfo.htm.

5. *Black Shoals Stock Market Planetarium*, http://www.blackshoals.net.

6. Julian Stallabrass makes a similar point in "A View from the Fish Tank," in *Black Shoals Stock Market Planetarium* (Copenhagen: Nikolaj Contemporary Art Center, 2004), chap. 4, n.p.

7. Cefn Hoile, "Black Shoals: Evolving Organisms in a World of Financial Data," in *Black Shoals Stock Market Planetarium*, chap. 5, n.p.

8. See Bethany McLean and Peter Elkind, *The Smartest Guys in the Room: The Amazing Rise and Scandalous Fall of Enron* (New York: Portfolio, 2003).

9. Wattenberg, *Map of the Market*, http://smartmoney.com/marketmap. What is the relation, further, between visualizations of financial information and the projects that make art out of banknotes and coins, Warhol, Beuys, Paolo Monti, and Otis Kaye? What are the abstractions in each? How would the issue of reference and the content of the reference differ? To start, Otis Kaye's early-twentieth-century trompe l'oeil paintings of U.S. currency are representational rather than simulational. Unlike the earlier trompe l'oeil paintings of William Harnett and John Haberle, which were confiscated by the Secret Service on the basis of their violation of counterfeit laws, and unlike the notorious transactional performances of J. S. G. Boggs in the 1980s and early 1990s, Kaye's work foregrounds composition instead of reproduction. Though Kaye's technique also produces a hyperrealism, his paintings maintain a collage effect through the superimposition of coins, bank notes, and text over fragments of replicated "masters" paintings by artists such as Rembrandt, Goya, Dürer, Picasso, and Whistler. See the catalog from the Federal Reserve Board exhibition, by Otis Kaye (New York: Gerald Peters Gallery, 2002); as well as Lawrence Weschler, *Boggs: A Comedy of Values* (Chicago: University of Chicago Press, 1999). Also see Warhol's *Eighty Two-Dollar-Bills* (1962); Monti's *Dollar Image* (1989) and *Cash* (1991), at http://www.uni-konstanz.de/FuF/wiwi/laufer/index-2.htm; and Kaye's trompe l'oeil works, some at http://www.otiskaye.com.

10. Cefn Hoile paper also available from http://blackshoals.net/ALife.html.

11. http://www.reas.com.

12. Manuel De Landa, "Markets, Antimarkets, and Network Economics," n.p.

13. Hardt and Negri argue that capital can only be reactive; the proletariat "actually invents the social and productive forms that capital will be forced to adopt in the future." Michael Hardt and Antonio Negri, *Empire* (Cambridge: Harvard University Press, 2000), 268.

14. Sylvère Lotringer, introduction to *The Grammar of the Multitude*, by Paolo Virno, trans. Isabella Bertoletti et al. (New York: Semiotext[e], 2004), 12.

15. Olav Velthuis, *Imaginary Economics: Contemporary Artists and the World of Big Money* (Rotterdam: NAI Publishers, 2005), 13.

16. Spencer E. Ante, "A Digital Artist's Portrait of Economic Darwinism," *Business Week*, June 6, 2001, http://www.businessweek.com:/print/technology/content/jun2001/tc2001066_336.htm?eb.

17. John Klima, *ecosystm*, http://www.cityarts.com/lmno/ecosystm.html.

18. Kevin Kelly, *Out of Control: The New Biology of Machines, Social Systems, and the Economic World* (Reading, Mass.: Addison-Wesley, 1994); David R. Henderson, "Survival of the Fittest," *Red Herring*, December 1997, http://redherring.com/mag/issue49/school.html; Evan I. Schwartz, *Digital Darwinism* (New York: Broadway Books, 2001); Eric A. Marks, *Business Darwinism: Evolve or Dissolve* (New York: John Wiley and Sons, 2002).

19. On the many challenges to territorial currencies, see Eric Helleiner, *The Making of National Money* (Ithaca, N.Y.: Cornell University Press, 2003), 5–12, 218–44. We might also see a connection here to Friedrich Hayek's theses toward the "denationalisation of money" (London: Institute of Economic Affairs, 1976), cited as one of the major influences on neoliberal economic policy makers.

20. Klima, "ecosystm," http://www.cityarts.com/lmno/ecosystm.html.

21. Emily Apter, "The Aesthetics of Critical Habitats," *October* 99 (Winter 2002): 39.

22. "The Update! Documents" (March 2002), http://www.treasurecrumbs.com/theupgrade/02_2klima.html.

23. In *Geography Lesson: Canadian Notes* (Vancouver Art Gallery, 1997), Allan Sekula writes at length about the design of the Bank of Canada, addressing in particular the significance of the elaborate botanical garden court as an enforced link between the money in the bank and Canada's natural resources.

24. Paul Virilio, *The Information Bomb*, trans. Chris Turner (New York: Verso, 2000), 13.

25. My thinking here is also informed by Dipesh Chakrabarty, *Provincializing Europe* (Princeton: Princeton University Press, 2000), particularly his reading of historical time as "out of joint with itself" (16).

26. Hardt and Negri, *Empire*, 32, 209.

27. Gilles Deleuze, "Postscript on Control Societies," in *Negotiations: 1972–1990*, trans. Martin Joughin (New York: Columbia University Press, 1995), 180.

28. Ibid., 172. Also see F. U. Rosenberger, "Metastability" (April 4, 2001), http://www.cse.wustl.edu/~fred/CLASSES/463FA02/Metastability.pdf. I can only gesture toward the relations between eighteenth- and nineteenth-century liberal doctrines of economic liberty (Adam Smith, Thomas Malthus, John Stuart Mill, Herbert Spencer) on the one hand and the contemporary neoliberal free-trade, antiregulation cult of the individual on the other. But it is worth generally noting in this context that Smith's reaction against prior mercantilist control of the economy by the state held that economics were best left to operate under their own natural laws without government interference and regulation of free competition. His theological view of markets imagined them as self-regulating and tending toward an equilibrium of supply and demand, its invisible hand allowing it to achieve its own natural efficiency. We move then from equilibrium to metastability.

29. Jameson, "Culture and Finance Capital," 251.

30. Giovanni Arrighi, *The Long Twentieth Century: Money, Power, and the Origins of Our Times* (New York: Verso, 1994), 2.

31. Joseph A. Schumpeter, *Capitalism, Socialism, and Democracy* (New York: Harper Torchbooks, 1962), 87.

32. Georg Simmel, *The Philosophy of Money*, 3rd ed., trans. Tom Bottomore and David Frisby (New York: Routledge, 2004), 510–11.

33. Arrighi, *The Long Twentieth Century*, 4.

34. Wriston, quoted in Thomas A. Bass, "The Future of Money," *Wired* 4, no. 10 (October 1996), http://www.wired.com/wired/archive/4.10/wriston.html.

35. Jerry Harris, "Globalisation and the Technological Transformation of Capitalism," *Race and Class* 40, nos. 2–3 (1998–99): 34.

36. Sean Cubitt, "Orbus Tertius," *Third Text*, Summer 1999, 8–9.

37. Jameson, "Culture and Finance Capital," 246–65.

38. Ibid., 260.

39. Hardt and Negri, *Empire*, xii.

40. Saskia Sassen, *The Global City: New York, London, Tokyo*, 2nd ed. (Princeton, N.J.: Princeton University Press, 2001), 349–50.

41. Allan Sekula, *Fish Story* (Richter Verlag, 1995), 202.

42. Ibid., 12.

43. Allan Sekula, "Freeway to China," in *Millennial Capitalism and the Culture of Neoliberalism*, ed. Jean Comaroff and John L. Comaroff (Durham, N.C.: Duke University Press, 2001), 150; and Sekula, *Fish Story*, 12.

44. Zillah Eisenstein, *Global Obscenities: Patriarchy, Capitalism, and the Lure of Cyberfantasy* (New York: New York University Press, 1998), 7.

45. Saskia Sassen, *The Global City: New York, London, Tokyo*, 2nd. ed. (Princeton, N.J.: Princeton University Press, 2001), 350.

46. Andrew Leyshon and Nigel Thrift, *Money/Space: Geographies of Monetary Transformation* (New York: Routledge, 1997).

47. Virilio, *The Information Bomb*, 9.

48. The dialectic of materiality and abstraction in this art project might profitably be compared to the K Foundation's burning of a million pounds on the island of Jura off the west coast of Scotland on August 23, 1994. See Chris Brook, ed., *K Foundation Burn a Million Quid* (London: Ellipsis, 1997); and http://www.ellipsis.com/k.

49. See http://www.olapehrson.com/index/yucca/index.html. Peter Stallabrass discusses Pehrson's plant in *Internet Art: The Online Clash of Culture and Commerce* (London: Tate Publishing, 2003), 31.

50. Commentary on Pehrson's work for the *Best Before* exhibition at the Association for Temporary Art, Sweden (1999). Archived at http://web.archive.org/web/20021225043440/http://www.art.a.se/best_before/about.

51. Paul H. Cootner's edited volume *The Random Character of Stock Market Prices* (Cambridge, Mass.: MIT Press, 1964) includes the Bachelier thesis as well as literature on efficient markets and the efficient-market hypothesis (EMH).

52. For example, P. S. Seward's *Technique of Speculation* (London: Sir Isaac Pitman and Sons, 1929) claims that "it [the stock exchange] is as legitimate a market as any other, possessing a definite scientific technique peculiarly its own" (preface). Seward advocates that investors eliminate uncertainty by "careful study of information and statistics" (13) and thereby suggests that market pricing has a kind of rationality, rather than an unpredictability, to it. Philip L. Carret's *The Art of Speculation* (1930; New York: John Wiley and Sons, 1997) links the two definitions of speculation—intellectual examination and trading—to claim that market fluctuations can be studied rationally and speculative investment strategies intelligently outlined.

53. Paul H. Cootner, ed., *The Random Character of Stock Market Prices* (1964; London: Financial Engineering Ltd. edition, 2000), 123.

54. Ibid., xi.

55. Arrighi, *The Long Twentieth Century*, 55.

56. Eric Hobsbawm speaks of a short twentieth century (1914–91) abbreviated by two decades of crisis and culminating in the collapse of communist regimes and subsequent political instability and uncertainty. See Hobsbawm, *The Age of Extremes: A History of the World, 1914–1991* (New York: Vintage, 1994), 10–11. Similarly, Wallerstein designates 1989 as the end of the modern world system begun in the "long" sixteenth century; see *The End of the World as We Know It* (Minneapolis: University of Minnesota Press, 1999).

57. Karl Marx, *Capital: An Abridged Edition*, ed. David McLellan (New York: Oxford University Press, 1995), 98.

58. Karl Marx, *Grundrisse*, trans. Martin Nicolaus (New York: Penguin Books, 1973), 537.

59. Ibid., 548–49; Jameson, "Culture and Finance Capital," 251.

60. Joseph Schumpeter, *Capitalism, Socialism, and Democracy* (New York: Harper Torchbooks, 1962), 83. For a comparison of Schumpeter and Marx's views of capitalism's future, see John E. Elliott, "Marx and Schumpeter on Capitalism's Creative Destruction: A Comparative Restatement," *Quarterly Journal of Economics* 95, no. 1 (August 1980): 45–68.

61. Schumpeter, *Capitalism, Socialism, and Democracy*, 83.

62. See J. Edward Chamberlin and Sander L. Gilman, *Degeneration: The Dark Side of Progress* (New York: Columbia University Press, 1985).

63. Marx, *Capital*, 99. Another link can be made to Ricardo's concept of the "organic structure of capital," which, according to Schumpeter, concerns the relation between "constant and variable capital" (*Capitalism, Socialism, and Democracy*, 26). Though it is not concerned with Marx or this passage, extended commentary on the representation of the Jewish body and circumcision as a "marker" of incompleteness, identity, and difference "within the parameters of 'healthy' or 'diseased'" can be found in Sander Gilman, *The Jew's Body* (New York: Routledge, 1991), 155.

64. Among the many subsequent exegeses of *Capital* on this point, see Benjamin

Lee and Edward LiPuma on capital's "self-propelling treadmill structure" and the economy as "an autonomous, self-regulating system." "Cultures of Circulation: The Imaginations of Modernity," *Public Culture* 14, no. 1 (2002): 208. Also see Robert Heilbroner: "Capitalism's most striking historical characteristic is its extraordinary propensity for self-generated change." Heilbroner, *Twenty-First Century Capitalism* (New York: W. W. Norton, 1993), 41.

65. Giovanni Arrighi and Beverly Silver, *Chaos and Governance in the Modern World System* (Minneapolis: University of Minnesota Press, 1999), 10. Their discussion of "a dominant state [that] becomes the 'model' for other states to emulate and thereby draws them into its own path of development" (27) follows the critical path of Gramsci on hegemony and George Modelski and William R. Thompson (1995). With respect to the reconfiguration of the function of the state vis-à-vis contemporary capitalism, Jerry Harris also notes, "[Transnationals use] government to help penetrate new markets, keep labour and environmental costs low and subsidise their global activities. This is not the disappearance of states, but the redefinition of their role" ("Globalisation and the Technological Transformation of Capitalism," 33).

66. Jameson, "Culture and Finance Capital," 249.

67. Michael Pryke and George Allen, "Monetized Time-Space: Derivatives—Money's 'New Imaginary'?" *Economy and Society* 29, no. 2 (May 2000): 270. Similarly, see RTMark's commentary on corporate power as a virus: "The flexibility of corporate power, its lack of a center, comes at a price: it has no brain. It may be as tenacious as a virus, but it also has the intelligence of one: mechanical, soulless, minuscule." "Sabotage and the New World Order," in *InfoWar*, ed. Gerfried Stocker and Christine Schöpf (Vienna: Springer, 1998), 242.

68. Hardt and Negri, *Empire*, 41.

69. Michael Rothschild, *Bionomics: The Inevitability of Capitalism* (London: Futura Publications, 1992), xi, xv. Also see Eric Drexler on corporations as "evolved artificial systems" that emerge from the competitive Darwinian marketplace in his *Engines of Creation: The Coming Era of Nanotechnology* (New York: Anchor Books, 1874).

70. De Landa, "Markets, Antimarkets, and Network Economics," n.p.

71. Rothschild, *Bionomics*, xiii. Essentially this is a kind of social Darwinism, as Paulina Borsook also notes: "The idea is that if the market does not validate your ideas, you are inferior intellectually." "Cyberselfishness Explained: An Interview with Paulina Borsook," in *Uncanny Networks: Dialogues with the Virtual Intelligentsia*, by Geert Lovink (Cambridge, Mass.: MIT Press, 2004), 338–39. Also see Konrad Becker's commentary on the "revival of 19th century 'adapt-or-perish' ideology," World-Infostructure, http://www.t0.or.at/wio/wisintro/html/3/es.htm.

72. J. K. Gibson-Graham, *The End of Capitalism (As We Knew It)* (Cambridge: Blackwell, 1996), 253–65.

73. Kathleen Woodward also notes the prevalence of the biological metaphor in

1970s analyses of the self-replicating quality of information, partly beginning with Daniel Bell's commentary on information as that which reproduces itself: "Underlying the process of the reproduction of information are metaphors drawn from biology and fission, both of which proceed at an exponential rate. . . . We speak of an information explosion that triggers an ever-accelerating growth in information." Woodward, *The Myths of Information: Technology and Postindustrial Culture* (London: Routledge and Kegan Paul, 1980), xv.

74. Gibson-Graham, *End of Capitalism*, 117.

75. Otto Imken, "The Convergence of Virtual and Actual in the Global Matrix," in *Virtual Geographies: Bodies, Space and Relations*, ed. Mike Crang, Phil Crang, and Jon May (New York: Routledge, 1999), 100–101. This point would for Žižek likely serve as confirmation of his argument that Deleuze has emerged as the premier ideologist of global capitalism (Žižek, *Organs without Bodies*).

76. Mark C. Taylor, *Confidence Games: Money and Markets in a World without Redemption* (Chicago: University of Chicago Press, 2004), 312.

77. Richard Hofstadter, *Social Darwinism in American Thought* (Philadelphia: University of Pennsylvania Press, 1945).

78. Clearing House Interbank Payments Company, CHIPCo, http://www.chips.org. In *The Twilight of Sovereignty* (1992), Walter Wriston makes a representative comment on the extent to which the telecom network began radically transforming the global financial markets with the introduction of Reuters's video terminal, "Monitor," in 1973; see *The Twilight of Sovereignty: How the Information Revolution Is Transforming Our World* (New York: Charles Scribner's Sons, 1992), esp. 40–42, 59–61.

79. See Marieke de Goede's important work on the war on terrorist finance, e.g., "Underground Money," *Cultural Critique* 65 (2007): 140–63.

80. With regard to regulation, Masao Miyoshi briefly considers the role of CHIPS in relation to the weakened power of national banks. Miyoshi, "A Borderless World? From Colonialism to Transnationalism and the Decline of the Nation-State," *Critical Inquiry* 19 (Summer 1993): 726–51. On the theme of self-facilitation, Geoffrey Ingham notes that "circuits of economic exchange obviously have been able to create their own *media of exchange*." Payment systems, in other words, require a network, hardware, and software. Ingham, "New Monetary Spaces?" *The Future of Money* (Paris: Organisation for Economic Co-operation and Development, 2002), 139.

81. Pryke and Allen, "Monetized Time-Space," 270.

82. Jean-Marie Guéhenno, *The End of the Nation-State*, trans. Victoria Elliott (Minneapolis: University of Minnesota Press, 1995), 54. Also see Richard J. Barnet and John Cavanagh's discussion of "money without a home" in their *Global Dreams: Imperial Corporations and the New World Order* (New York: Simon and Schuster, 1994), 385–402. Employing a somewhat literal definition of the deterritorial in their discussion of financial markets and monetized time-space, Pryke and Allen conclude that money "has become increasingly deterritorialized . . . as previously separate

financial markets have lost their regulatory and geographical distinction" ("Mone-tized Time-Space," 282). In response, much contemporary work on global capital markets and the hazards of derivatives calls for the international and national regulation of speculative trading, e.g., Adam Tickell, "Dangerous Derivatives: Controlling and Creating Risks in International Money," *Geoforum* 31 (2000): 87–99.

83. In *The Rise of the Network Society,* Manuel Castells notes that "one of the key features of informational society is the networking logic of its basic structure" (21). Barnet and Cavanagh cite the *New York Times* writer Peter Passell on the reliance of global banking and financial systems on electronic communications networks. Passell also uses the language of the body to characterize the operation of the network: it is "the computer system that is the heart of global capitalism" (Barnet and Cavanagh, *Global Dreams,* 387). Leyshon and Thrift use the same metaphor but figure the city of London as the electronic "heart" of the "international imperium of commercial capital" (*Money/Space,* 336).

84. Jean-François Lyotard, *The Postmodern Condition: A Report on Knowledge,* trans. Geoff Bennington and Brian Massumi (Minneapolis: University of Minnesota Press, 1984), 67.

85. By extending speech-act theory to economic practices, Lee and LiPuma investigate the performativity of capital.

86. Paul Baran, *On Distributed Communications* (Santa Monica, Calif.: Rand, 1964), http://www.rand.org/about/history/baran.list.html. Also see Alexander Galloway, *Protocol: How Control Exists after Decentralization* (Cambridge, Mass.: MIT Press, 2006), 30–35.

87. Kevin Kelly, *Out of Control: The New Biology of Machines, Social Systems, and the Economic World* (Cambridge, Mass., Perseus, 1995), 3. Nicholas Negroponte, *Being Digital* (New York: Vintage, 1996), 181. For an overview of the "wired" 1990s, see Thomas Streeter, "The Moment of *Wired*," *Critical Inquiry* 31, no. 4 (Summer 2005): 755–79.

88. Kevin Robins and Frank Webster, *Times of the Technoculture: From the Information Society to the Virtual Life* (New York: Routledge 1999), 69–70.

89. Kelly, *Out of Control,* 25. Terranova, "Digital Darwin: Nature, Evolution, and Control in the Rhetoric of Electronic Communication," *New Formations* 29 (Autumn 1996): 70. A compelling counterpart to the figure of the "nest of snakes" is Ben Fry's "organic information design," for example, *Anemone,* which envisions information as a complex, biological system that is both interactive and emergent. Here the nodes of data are analogized to creatures in an ecosystem and grow or atrophy depending on user engagement and their relations with other nodes. See http://acg.media.mit.edu/people/fry/anemone.

90. For an in-depth analysis of the debates about the Clipper Chip, see Laura Gurak, *Persuasion and Privacy in Cyberspace: The Online Protests over Lotus Marketplace and the Clipper Chip* (New Haven, Conn.: Yale University Press, 1997).

91. Terranova, "Digital Darwin," 71.

92. Ibid., 82. Though she laments the figuration, Terranova strangely adheres to the ideology of the market as a "natural, self-evolving system" (82), "an indifferent, flexible, demanding, yet, alas, 'natural' market-system" (83), what Julian Stallabrass and others will call a "conservative view." Stallabrass reads hacktivism as unwittingly reinforcing "the conservative view of the market and its creatures as natural forces," in that the premise of this mode of political-artistic practice is that an attack prompts "mutation," structural adjustments that are read as transformative change (*Internet Art*, 94).

93. Slavoj Žižek, *The Plague of Fantasies* (London: Verso, 1997), 156–57. Terranova's concern ultimately is the "removal of the physical body from the process of communication" ("Digital Darwin," 82), which prevents our seeing real-life power differentials (this component of her argument situates her piece in proximate relation to the mid-1990s discourse of identity and the Internet, of which representative examples include Sherry Turkle, Julian Dibbell, and Lisa Nakamura). The interfaces of biology and computing are of course not only metaphoric but also literal and the province of research by Eugene Thacker and others. See Thacker's *Biomedia* (Minneapolis: University of Minnesota Press, 2004).

94. Fernand Braudel, *The Perspective of the World*, trans. Siân Reynolds (London: Collins, 1984), 83–85.

95. Giovanni Arrighi, *The Long Twentieth Century: Money, Power, and the Origins of Our Times* (New York: Verso, 1994), 19. In the study, he periodizes the long twentieth century with respect to finance capital: "As this approximate and preliminary periodization implies, consecutive systemic cycles of accumulation overlap, and although they become progressively shorter in duration, they all last longer than a century; hence the notion of the 'long century,' which will be taken as the basic temporal unit in the analysis of world-scale processes of capital accumulation" (6–7). Arrighi's periodization of the long twentieth century is based on three periods of crisis: the Great Depression of 1873–96, the thirty-year crisis of 1914–45, and the economic crisis of the 1970s.

96. In contrast, Samir Amin argues that the current crisis of the world system "reveals that the polarization of the world really constitutes a historic limit for capitalism." Amin, *Empire of Chaos* (New York: Monthly Review Press, 1992), 13.

97. Giovanni Arrighi, "Marxist Century–American Century: The Making and Remaking of the World Labor Movement," in *Transforming the Revolution*, ed. Samir Amin (New York: Monthly Review Press, 1990), 55–56.

98. On the new Empire and the contemporary relations between American military and economic power, see Immanuel Wallerstein, *The Decline of American Power* (New York: New Press, 2003); Alain Joxe, *Empire of Disorder*, trans. Ames Hodges (Los Angeles: Semiotext(e), 2002); Ellen Meiksins Wood, *Empire of Capital* (New York: Verso, 2003); and Michael Mann, *Incoherent Empire* (New York: Verso, 2003).

99. Moreover, an analysis of the interface between global capitalism and new technologies could only really be in the mode of the speculation, partly because there are no strict answers for these questions, partly because of the uncertain futures of the market, but also because the market and capital itself exist now in the mode of global financial speculation, as do the new technologies, which cannot eliminate (or shake off) either vaporware or the system of initial public offerings (IPOs).

100. Giovanni Arrighi and Beverly J. Silver, *Chaos and Governance in the Modern World System* (Minneapolis: University of Minnesota Press, 1999), 35.

101. Terence Hopkins and Immanuel Wallerstein, *The Age of Transition: Trajectory of the World-System, 1945–2025* (London: Zed Books, 1996), 8.

102. Arrighi and Silver review the criticism linking chaos theory to changes in the global political economy (*Chaos and Governance*, esp. 21–26). Also see Amin, *Empire of Chaos*. In contrast, Joxe draws on the rhetoric of equilibrium in his commentary on the question of the "end of capitalism" (*Empire of Disorder*, 189).

103. Hopkins and Wallerstein begin *The Age of Transition* with a section titled "The World-System: Is There a Crisis?" Also see Hobsbawm, *The Age of Extremes*, and Arrighi and Silver, *Chaos and Governance*, 2.

104. Arrighi and Silver, *Chaos and Governance*, 356.

105. Schumpeter, *Capitalism, Socialism, and Democracy*, 82. Schumpeter summarizes his position vis-à-vis Marx in a 1949 address: "Marx was wrong in his diagnosis of the manner in which capitalist society would break down; he was not wrong in the prediction that it would break down eventually" (424–25). Though they focus primarily on the efforts to prolong hegemony, and not on the successful hegemonic runs, Hopkins and Wallerstein suggest a systemic logic similar to that articulated by Arrighi for what they call the capitalist world-economy, whereby "the very efforts made to prolong the power themselves tend to undermine the base of the power, and thus start the long process of relative decline" (*The Age of Transition*, 9).

106. Schumpeter, *Capitalism, Socialism, and Democracy*, 84, 87.

107. I am grateful to Alan Liu for pointing me to this passage in Schumpeter as a means to bridge organicism and the language of complexity. The importance of rhetoric and speech performance in Schumpeter's analysis is underscored by Joan Robinson, review of *Capitalism, Socialism, and Democracy, Economic Journal* 53 (December 1943): 381–83.

108. Bill Maurer, "Complex Subjects: Offshore Finance, Complexity Theory, and the Dispersion of the Modern," *Socialist Review* 25, nos. 3–4 (1995): 114–15.

109. Fernando Coronil, "Toward a Critique of Globalcentrism: Speculations on Capitalism's Nature," in *Millennial Capitalism and the Culture of Neoliberalism* (Durham, N.C.: Duke University Press, 2001), 79; Charles Sanford, "Financial Markets in 2020," Federal Reserve Bank of Kansas City (1994), 1–10, http://www.kc.frb .org/publicat/econrev/pdf/1q94sanf.pdf.

110. Hardt and Negri, *Empire*, 41.

111. Guéhenno, *End of the Nation-State*, 49.

112. Lee, "Structures of Knowledge," 197.

113. Manuel Castells, *The Power of Identity* (Oxford: Blackwell, 1996), 360.

114. Arrighi, *The Long Twentieth Century*, 4. Alexander Bard and Jan Söderqvist also counter the equilibrium theories of capitalism and suggest that economic systems are instead flexible: "The market economy is 'natural': an unplanned but still highly structured ecological system in a state of constant change." Bard and Söderqvist, *Netocracy: The New Power Elite and Life after Capitalism* (London: Pearson Education, 2002), 166.

115. For (often indirect) allusions to a complexity model, with implications of the inconclusive, unpredictable, and nontotalizable, for the "global," global culture, and global orderings, see Gearóid Ó Tuathail, *Critical Geopolitics: The Politics of Writing Global Space* (Minneapolis: University of Minnesota Press, 1996), 15; Hardt and Negri, *Empire*, 41; Richard Lee, "Structures of Knowledge," in *The Age of Transition: Trajectory of the World-System, 1945–2025*, ed. Terence Hopkins and Immanuel Wallerstein (London: Zed Books, 1996), 197; and Arrighi and Silver, *Chaos and Governance*. Alvin and Heidi Toffler make very general use of the chaos and complexity paradigms in *War and Anti-War: Making Sense of Today's Global Chaos* (New York: Little, Brown and Company, 1993). Ulf Hannerz also loosely links global culture to complexity theory by arguing that "people like the cosmopolitans have a special part in bringing about a degree of coherence; if there were only locals, world culture would be no more than the sum of its separate parts." Hannerz, *Transnational Connections* (New York: Routledge, 1996), 111.

116. We can trace the emergence of the rhetoric of complexity, as does Taylor, back to theories of Brownian motion and stock prices (early twentieth century), the efficient-market hypothesis (EMH), and theories of market equilibrium (*Confidence Games*, 244–48).

117. Jean Comaroff and John Comaroff, "Millennial Capitalism and the Culture of Neoliberalism," public seminar, Rice University (March 30, 2005).

118. Marx, *Capital*, 98.

119. An interesting counterpart here is Étienne Balibar's commentary on our collective fantasy, "the *impression* of a turning point in the history of civilization" precipitated by the emergence of multinational corporations, the collapse of the Soviet socialist system, and the commingling of technical and natural components, such that earth is imagined to have become a singular entity, a "'system' in which flows of information, energy and matter influence one another." Balibar, *We, the People of Europe? Reflections on Transnational Citizenship*, trans. James Swenson (Princeton, N.J.: Princeton University Press, 2004), 103–5 (italics mine).

120. Geert Lovink, "Demystifying the Virtual Power Structures: An Interview with Susan George," in *Uncanny Networks: Dialogues with the Virtual Intelligentsia*, by Geert Lovink (Cambridge, Mass.: MIT Press, 2004), 292.

121. George Soros, *The Alchemy of Finance* (Hoboken, N.J.: John Wiley and Sons, 2003), 4.

122. Ibid., 10, 14, 32. See also the discussion of market fundamentalism in Soros, *Open Society: Reforming Global Capitalism* (London: Little, Brown, 2000), 143–44, 196–98.

123. It is important to emphasize, as does Slavoj Žižek in a commentary on Kojin Karatani, financial speculation and real production should not be read as mutually exclusive. Both Karatani and Žižek reject any strict opposition between production and speculation and read them rather in terms of "parallax." Žižek, "The Parallax View," *New Left Review* 25 (January–February 2004): 121–34. On this third speculative stage of capital, see Jameson, "Culture and Finance Capital," 246–65.

124. Also see Derek H. Aldcroft and Michael J. Oliver, *Exchange Rate Regimes in the Twentieth Century* (Northampton, Mass.: Edward Elgar, 1998). There is another critical trajectory to follow with respect to the gold standard and the naturalizing of finance: Jean-Joseph Goux's *The Coiners of Language* aligns the decline of the gold standard and the shift to paper money with the decline of literary realism, and in response, Derrida's *Given Time: I. Counterfeit Money* critiques Goux's historical map as naturalizing gold money.

125. Susan Strange, *Casino Capitalism* (Manchester University Press, 1986) draws an extended analogy between the global financial system, particularly foreign exchange markets, and gambling for this very reason.

126. Philip G. Cerny, "The Dynamics of Financial Globalization: Technology, Market Structure, and Policy Response," *Policy Sciences* 27 (1994): 337. "Friction-free capitalism" and market efficiency are cited as the Information Age equivalent of trickle-down economics. On the ideology of Bill Gates's promise that the Internet would approximate Adam Smith's perfect market, see Žižek: "In the social conditions of late capitalism, the very materiality of cyberspace automatically generates the illusory abstract space of 'friction-free' exchange in which the particularity of the participants' social position is obliterated" (*The Plague of Fantasies*, 156).

127. Jameson, "Culture," 251; Hardt and Negri, *Empire*, xii.

128. Marx, *Grundrisse*, trans. Martin Nicolaus (New York: Penguin Books, 1973), 519; Otto Imken, "The Convergence of Virtual and Actual in the Global Matrix," *Virtual Geographies: Bodies, Space and Relations*, ed. Mike Crang, Phil Crang, and Jon May (New York: Routledge, 1999), 99.

129. Žižek, *Welcome to the Desert of the Real* (New York: Verso, 2002), 36. On electronic and virtual money, see Saskia Sassen, *Losing Control?* 49; Kevin Kelly's chapter on "e-money" in *Out of Control*; Kelly, "E-Money," *Whole Earth Review* (Summer 1993); Keith Hart, *Money in an Unequal World* (New York: Texere, 2001), 203–29; Geoffrey Ingham, "New Monetary Spaces?" in *The Future of Money* (Paris: Organisation for Economic Co-operation and Development, 2002), 123–45; Andrew Leyshon and Nigel Thrift, *Money/Space: Geographies of Monetary Transformation* (New

York: Routledge, 1997), esp. 20–22; Elinor Solomon, *Virtual Money: Understanding the Power and Risks of Money's High-Speed Journey into Electronic Space* (New York: Oxford University Press, 1997); and Keith Hart, *Money in an Unequal World* (New York: Texere, 2001). Advocates of electronic forms of money (corporate currencies) contribute to the challenge to the state's control of currency popularized by Friedrich Hayek's *The Denationalisation of Money* (1978). Hayek suggests that market forces would determine the value of privately issued currencies.

130. Mark C. Taylor, *Disfiguring: Art, Architecture, Religion* (Chicago: University of Chicago Press, 1992), 154. Here Taylor's reading of the substance of money after the collapse of the gold standard dovetails with the early *Wired* investment in the insubstantiality of the electronic interface, the paradigmatic fictional register of which is the *Neuromancer* trope of jacking in and transcending the "meat." As redress to the immateriality idea, Matt Kirschenbaum's forthcoming book *Mechanisms* addresses among other topics the forensics of electronic data.

131. Coronil, "Toward a Critique of Globalcentrism," 63–87.

132. See Lynn Hershman, "The Raw Data Diet, All-Consuming Bodies, and the Shape of Things to Come," *Leonardo* 38, no. 3 (2005): 208–12; and Meredith Tromble, ed., *The Art and Films of Lynn Hershman Leeson* (Berkeley: University of California Press, 2005).

133. Mary Poovey, "Residual Materialities," paper for *Digital Retroaction*, University of California, Santa Barbara (September 2004), p. 26, http://dc-mrg.english .ucsb.edu/conference/D_Retro/conference.html.

134. See Žižek on the fallacy of linear historical evolutionism and his critique of progressivism inherent in historiographic paradigm offered by theorists of the "netocracy" in *Organs without Bodies*. To a certain extent, the "netocracy" thesis mirrors Fukuyama's polemic about the end of history and its suggestion that capitalism has evolved into its perfect final form.

135. See Lise Autogena and Joshua Portway, "The Project," http://blackshoals.net/ project.html.

136. Cefn Hoile, "Black Shoals: Evolving Organisms in a World of Financial Data," in *Black Shoals Stock Market Planetarium*, chap. 5, n.p.

137. Fischer Black published "The Pricing of Options and Corporate Liabilities" with Scholes in 1973 but died before the Nobel was awarded; Merton published "Theory of Rational Price Optioning" shortly after the Black-Scholes paper appeared. See Mark Taylor's discussion of LTCM in *Confidence Games: Money and Markets in a World without Redemption* (Chicago: University of Chicago Press, 2004), 250. Also particularly instructive is "Trillion Dollar Bet," *Nova*, February 2000, http://www .pbs.org/wgbh/nova/stockmarket; as well as "The Midas Formula," BBC2, December 1999, http://www.bbc.co.uk/science/horizon/1999/midas.shtml.

138. Nicholas Dunbar, cited in Taylor, *Confidence Games*, 259. Also see Donald Mackenzie, "How a Superportfolio Emerges: Long-Term Capital Management and

the Sociology of Arbitrage," in *The Sociology of Financial Markets,* ed. Karin Knorr Cetina and Alex Preda (Oxford: Oxford University Press, 2005), 62–83.

139. Autogena and Portway, "Thoughts behind the Project," http://www.blackshoals .net/Thoughts.html.

140. Nicholas Dunbar cited in Taylor, *Confidence Games,* 259.

141. "Feedback," *Principia Cybernetica Web,* http://pespmc1.vub.ac.be/FEEDBACK .html.

142. Jacques Rancière, *Disagreement,* trans. Julie Rose (Minneapolis: University of Minnesota Press, 1999), viii.

143. Schumpeter, *Capitalism, Socialism, and Democracy,* 83.

144. Hoile, ""Black Shoals," n.p.

145. Hoile's development of the creatures was also informed by Karl Sims, Thomas Ray's *Tierra,* and Theo Jansen's wind-powered beach animals, e.g., "Animaris Sabulosa." See Theo Jansen's site, http://www.strandbeest.com, as well as "Interview with Theo Jansen," *artificial.dk* (October 2005), http://www.artificial.dk/articles/ theojansen.htm. On Karl Sims see N. Katherine Hayles, "Simulating Narratives: What Virtual Creatures Can Teach Us," *Critical Inquiry* 26, no. 1 (Autumn 1999): 1–26.

146. Anders Michelsen, "The fact of would-be worlds—comments on the Black Shoals art project," http://blackshoals.net/textpages/AndersText.html. William Grey Walter, "An Imitation of Life," *Scientific American,* May 1950, 42–45; Walter, "A Machine That Learns," *Scientific American,* August 1951, 60–63; Walter, *The Living Brain* (New York: Norton, 1953); Owen E. Holland, "Grey Walter: The Pioneer of Real Artificial Life," in *Proceedings of the Fifth International Workshop on the Synthesis and Simulation of Living Systems,* ed. Christopher Langton (Cambridge, Mass.: MIT Press, 1997).

147. I am grateful to Katherine Hayles for posing a question about significance of the material properties of stars in the context of this work.

148. Jaime Stapleton, "A Meditation on Cosmology, Artificial Life and the Aesthetics of Political Economy," http://blackshoals.net/textpages/JamieText.html.

149. Hoile, "Black Shoals," n.p.

150. See Autogena and Portway, "The Project," http://blackshoals.net/project.html.

151. Anthologies are often a visual confirmation of the centrality of intellectual questions. We might thus note, as just one example, Claire Bishop's recent anthology, *Participation* (Cambridge, Mass.: MIT Press, 2006).

152. De Certeau, *The Practice of Everyday Life,* trans. Steven Randall (Berkeley: University of California Press, 1984), 26.

Index

A* algorithm, 19–20, 93
Aarseth, Espen, 90, 172n80
Abu Ghraib photos, 98
Afghanistan, war in, 68, 91–96, 101
Agamben, Giorgio, 38, 39, 160n25
agency, 27
agoraXchange, 85–86
ALife: and *Black Shoals*, 114, 125, 144–45, 147–49; and *ecosystm*, 118–20; and William Grey Walter, 147, 149
Allen, George, 129, 133
al-Massari, Mohammed, 82
al-Qaeda, 78
Al-Zarqawi, Abu Musab, 98
Amazon.com: search engine of, hijacked, 18–19; visualization of purchases on, 23–24
America's Army, 82–83, 84, 88, 104; Joseph DeLappe's intervention in, 11, 16, 83, 103–7
Amoore, Louise, 163n60
Andreas, Peter: *Border Games*, 34–35
antiglobalization, 1, 48
Antiwargame, 88–89
antiwar games, 71, 84–89; ambiguity of, 90. *See also* persuasive games; war games
Apter, Emily, 97, 119

Arendt, Hannah, 29
Arquilla, John, 45; *Networks and Netwears*, 43, 162n41
Arrighi, Giovanni, 134, 178n65, 181n95; and cycles of capitalism, 127, 128–29; and ends of capitalism, 136, 137, 138; *The Long Twentieth Century*, 136; and mobility of capital, 121
Autogena, Lise. *See Black Shoals*

Bachelier, Louis, 126
Back to Israel: *Wild West Bank*, 88
Baker, Rachel: *BorderXing Guide*, 50–51
Balibar, Étienne, 183n119; on border control, 34, 159n13; on citizenship, 52–53
Balkans: wars in, 68
Baran, Paul, 134
Bard, Alexander, 143
Battlefield 2: Special Forces, 74–76, 78
Baudrillard, Jean, 57; on virtual war, 66–67, 71, 90
Bauman, Zygmunt: on "liquid modernity," 53–54
Beck, Ulrich: and risk, 35
Becker, Konrad: Netbase/t0, 8–9
Bell, Daniel, 3
Bernhard, Hans: *Amazon Noir*, 18–19

recruitment, 82–83; and sympathy, 78. *See also* antiwar games; *specific games*

War on Terror, 87–88

war simulations, 62, 68–71, 84, 85; influence future events, 70. *See also* antiwar games

Watkins, Peter: *The Gladiators,* 84

Wattenberg, Martin: *Map of the Market,* 113–14

Webber, Francisco de Sousa: Netbase/t0, 8–9

Webster, Frank, 134–35

We Interrupt This Empire, 71–72

Werthein, Judi: *Brinco (Jump),* 51

Wild West Bank, 88

Wilson, Stephen: *Information Arts,* 6, 157n59

work. *See* labor

World Bank, 140

World Trade Organization, 1

Wray, Stefan, 41, 44

Wright, Alyssa: *Cherry Blossoms,* 100–101

Wriston, Walter, 122

Yes Men, 7, 11, 18

Zapatista movement, 26, 41, 43; digital Zapatismo, 56, 59

Žižek, Slavoj, 10, 179n75, 184n123, 185n134; on dematerialization of money, 142, 184n126; on nomadism, 53, 135

Zurich Capital Markets, 117, 124

RITA RALEY is associate professor of English at University of California, Santa Barbara.